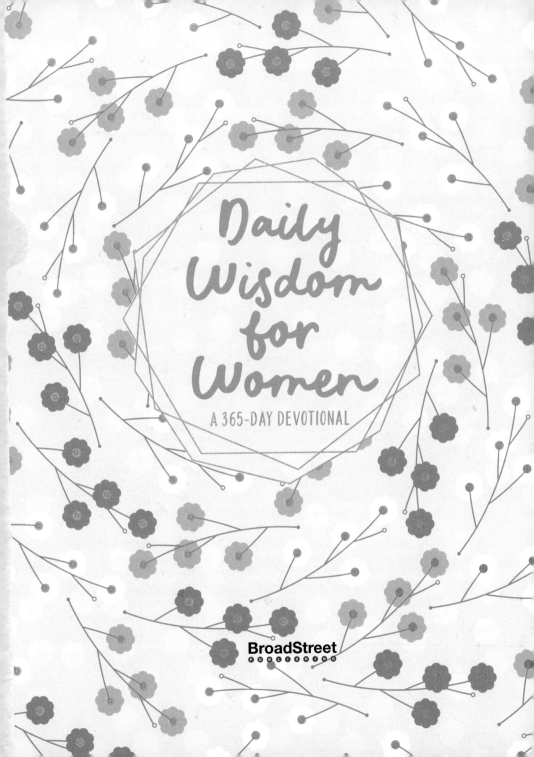

Daily Wisdom for Women

A 365-DAY DEVOTIONAL

BroadStreet
PUBLISHING

BroadStreet Publishing Group, LLC.
Savage, Minnesota, USA
Broadstreetpublishing.com

Daily Wisdom for Women

9781424566976
9781424566983 (eBook)

Devotional entries composed by Brenna Stockman and Sara Perry.

Typesetting and design by Garborg Design Works | garborgdesign.com
Editorial services by Michelle Winger | literallyprecise.com

Printed in China.

24 25 26 27 28 29 30 7 6 5 4 3 2 1

Wisdom is far more valuable than rubies.
Nothing you desire can compare with it.

PROVERBS 8:11 NLT

Introduction

Jesus is wisdom personified; he is always ready with revelation to expand our understanding. The fountain of his life pours into our hearts every time we search after him. His wisdom is full of loving leadership, calm confidence, and honest conviction. There truly is no better thing to pursue in this life.

The Bible is full of practical advice with physical and spiritual benefits. As you meditate on these proverbs, devotional entries, and prayers, lean into the knowledge revealed in God's living Word. Find treasures of wisdom as you turn your attention to Jesus and listen for his voice in the stillness. You can build a hopeful future on the foundation of his love with wisdom as your guide.

January

The fear of the LORD
is the beginning of knowledge;
fools despise wisdom
and discipline.

PROVERBS 1:7 CSB

Wise King Solomon

These are the proverbs of Solomon,
David's son, king of Israel.
PROVERBS 1:1 NLT

*A*s we begin our journey through Proverbs, it is wise to consider the position of Solomon, the author of most of the book. Solomon was the son of David and Bathsheba. He was the third king of the united kingdoms of Israel and Judah. He ruled for forty years in the late 900s BC and was well-known for his wisdom. This wisdom was a direct gift from God after Solomon prayed for guidance as a new and insecure ruler. Solomon's wisdom was known throughout the world, and he was "richer and wiser than any other king on earth" (1 Kings 10:23).

Since God did not allow David to build the temple because he was a warrior (1 Chronicles 28:3), David prepared the workers and materials for his son to carry out the vision. Although not his only venture, the temple was the grand opus of Solomon's life. Wisdom guided him in his focus and in his building. What a beautiful and accessible gift we have in the God-given wisdom of his proverbs.

Lord, move through Solomon's proverbs as I read them, so I may gain wisdom to live my best life.

Wise Words

They teach wisdom and self-control;
they will help you understand wise words.
PROVERBS 1:2 NCV

Solomon addresses the need for understanding right from the beginning of Proverbs so we can recognize the impact of wisdom in our lives. There is little point in reading anything without understanding it. God's Word is a seed that is planted in our hearts; as it grows, it nurtures us into mature believers. This work can't happen without fertile ground in our hearts and minds. As we remain openhearted and willing to change, God can move us in understanding. His wisdom teaches us when to reach out and when to restrain ourselves.

A heart open to the Word of God is teachable. A humble and teachable heart leads to wisdom and self-control. The Holy Spirit moves in us, helping us comprehend his Word as we read and learn under the teaching of wise King Solomon.

Dear Father, ready the soil of my heart and teach me your ways as I learn from Proverbs. Give me understanding to know what your wisdom looks like.

Purpose of Proverbs

Their purpose is to teach people to live
disciplined and successful lives,
to help them do what is right, just, and fair.
PROVERBS 1:3 NLT

Today's verse is clear that if you want true insight and understanding, the Word of God is where to find it. Proverbs in particular addresses what wisdom looks like in practical life. It is not always easy to follow the path of wisdom. It will challenge you to think and act differently than you might at this moment. Its purpose is to lead you toward integrity, where you have nothing to hide from others or from the Lord.

We often struggle with selfishness as humans. It can be hard to get out of our comfort zones and reject excess. These things can sidetrack us from the life God intends for us. Learning to be wise will help us be both disciplined and successful. As we allow God to teach us hard lessons that go against our natural tendencies, we will learn to do what is right, fair, and just. True success comes from living with integrity.

Dear Lord, open my eyes to see where I am not living in accordance with your wisdom. Let me not just accept your discipline but appreciate it for the blessing it is.

Impact of Proverbs

To give prudence to the simple,
To the young man knowledge and discretion.
PROVERBS 1:4 NKJV

*P*rudence is when a person shows level-headedness and discernment in managing their affairs. They are able to discipline themselves and weigh the best options when faced with a dilemma. They have skill and good judgment when using personal resources. They show discretion and caution in the face of danger or risk. They do not reject reasoning but use it to see a bigger picture than what they may be able to sense through their initial reactions.

In our verse today, God says that prudence is a gift given to even the simplest and youngest of people. Those who seek find. No matter how we have operated in the past, God makes wisdom available to us. The gift of wisdom offers us tools to help us through every twist and turn that life brings.

Father, I humble my heart before you today. I long to live by your wisdom and to grow in the depth of your understanding. Increase my capacity to walk in your ways.

Lifelong Learning

Wise people can also listen and learn;
even they can find good advice in these words.

PROVERBS 1:5 NCV

The power of wisdom does not begin and end with us. God uses it to better prepare us to help others. It can be applied to every relationship we have. The purpose of God's wisdom is communal. Its power is amplified in our families and communities. The Bible is full of wisdom that is accessible and understandable to everyone. No matter how much wisdom we already have, we can still glean more wisdom from the pages of Scripture. There is always more to learn and discover in the glorious kingdom of our God and King.

Let's strive to always grow in wisdom and understanding because we are never too wise to learn more about God and his ways. In the Bible, how often do we see examples of God using seemingly simple people, like children or fishermen, to be recipients of his wisdom and change the world? Pride keeps us from true wisdom, but a humble heart willingly receives it. Humility is required to grow in wisdom.

Dear God, I want to know more of your wisdom even today. Teach me, Lord. Open my ears to hear and my heart to understand.

Wise Riddles

Anyone can understand wise words and stories,
the words of the wise and their riddles.
PROVERBS 1:6 NCV

Solomon wrote these words to his children to assure them that
no kingship, scholarly education, or good upbringing is needed
to understand the Word of the Lord. The Lord does not speak in
riddles to confuse us but to separate those who desire to learn from
those who aren't willing to put in the effort to understand. No matter
our situation, we have access to God's wisdom and the ability to
become wise. What a gracious invitation this is today!

Like Solomon, when we receive wisdom, we should be willing
to pass it along. He wanted his children to grow in love and
understanding of God, so he encouraged them to receive his wisdom
and learn from his life. Let's openly share ourselves the same way
and pass our wisdom on to others.

*Father, as I learn and grow in wisdom, help me to be purposeful in
passing that wisdom along to others. Thank you for explaining your
mysteries to me when I choose to humbly listen and learn from your
Spirit.*

Fear of the Lord

The fear of the LORD is the beginning of knowledge,
But fools despise wisdom and instruction.

PROVERBS 1:7 NKJV

What does it mean to fear the Lord? Our loving Father doesn't want us hiding from him, guilt-ridden and ashamed, like Adam and Eve in the Garden of Eden. He wants us to have a healthy reverence that leads to lives of obedience and worship. He is King of the universe and fully worthy of our respect and honor.

Sin is direct disobedience against the Creator who loves and sustains our souls, and it carries consequences. God is merciful and wants to liberate us from our sin. Through Christ, he does! A willing and repentant heart knows the power of holy fear. It draws near to the Lord and depends on him. Fearing the Lord is an appropriate response to understanding how great he is. When we insist on our ways over God's, it is neither wise nor beneficial. God knows and wants what is best for us, and his wisdom is always best.

Lord, I want to worship you with my life and every choice I make. You are my King, and the healthy fear I have for you reminds me that your wise ways are better than foolishly hasty decisions.

Loving Discipline

Listen, my son, to your father's instruction
and do not forsake your mother's teaching.
They are a garland to grace your head
and a chain to adorn your neck.

PROVERBS 1:8-9 NIV

Discipline can be misunderstood if all we know of it are abusive tendencies. Loving parents correct their children. God's discipline is always laced with kindness. He wants what is best for his children, and he knows that we need his guidance and correction. God, our loving Father, wants what is best for us. When we heed his discipline, it's as if we clothe ourselves in fine garlands and jewelry. The change in our lives becomes apparent.

Whether or not we had good parents who raised us to be disciplined adults, we have a heavenly Father guiding us down the best path. Let's not despise his hand of correction, for it teaches us to walk in wisdom and keeps us from falling into pits of sin. Some lessons are difficult to learn, and sometimes discipline feels harsh, but if we remain teachable, we will reap his blessings.

Lord, thank you for teaching and guiding me. I will not despise your discipline but embrace it because it comes from your great love. I never want to forget the lessons you have taught me.

Follow God

My child, if sinners try to lead you into sin,
do not follow them.

PROVERBS 1:10 NCV

Following God means we follow him above all else. Not everyone who wants to join us in life or work has our or God's best interest at heart. It is important to have our eyes wide open to the intentions of those who want us to join them in various endeavors. A person who does not spend time with God will not know his voice from the other voices crowding daily life. We may miss or even choose to ignore the wisdom that would take us to where God wants us to be.

Our Father addresses us as children for a good reason. We have childish tendencies if we do not mature in the Word which leads to life and goodness. Without this maturity, we tend to allow the sinners in our lives to convince us to sin. Following them down wrong paths will require repentance and repair before we are back in the light of God's plan. God longs to lead you on the path of his life. When you allow him to lead you, you will find his presence is more than enough to sustain you.

Dear Lord, make and mold me in your image. Lead me closer to you and give me discernment to decipher the fruit of your Spirit in the people around me.

Wisdom Isn't Silent

Wisdom calls aloud outside;
She raises her voice in the open squares.
PROVERBS 1:20 NKJV

Job 28:28 tells us, "The fear of the Lord, that is wisdom, and to depart from evil is understanding." Wisdom is not a quiet, personal virtue; it is obvious and has a great impact on those around us. Wisdom is active: it calls aloud and departs from evil. Wisdom leaves a trail and a legacy.

What is our legacy? How is wisdom evident in our lives? Does the way we act under pressure or hardship reveal the trust we have in our Maker? Do we stay out of drama and gossip? Are we planning and making smart decisions for our future? Wisdom calls aloud; she doesn't stay silent. What is our impact? Whom are we influencing? How are we known? Is the influence of God on us evident to everyone watching how we live?

Father God, teach me when to speak and when to stay silent, when to step forward and when to wait. Help me depart from any evil that tries to ensnare me.

Wisdom Calls

> She calls to the crowds along the main street,
> to those gathered in front of the city gate.
>
> PROVERBS 1:21 NLT

In biblical times, city gates were a place of business. Transactions were made, connections formed, and decisions solidified that affected the community. Provision and protection formed in this important location, and people gathered so they would know what was happening with those around them. When Solomon said wisdom calls to the crowds on the main street and the city gate, he was speaking of the importance of sharing wisdom with as many people as possible. Wisdom is especially crucial to those making decisions for everyone. The wise path is good news for all.

We would be wise to not just learn wisdom but to speak about it as well. Let it be a topic of conversation so we can encourage others to make good decisions and live well. The more we think about wisdom, the less we will be distracted by foolishness.

My Father, your wisdom leaves its mark in this world. I want to walk in your wise ways all the days of my life and share your wisdom with everyone I know.

Repent When Rebuked

"Repent at my rebuke!
Then I will pour out my thoughts to you,
I will make known to you my teachings."
PROVERBS 1:23 NIV

As we learn about wisdom, we naturally take our old behaviors into account, and that is good. Learning from our failures is a solid way to identify Christ-like traits, but God's thoughts don't stop there. His teachings move us forward instead of freezing us in the moment. He is always leading us in loving-kindness.

Repentance is a necessary step toward building a strong and wise character. It is a key element resulting from humble acceptance of the truth that we all fall short of the glory of God. Repentance is the impetus for change. We admit that we have failed, and it is Christ that redeems and liberates us. In Christ, every cell of our hearts, minds, and bodies is washed as clean as snow. We are a new creation free to accept God's thoughts and teachings.

Dear Lord, you are my all-in-all. You are my purpose and path. When you show me the error of my ways, I change course and humble myself before you. May my life reflect your wisdom.

Don't Harden Your Heart

"Then you will call to me,
but I will not answer.
You will look for me,
but you will not find me.
It is because you rejected knowledge
and did not choose to respect the LORD."

PROVERBS 1:28-29 NCV

There are three things happening in today's excerpt from Proverbs. Some people ignore God's call, then they look for God but don't find him, and some reject the truth and thus disrespect God. If God calls and we ignore that voice, we potentially lose the opportunity to have his help when we need it most. Our choices made in good times will reflect in God's response when we need him in challenging times. There are consequences to our choices, and it is prudent to have God foremost in our hearts.

It is unwise to ignore the voice of God. Once we have walked away from him, the divergence from his path becomes increasingly obvious in our lives. The warning in these words is clear and concise: refusal to listen to God will create distance in our relationship with him.

Lord my God, let me hear your voice as I seek your wisdom. Give me grace and strength to follow you always, for you always know best. I don't want to drive a wedge between us.

Bitter Fruit

"They rejected my advice
and paid no attention when I corrected them.
Therefore, they must eat the bitter fruit of living their own way,
choking on their own schemes."
PROVERBS 1:30-31 NLT

According to Mark 3:22-30, the only unforgivable sin is the blasphemy of the Holy Spirit. "All sin and blasphemy can be forgiven, but anyone who blasphemes the Holy Spirit will never be forgiven" (vv. 28-29). So what does our verse today mean?

It's about consequences. When we make plans and ignore God's wisdom and correction when he offers it, we lay a path that deviates from God's. The consequences of that decision are bitter fruit. Ultimately, the bitter fruit causes us to choke. We can't sin freely and toss in a prayer of repentance at the end of the day. Our minds and hearts will solidify into a self-track rather than a God-track. We can turn that train around through prayer and reading the Word, but it takes diligence and the moving of the Holy Spirit in our hearts.

Lord Almighty, you are my advisor and authority. Move in my heart and mind. I want your guidance and direction, not to forge my own path without you. Thank you for leading me.

Make Your Choice

"The simple are killed by their turning away,
and the complacency of fools destroys them."
PROVERBS 1:32 ESV

*D*oing nothing is a choice. Being apathetic about everything will eventually destroy a person. Turning away from God will dull the soul. Make no mistake, dear believer; you are choosing something when you choose nothing. Complacency is a lack of caring, and we know that God's heart cares for everyone. God tells us throughout Proverbs and the whole Bible that we are to seek him and serve him and to love others well. We are to spread his beautiful, life-restoring message and live redeemed and humble lives. Each of these commands are actions. They require a purposeful heart and mind which is the opposite of complacency.

Throughout the Word, God also promises to equip us for the work he has set out for us. "May the God of peace… equip you with everything good that you may do his will, working in us that which is pleasing in his sight" (Hebrews 13:20-21). You are wise to keep your heart connected to compassion and to the Lord.

Dear God, I want my heart to burn with love for you and for others. I know that my choices matter. Help me rest when I need rest and act when I should act.

Live without Fear

"Those who listen to me will live in safety
and be at peace, without fear of injury."
PROVERBS 1:33 NCV

Listening to God's wisdom can transform every area of our lives. When God's wisdom directs our paths, our perspectives of this earthly life are illuminated by his truth. While the world swirls around us in conflict and upheaval, we are graciously covered by his protection and provision. When life is hard, God's presence is close.

When we focus our attention on God, the weight of the worries of this life are lifted. We may be rich or poor, sick or healthy, old or young, but when God's love overwhelms our hearts, we can rest in his purpose and plans. There will come a time where every pain, fear, grief, and loss is abated in the fullness of Christ's kingdom. Even as we wait for this day, we can live with the peace of God as our covering here and now.

Lord, thank you for your peace that passes all understanding. When the world is raging, keep me close to your heart and direct me with your words of wisdom. I want to dwell in your powerful peace all the days of my life.

A Listening Heart

My child, listen to what I say
and remember what I command you.
Listen carefully to wisdom;
set your mind on understanding.
PROVERBS 2:1-2 NCV

Today's verse reveals the difference between hearing and listening by instructing us to set our minds on understanding. Hearing Scripture is not the same as fully understanding the meaning and intention behind the words. If we want to understand wisdom, we must take the time to listen. To *listen* means to hear with thoughtful consideration. How much of our prayer times are spent this way?

The writer of this proverb starts by drawing our attention with, "My child." Children don't always realize that their parent has their best at heart when they instruct them. The Father is better at parenting us than our best efforts with our own children. We can trust his intentions are good and for our good. Why not listen to his wisdom and adopt his ways today?

Dear Father, thank you for your patience with me as I turn my attention to what you have to say. May my heart and mind be open and teachable, remaining aware of the consequences of my decisions. Thank you for your help in all things.

Mining for Treasure

Cry out for insight,
and ask for understanding.
Search for them as you would for silver;
seek them like hidden treasures.
Then you will understand what it means to fear the LORD,
and you will gain knowledge of God.

PROVERBS 2:3-5 NLT

Silver is typically not found in handy little nuggets. It is mixed in long veins with a variety of ores and metals. It takes an incredible amount of skill and focus to extract it. Once extracted, it must be refined. Isaiah 48:10 speaks about silver being refined in a furnace, as does Proverbs 27:21. Exodus 31:3-5 outlines the specialized level of skills necessary for working with silver and other metals. This was no ordinary task.

It is our honor and responsibility as believers to search out wisdom in the Word of God with this level of diligence and attention. Searching for hidden treasure requires a level of commitment to the cause. And the reward is great! Scripture says that wisdom is even more costly than gold and silver. When we mine the Scriptures and keep our eyes open to wisdom as it meets us in the wilds of this world, God rewards us with the treasure of his wonderful ways.

Dear God, I have a hunger for your wisdom that won't be satiated with pat answers. Give me eyes of understanding as I go about my day and pierce my heart with your truth as I encounter it. My heart is yours!

True Source

The LORD grants wisdom!
From his mouth come knowledge and understanding.
PROVERBS 2:6 NLT

Solomon was the wisest man to ever live, and he attributed all his wisdom to God. It was clear to Solomon that the wisdom he received was a direct gift from God. As today's verse reminds us, the Lord grants wisdom! He gives knowledge and understanding to the searching soul.

If we want to be wise, the place to start is in seeking the Lord. We don't have to go to the halls of the powerful to learn God's ways. In fact, it is often through the dark valleys of this life that we find the most precious wisdom: the hidden treasures of darkness (Isaiah 45:3). The most important part of growing in wisdom is in nurturing our relationship with the Lord. If he is the granter of wisdom, why wouldn't we go straight to the source? The more we listen to him, spend time with him, and obey his Word, the wiser we become as our hearts and minds align with his.

Oh God, I'm so grateful for your generosity. You give wisdom when we ask, and you fill us with understanding when we seek you. No amount of knowledge found in this world can compare to the sweetness of knowing and understanding you.

Our Shield

He stores up sound wisdom for the upright;
He is a shield to those who walk in integrity.
PROVERBS 2:7 NASB

Life can feel overwhelming at times, but how comforting is it to know God never leaves us alone? He is our shield against evil and our strength when we have nothing left to offer on our own. When we need wisdom, he pours his out for us and leads us down the path of his righteousness.

We can confidently walk through the darkness of this world with integrity and wisdom because we know he is protecting us on all sides. Instead of departing from the wisdom of his love, we wear it like a cloak, trusting God to guard and watch over us. He has already accounted for the things that concern us. He has made the proper provisions. We don't have to worry about a thing! Our response then is to continue to walk in his ways and trust him, without worry or compromise. Our heavenly Father has everything under control.

Lord, thank you for watching over me. No matter what I encounter in this life, I rest in the truth that you fight my battles. I will walk forward with confidence and integrity, for you are my shield and confidence. You are always with me.

He Guards Us

He guards the paths of the just
and protects those who are faithful to him.
PROVERBS 2:8 NLT

When life gives us lemons, we might decide God has forsaken us or we have done something wrong. We might not recognize that he is guarding our paths or protecting us at all. Where is God when our days are filled with tragedy and hardship?

God doesn't promise us a life filled with ease. We don't get to opt out of the troubles of this life. We will all know suffering to some degree. We will know the pain of losing loved ones and having to grieve their absence. We may experience tremendous heartbreak. But there is good news in the midst of it all. God is with us. Even when we cannot see where the Lord is working, he is there, sowing seeds of mercy and redemption that will bear fruit in the light of day. Continue to trust him. Continue to rely on him. Jesus walked a hard path through this life, but he overcame death, and we will overcome every trial that comes our way.

Dear Jesus, open my eyes to see where your hand is moving in my life. Show me where you have guarded and protected me. Keep me close to your heart and lead me on the path of your truth.

Good Paths

Then you will discern righteousness, justice,
And integrity, and every good path.
PROVERBS 2:9 NASB

Growing in wisdom doesn't happen by accident. The same is true of most things in this life. You won't learn an instrument without practicing. Muscles are trained by consistent effort. This is true with wisdom, too! You won't wake up one day and suddenly find that you are wise if you don't put the time and effort into knowing the Lord and how he does things.

Jesus is our best example of embodied wisdom. If we want to know what integrity looks like, we should look at the way Jesus lived. How did he act toward people? What did he prioritize? If we want to walk in integrity, we must be honest and live wholeheartedly. Then we will have nothing to hide. The more we grow in wisdom, the more readily we will discern what is good, what is just, and the right paths to take as we weigh our futures.

Father, I know that wisdom is like a treasure sought after. I want to walk in your ways, following the path of your righteousness, justice, and truth. Help me to be full of integrity—reliable, honest, and humble—in every area of my life.

Delight in Wisdom

Wisdom will enter your heart,
And knowledge will be delightful to your soul.
PROVERBS 2:10 NASB

Sin can make people blind to the effects of their actions. When we compromise our standards by acting in a way that goes against God's heart and refuse to correct it, we desensitize our ears to hear the Spirit's wisdom. We all need the gracious help of the Lord. May we always be dependent on him and turn to him when we know we have stumbled, relying on his grace and mercy to pick us up and right our paths.

God blesses the humble, for they are teachable. A woman with a humble heart is able to admit when she is wrong and correct it. We can rejoice in our dependence on God because true knowledge comes only from him. He always knows what is best. What a relief to know we do not carry that burden on our shoulders. God becomes the delight of our souls as we trust him. He alone gives wisdom that leads to life.

Jesus, I rely on you more than anyone else. Your words of life bring delight to my heart. May my life reflect the power of your wisdom, mercy, and grace as I continually surrender to you.

Guides and Protects

Good sense will protect you;
understanding will guard you.
PROVERBS 2:11 NCV

What does it mean to have good sense? In other versions of the Bible, this phrase is translated as direction or wise choices. Discretion is an important part of this concept. Discretion is the ability to be thoughtful in the way you make decisions and in how you act. It is also the freedom to choose what should be done in a particular situation. Careful consideration is the way of the wise.

The counsel of trusted friends can help us as we consider next steps, and so can the Holy Spirit. The Holy Spirit helps us to understand the ways of God so we can act in accordance with his character. Take heart that God is with you every step of the way. He will correct your course and direct your steps as you move in faith and trust. Keep following him and lean on his wisdom. He will help you build good sense, and he will guard and protect you.

Holy Spirit, thank you for being a tried-and-true help in times of trouble. I don't want to stay stuck in indecision or rush ahead in haste without thinking things through. Help me walk in the confidence of your care today and every day.

Recognizable Fruit

It will rescue you from the way of evil,
from anyone who says perverse things.
PROVERBS 2:12 CSB

Most of us are familiar with the concept of a wolf in sheep's
clothing. Jesus spoke about these kinds of people in Matthew 7:13-23.
They will claim to speak on behalf of God, disguising themselves
as pious people. He warned that their intentions are like hungry
wolves. How do we know them? By the fruit of their lives and
relationships. How do they make people feel? Do they leave chaos or
peace in their wake?

The perversion today's verse speaks of is not curses, but lies,
contradictions, and twisted narratives. Duplicitous people are not
trustworthy. It is wise to believe the fruit of a person's life. There is
so much grace in God, but there is also wisdom to know who the
trustworthy people of God are.

Father, give me eyes to see and ears to recognize those whose words
cannot be trusted. With the fruit of your Spirit as my guide, I trust that
you will help me stay on the path of your love all the days of my life.

Paths of Righteousness

Follow the steps of the good,
and stay on the paths of the righteous.
PROVERBS 2:20 NLT

God has promised wonderful things to those who follow him and live righteously. How, then, do we stay on the path of his righteousness? Jesus is the personification of wisdom. He is the imprint of God's character in human form.

Most of us can probably think of a few good people that we want to be more like. Those are good examples to follow! But we must not forget the best example of all: the Son of God who took on flesh and bones to reveal what the Father is truly like. If we follow him on the path of his love, he will not fail us. And we need not fear what tomorrow brings. There is no greater revelation of what it means to be good and righteous than Christ. What a treasure we have in knowing him and following his wise steps!

When faced with two paths, I will choose you, dear Jesus. More than anything else, I want to be found in you. Help me to keep my eyes fixed on you, the author and perfecter of my faith.

Our Promised Home

The upright will live in the land,
and the blameless will remain in it.
PROVERBS 2:21 NIV

It is wise to remember that there are consequences to our choices. Many are not life or death choices, but they do affect how our lives unfold. We cannot give our energy to everything we want. We have to prioritize. May we be those who prioritize peace, integrity, and love. Only you can choose the guiding values of this season of your life. Choose them wisely and trust God with the rest!

There is no need to worry about what only God has the power to accomplish. Faith in God is our all-in-all story because we trust him to work out the details. That doesn't mean there won't be difficulties or stress in the moment, but the story is already written, and our eternal home is already determined. We have hope in the promised kingdom of Christ, and we will remain in it.

Dear Father, please increase my faith so I can see you in the land of the living. Give me confidence to keep following your ways and help me to release the things I cannot control. Thank you for the promise of eternity in the land you have already prepared.

Our Blessed Hope

The wicked will be removed from the land,
and the treacherous will be uprooted.
PROVERBS 2:22 NLT

The hope for true peace lies in Christ alone. Revelation 21:4 encourages us that one day, "He will wipe every tear from their eyes, and there will be no more death or sorrow or crying or pain. All these things are gone forever." Do you know what else will be gone? Those who sow such things. There will be no more chaos, fighting, or lies. No more manipulation or fear. We will live in true peace. It is hard to imagine, but oh what glorious hope we have in that promise!

As we cling to that hope, we get to partner with God's heart by living out his commands. We don't make excuses for our lack of love for our neighbor, for we know that God honors those who care for others. Let's be sure to align our actions and choices with the mercy-kindness of our Father and rely on his wisdom to correct us when we begin to lose sight of his ways.

Lord Jesus, I want my life to reflect your heart and values. Help me to choose peace when others choose violence. May my life be a lighthouse in a dark world. Even as I cling to the hope of a life without pain or fear, I choose to walk in the presence of your love here and now.

Benefits of Wisdom

Do not forget my law,
But let your heart keep my commands;
For length of days and long life
And peace they will add to you.

PROVERBS 3:1-2 NKJV

God created this world and everything in it with wisdom and grace. He orchestrated the laws of gravity and thermodynamics to ensure everything works together for good. There is so much we don't perceive, yet it is working in accordance with what God first set into motion. Even our decaying planet is structured so God's goodness will prevail over evil. Momentary evil will be overcome by the glory of God.

Within the lives of God's people, God's goodness also has overriding strength. When we live within the laws the Lord has specifically structured and orchestrated for our blessing, we will see those blessings play out in a longer life and peaceful existence. Let's keep pressing in to know him more and live according to his wisdom. It is for our good!

Father, I love your laws and your creation. You already know the number of my days, and I don't have to fear. I choose to follow you. May my life reflect the peace you offer us in your presence.

Loyal and Kind

Never let loyalty and kindness leave you!
Tie them around your neck as a reminder.
Write them deep within your heart.
PROVERBS 3:3 NLT

Loyalty and kindness are so valuable, God tells us to tie them around our necks and write them on our hearts. A kind and loyal person is not only a trustworthy one, but a delight to be around. These are highly sought-after virtues in most every relationship. Jesus offered us the ultimate example of loyalty and kindness when he shared his life with us: from his birth to his death and continuing eternally afterwards.

In a world of self-protective self-serving hearts, God knew loyalty and kindness would not be easy mandates to maintain, so he showed us how to walk them out with his own life. and he instructed us with strong metaphors like tying them to our necks and writing them on our hearts. It's going to take incredible intentionality, but with God's help, we can keep them close and walk them out in our lives.

Oh Lord, the kindness and loyalty you have shown me is unmatched. I want to be kind and loyal as well; I will not lose sight of them, even as I go about my day today. Thank you for your help in this.

Esteemed

Find favor and high esteem
In the sight of God and man.
PROVERBS 3:4 NKJV

What does it look like to be favored? A person who is highly esteemed has gone beyond expectations. They have invested in relationships, maintained a disciplined life, and built a respectable reputation. This person is noble in the eyes of the public as well as in private where only God bears witness. This type of person works through conflict, embraces challenge, does what is right even when nobody seems to notice, and isn't swayed by the majority opinion. They know the best things in life are worth fighting for and don't come easily or quickly. They are kind, patient, and loving.

This esteemed person finds favor with God and with others, not because they are lucky, but because they have a legacy of being reliable and good. A person like this is not perfect, but they are aware of their weaknesses and go to God for help. They use their strengths to serve the Lord and others, and they are trusted with more responsibility because of their faithfulness. We cannot wish this kind of favor into existence. We must live it out, and every little choice matters.

Lord, by your strength and for your glory, I choose to live a life of integrity.

February

Guard your heart above all else,
for it is the source of life.

PROVERBS 4:23

Leaning on the Lord

Trust in the LORD with all your heart,
And lean not on your own understanding.
PROVERBS 3:5 NKJV

This world is notorious for mixed signals and unclear instructions. This is why we look to God for direction and understanding. Our perspective is linear and limited, but God's point of view is perfect and endless. How can we fully trust our temporal and flawed perceptions? It is best to put our trust in him.

Even in our carefully crafted plans, it's important to stay adaptable. When we remain open to God's intervention in our lives, we remain ready to pivot when he leads us another way. We will always receive the greatest outcome when we remain positioned to receive God's direction instead of clinging to our own agendas. When the path becomes murky, God guides us through. Song of Solomon 8:5 offers an illustration of what it is to depend on God for guidance. The bride was brought out of the desert while leaning on her beloved for strength. Let's lean on God today and trust he will guide us through every landscape of this life.

I am ready to trust you completely with my life, Father God. Help me lean on your grace instead of my limited understanding. You are always faithful, and no matter what I'm dealing with, I know you will bring me through it.

Acknowledge God

In all your ways acknowledge Him,
And He will make your paths straight.
PROVERBS 3:6 NASB

King Solomon was no stranger to self-pursuit, and he wanted better for his son. Whenever he took his eyes off God and became distracted by some worldly pursuit, his life would begin to unravel. He had learned his lesson; self-indulgence leads to crooked, confusing paths. Solomon had incredible worldly wealth at his fingertips, but his true success was found in following the Lord. He chose to acknowledge the Lord in everything, showing true wisdom. The path he walked was clear and straight when he kept his eyes fixed on God.

We avoid a lot of unnecessary trouble when we choose to acknowledge God in all things and walk in his way. It truly is the best thing we can do for our families, our communities, and ourselves. Consider how often you acknowledge God in your day-to-day decisions.

I want to walk in your ways, oh God. Even when your path leads me out of my comfort zone, I know your strength will lead me through. I choose to acknowledge you in every area of my life today. Thank you for straightening the path before me as I do.

Strong Bones

It will be health to your flesh,
And strength to your bones.
PROVERBS 3:8 NKJV

*D*irectly before this verse, Solomon talked about God's understanding versus human understanding. At no point do humans have a better point of view than God has. He sees things fully, whereas we see a tiny fragment. When we remain humble before God, our hearts remain ready to embrace change as we grow in wisdom. We can embrace the fact that our Creator, who made us and adores us, knows what is best for us. A healthy dependency on our God is the strength of our confidence, not the power of our own abilities.

According to verse six, the first step to a good life is to submit to God in everything we do. Check in with the Almighty with your plans and wait for his go-ahead before solidifying the next step. He assures us his way leads to health in our flesh and strength in our bones.

Dear Lord, I see how limited my understanding is. I don't want to be fooled into thinking I've learned all there is to know of you. I love your ways, and I long to be close to you. Lead me in your love; my confidence is in you.

First Comes God

Honor the LORD with your possessions,
And with the firstfruits of all your increase.
PROVERBS 3:9 NKJV

One of the core principles of Scripture is to offer God the best from the firstfruits of our lives. When we offer God our best out of the resources we have before we do anything else, we are intentional about honoring God. This is as true with our possessions as it is with our time and our hearts. The Lord doesn't necessarily ask us to give up everything, but he does ask that we give to him first.

One way we can honor the Lord with our stuff is to use what we have to advance his kingdom. Whether that's showing hospitality through our homes by welcoming people in and serving them, using our vehicles to deliver groceries to a needy family, or donating to a cause that reflects the heart of God, we can honor God with our generosity. God is so very generous with us. It is his example we follow when we use what we have to serve others in love.

Lord, thank you for not only giving me daily bread, but for blessing me with more than enough. I don't want to take your generosity for granted. Show me ways to honor you with my income and possessions.

Cycles of Blessing

Your barns will be filled with plenty,
And your vats will overflow with new wine.
PROVERBS 3:10 NKJV

The consequence of sin is death (Romans 6:23), but repentance leads to everlasting life (Luke 13:5). In other words, we all sin and need the mercy of God to restore us and set us right. Repentance is a choice. When we mess up, we have the opportunity to humble ourselves before God, asking his forgiveness and changing going forward. Following God's path is how blessings, especially eternal ones, start to flow, but Scripture is clear that there are also blessings before eternity.

In our verse today, God says we will see abundance when we behave with wisdom. This starts with giving first to God out of the blessings we receive. When we make a profit, we offer part of that back to God. It is a practice of gratitude. We can give generously with our finances; we can spend time with God interceding for people who need prayers. We can use our time to help those in need. However we do it, it is important that gratitude is shown through offering back to God what he so graciously offers us!

Lord, thank you for the opportunity to graciously offer you my gratitude in practical ways. It is an honor to serve you through my resources and to offer to others the same generosity and grace I receive from you.

Stay Humble

Do not despise the chastening of the LORD,
Nor detest His correction.
PROVERBS 3:11 NKJV

There are some lessons we learn that the purposes behind them are clear. There are others that we may stumble through a bit more blindly. Not all hard times are a direct result of our actions. They simply happen. But even these can refine us when we lean on the Lord and choose to trust him.

The book of Job is a good read for encouraging us to trust God when nothing makes sense. The background message of Job is to trust the Lord through every hardship because it isn't always about us. God gives us blessings and allows some challenges as well, but the purpose of either one is still left to him. There are times when God corrects us by showing us where we are out of line with his heart. And there are other times where we simply have to hold on to the Lord through the hardships of life we can't avoid. The goal is to receive both blessings and trials with a heart that leans into the Savior and seeks to honor him through the season we're in.

I lift my eyes toward you, Lord. In difficult seasons and in times of ease, let me see areas where I can grow in your wisdom, grace, and mercy.

Loving Correction

Whom the LORD loves He corrects,
Just as a father the son in whom he delights.
PROVERBS 3:12 NKJV

Life is not easy. There may be times when we experience the blessings of God through peace and prosperity. Still, there may be other times that are harder than we could have ever imagined. No matter where we are at in life at this moment, God is an attentive and caring Father. He wants to protect us. If he sees us veering into habits, places, or relationships that bring harm, he will let us know. It is important that we remain open to his correction!

The Holy Spirit is a good teacher. It is not your job to foresee every mistake to avoid it. That is completely unachievable. God is not looking for perfection from you. Not even a little! He just wants your attentive heart. Learn from each mistake and failure; they are not reflections of your worth. You are a beloved daughter of God, and he leads you lovingly. Trust him!

Father, thank you for loving me fully and leading me well. Teach me and correct me, for I trust you more than anyone else. Your wisdom is life to me!

Finding Wisdom

Blessed is the person who finds wisdom.
And one who obtains understanding.
PROVERBS 3:13 NASB

How blessed we are to receive God's gifts and to be led by his gracious hand. We must never quit our search for his wisdom because wisdom from God is far superior to anything this world offers. We have not reached the lengths of his love or the limits of his delight. There is always more to find and feast upon! As we spend time in his Word and fellowship with his presence, we become more like him. This is how we gain understanding. We learn the heart and mind of God by growing in relationship with him.

God's path is wisdom and truth. He wants to share his wisdom and understanding with us. As we open our hearts to him every day, we practice staying humble, teachable, and patient while we attune to God's voice. There's so much to feast upon and enjoy in our incredible relationship with him. He wants to share all things with us. How wonderful he is!

Father, I depend on you for wisdom and understanding. Without you, I stumble around, but when I look to you, your hand steadies my steps.

Wisdom's Worth

The gain from her is better than gain from silver
and her profit better than gold.
PROVERBS 3:14 ESV

Wisdom is priceless. No amount of gold or silver could buy her. Ecclesiastes 7:19 says, "Wisdom gives strength to the wise man more than ten rulers who are in a city." Wisdom is more effective than earthly power. Knowing this, we should evaluate how much energy we invest in growing in God's wisdom. So much of our lives is spent working to make a wage, but how much in finding wisdom? Are we truly seeking God, or just checking in from time to time? Yes, we need our daily food, but our spiritual nourishment is even more important, and we don't always realize when we're starving our souls. We could gain the whole world and lose ourselves in the process.

Commit to seeking God first. We need to desire his wisdom more than gold and more than our paychecks. We can then watch as everything either falls into place or falls away. God directs our steps and determines the course of our lives. Why not seek him instead of wasting our lives chasing what doesn't last?

God, you matter more than anything. Please help me keep a proper perspective on my daily pursuits and lifetime dreams.

Full Surrender

She is more precious than rubies,
And all the things you may desire cannot compare with her.
PROVERBS 3:15 NKJV

Matthew 13:46 tells the story of a merchant who found a pearl of great value and sold all he had to buy it. The merchant recognized that the pearl was of greater worth than everything else he owned, and so he gave everything to obtain the valuable pearl.

Similarly, everything we own in the world is not worth the price of wisdom. Our homes on earth are insignificant compared to the kingdom of God. We serve a king worth surrendering everything for. Wisdom is worth the sacrifice too. Imagine everything desirable in the entire world and lay it all at the doormat of God's kingdom. Leave it there. It's not worth your allegiance. God wants better for you and your life. What price are you willing to pay for the precious gift of wisdom?

God, I lay all my dreams, desires, and everything that's mine at your feet. Thank you for the gifts you have given me. More than anything, please give me wisdom so I can walk in your ways.

Both Hands

Length of days is in her right hand,
in her left hand riches and honor.
PROVERBS 3:16 NKJV

Both hands are full when we acknowledge the Lord working in our lives. Suddenly we have eyes to see and ears to hear the details of his work through us. Without knowing God, the true source, we may not see where we are being blessed. We know there are ups and downs in life, but we can't see the spiritual work in the background.

Knowing life with God is an eyes-wide-open situation means also knowing whom to credit. Giving thanks for long, wonderful days spent in service to the King is an honor. Living in his way allows us to see which riches have an eternal impact. Putting God into his proper, respected, and beloved place in our lives balances everything. What overwhelming generosity he has, and what blessings he has offered us.

Give me awareness, Father, so I know when you have given me another wonderful blessing. I know blessings often come hidden, so open my eyes to your gifts and your work in my life.

Peaceful Paths

Her ways are ways of pleasantness,
and all her paths are peace.
PROVERBS 3:17 ESV

Wisdom is addressed as a woman who creates, just through her existence, pleasant ways, and peaceful paths. But what does it take for us to familiarize ourselves with wisdom? It takes focus; it takes diligence. It takes persistence. It's a matter of the heart.

When we turn our hearts toward Jesus, our perspectives are transformed by the Creator's. We start to see clearly, and that allows decisions to be made in righteousness. When we are fully immersed in God's Word, following his path and communing with the Lord, wisdom seeps into the tissue and sinew of our very beings. We need the living Word of God to start down the pleasant way and peaceful path.

Jesus, I know your ways are pleasantness, and your paths are peace. Wisdom is found in following you, so that's where I begin today. By looking to you. Teach me your ways so I may grow in wisdom, finding pools of refreshing and peaceful paths as I journey with you.

Take Hold

She is a tree of life to those who take hold of her,
And happy are all who retain her.
PROVERBS 3:18 NKJV

The tree of life has deep roots entrenched in fertile soil and fed by living waters. This is not a regular tree. Wisdom is not a regular characteristic, either. The tree of life has a strong trunk, many branches, green leaves, and healthy fruit. The same can be said about wisdom.

A strong trunk is achieved by careful nurturing through the younger years and weathering heavy storms as the tree matures. Many branches shoot off the trunk as it can sustain the developing dependency. Green leaves grow well with plenty of sunshine and time in the light. Healthy fruit is supported by way of pollination and protection from damaging winds. Overall, wisdom is a tree of life. Take hold of her, and you will find the shade you need, the sustenance you need, and the rest you need. She is sturdy and strong in every season!

I am in awe, Lord, of your creation. There is so much to learn from nature. Thank you for wisdom that is firmly rooted in you. It bears fruit in season, and I know this is true for my life, as well!

Founded by Wisdom

The LORD by wisdom founded the earth;
By understanding He established the heavens.
PROVERBS 3:19 NKJV

Wisdom is behind everything God does. This includes when the Lord created the heavens, the earth, and everything in them. Wisdom is sown into the very fabric of the universe. If we are God's workmanship, which we know that we are, that means that wisdom went into our creation too.

God doesn't make mistakes. Psalm 139 expresses the delight and intention with which we are all made in the image of God. He formed us with skill and joy. None of us is hidden from him, not even in the womb. What does it mean for you to know that the Lord created you by his wisdom? You were made to know him in Spirit and in truth. He loves to come in close when you draw near to him. Turn your attention to him even now.

Lord, thank you for your creation, of which I am a part! There is so much mystery and joy in nature, and I am awed by the thought that I bring you joy. I turn my heart and attention to you right now. Your thoughts are precious to me. Speak to me, Father.

Clouds Drop Dew

By His knowledge the depths were broken up,
And clouds drop down the dew.

PROVERBS 3:20 NKJV

God created the heavens and the earth. Genesis 1:2 says, "The Spirit of God was hovering over the face of the waters." Wisdom was present with God from the beginning because God is full of wisdom. God knew how to separate light from darkness and the deep waters with land. Clouds drop down dew every morning, leaving a fresh drink on the land. This, too, is God's wisdom.

Just like the dew of the morning, the Spirit rests on us each and every day, offering us fresh living water to restore our souls. God's mercies are new every morning. His wisdom is never stale; it always speaks to the moment, to our need, and to his provision. If you sleep late enough, you will miss witnessing the miracle of dew. But that does not mean it didn't happen. Tune your attention to God every morning by building the habit of inviting God to teach you. Pray for the Lord to open your eyes to his provision and thank him. His wisdom is found in even the most ordinary places.

Creator God, thank you for your wonderful planet. Thank you for the rain and dew that teaches me about your wisdom.

Discretion and Wisdom

Let them not depart from your eyes,
Keep sound wisdom and discretion.
PROVERBS 3:21 NKJV

Just like muscles can be trained and strengthened, so can wisdom and discretion as you use them. When you practice pausing before blurting out what is on your mind, you train yourself in discretion. When you consider the impact of your words rather than thoughtlessly speaking, you strengthen that muscle. Wisdom and discretion are not hidden; they are revealed through how we live. This includes how we talk and how we treat others.

We all have days when choosing discretion is hard. When we say or do things that hurt others, let's be quick to repent and repair. We are not responsible for how others act, but we should take ownership of our own actions. This, too, is an act of wisdom.

Alert me, God, when I'm off-kilter and need time with you. Show me how I can repair areas where I have been thoughtless to others. I know your wisdom is always the answer.

Life and Grace

They will be life to your soul
And grace to your neck.
PROVERBS 3:22 NKJV

Our bodies need sustenance, and so do our souls. There are clues to help us recognize when our souls are starving. We may get discouraged, lose direction, and our personalities may flatten. Our complexity and creativity can feel diminished. We were created to commune with God. Jesus is the bread of life. Relationship with him sustains and nourishes our souls. Wisdom and discretion keep us alert and close to him.

It takes time and effort to be in any relationship and that includes one with God. Time and effort won't get you into heaven; only the resurrection power and saving grace of Jesus Christ can do that. But you were made for more here and now. God wants you to experience the fullness of his love in the land of the living. Spend time with the Lord in prayer throughout your day, keeping your heart open to his Word and wisdom.

Dear God, I need you more than I can say. I want to know the power of your life in me today, not just when I see you face-to-face. Empower and nurture me by the presence of your Spirit here and now. I am hungry!

No Stumbling

You will walk safely in your way,
And your foot will not stumble.
PROVERBS 3:23 NKJV

Hiking is a wonderful pastime and a beautiful metaphor for walking with God. It can also be a literal walk with God if the hike is spent in prayer and conversation with God, but that's up to the hiker and the circumstances. Time walking outdoors offers fresh air for the lungs, sunlight for the face, and movement for the legs.

Walking with wisdom takes more effort than a simple walk, but it's also a worthy effort for the mind. It's smart to walk a distance that blesses and doesn't harm. It's sensible to ensure the path is not so rough that ankles will twist, or roots, rocks, or outcroppings will cause stumbling. Planning a proper time without overextending will result in feeling refreshed rather than weary.

Dear Jesus, let me know your path so I may hike toward heaven. Let me see clearly so rocks and roots don't cause me to stumble. Please pick me up when I fall and help me keep going on the worthy path.

Peaceful Sleep

When you lie down, you will not be afraid;
When you lie down, your sleep will be sweet.
Do not be afraid of sudden danger,
Nor of trouble from the wicked when it comes.

PROVERBS 3:24-25 NASB

Is your sleep peaceful? Can you go to bed with a clean conscience? Do you leave the day's worries in the hands of your capable God? It's easier to sleep at night when our trust is in God. True safety is only found in the loving arms of our Father and in the promise of his provision. Psalm 4:8 says, "In peace I will lie down and sleep, for you alone, Lord, have me dwell in safety." Acts 12:1-12 relays the story of Peter sleeping peacefully in prison even though his execution was scheduled for the morning. We also know that Jesus slept peacefully in the belly of a boat during a frightening storm. We can trust God, no matter how rough our circumstances.

Sin will keep us tossing all night. Worry and fear drive peaceful dreams away. Trusting God does not remove all trouble and trials from our lives, but it does do away with many unnecessary headaches and hardships. We're more likely to get a good night's sleep too.

Even if evil comes knocking at my door, I will not be afraid, dear God, because I have placed my life in your hands. You are my confidence in the day and my peace at night.

Confident Stepping

The LORD will be your confidence,
And will keep your foot from being caught.
PROVERBS 3:26 NASB

Some seasons of life feel like walking across a minefield and never knowing when something might blow up in our faces. But when we look up past the potential pitfalls and into the loving gaze of our Savior, we find the confidence to go forward.

We don't tiptoe; we run to the open arms of our Creator. He determines our steps and makes our path forward clear. We don't need to worry about getting caught or tripped up because even if we do, he will catch us. All we need to do is keep our eyes fixed on heavenly things and not become distracted by the chaos of this world. Fear distracts and casts doubt over the goodness of God. He is faithful through it all. We can have confidence in that.

Dear God, thank you for your steady hand when my life, and the world, is shaking. You are my firm foundation and my rock of refuge. I trust you!

Generous and Timely

Do not say to your neighbor,
"Go, and come back,
And tomorrow I will give it,"
When you have it with you.

PROVERBS 3:28 NKJV

Jesus said, "Heal the sick, cleanse the leprosy, raise the dead, cast out demons. Freely you have received, freely give" (Matthew 10:8). His words were an encouragement to go and do good, and to do it open-heartedly. Reluctance was not a part of the equation.

Solomon addressed a reluctant giver in today's verse. God Almighty doesn't appreciate it when his people have the means to bless someone and put it off for no reason but their own convenience. When we have the means to help, we should help. Matthew quoted Jesus as saying "freely." This is no mistake. Give without hesitation, without reservation, and without restriction. Why? Because that is how God so freely gives to you.

Father, help me learn how to give without holding back. You held nothing back from me, and I see it every day. You gave me so much, and I want to give that way to others.

Manage Your Mood

Do not strive with a man without cause,
If he has done you no harm.
PROVERBS 3:30 NKJV

It's important to pick your battles; it's equally important to learn not to be petty. Everyone has the capacity to get in a bad mood, and behavior goes downhill. As God's children, we don't use a bad day as an excuse to pick fights with people. This applies to all of our interactions. Let's be wise with our words, especially when it's difficult to be. This may mean we need to take some time apart to cool down.

Go to God. We can talk to our Father at any time and in any situation. We can ask him for help with bad feelings and a lack of control. We can breathe, take a moment, and regroup with God foremost in our minds and hearts. Let God have your worst; he can handle it. His grace is available to empower you in wisdom in your less-than-stellar moments.

Lord, my God, you are everything, and I need you. I need you to guide my tongue and keep me calm when things go badly. I don't want to pick fights or be unkind to people who have done nothing to deserve it. Help me!

A Better Way

Do not envy the oppressor,
And choose none of his ways.

PROVERBS 3:31 NKJV

An oppressor is someone who treats others, sometimes a specific person or group of people, unfairly or cruelly. They use their power over others to do harm, or to repress those who disagree. To be sure, this is not the way of the wise. It is not how God relates to us, and it is certainly not how he wants us to relate with others.

Jesus set people free. Instead of focusing on what not to do, let's focus on who we can become. Just as the prophet said in Isaiah, we can join with his vision "to preach good tidings to the poor…to heal the brokenhearted, to proclaim liberty to the captives, and the opening of the prison to those who are bound" (Isaiah 61:1). These are the ways of Christ, the one who called us and who calls us to follow his lead. Choose these ways instead of the oppressive ways of this world.

Thank you, Jesus, for a better way to live. You are the liberator of every heart, and I want to join you in your purposes. May I be a good news teller and one who seeks to heal instead of harm. May you be glorified in my life!

The Power of Humility

He scorns the scornful,
But gives grace to the humble.
PROVERBS 3:34 NKJV

Humility is the way of the cross. When we admit our shortcomings and that we need a Savior, we stay open to the grace of God. Peter quotes today's verse in his first letter, encouraging the reader to be clothed with humility and saying, "God resists the proud, But gives grace to the humble" (1 Peter 5:5).

Don't get too caught up in what it means to be scornful; instead, put your focus on what it means to be humble. Lean on the Lord for understanding and correction. Be willing to admit when you are wrong to others. Change your mind when presented with better information than you once knew. There is so much grace in staying humble before God and before others. Don't discount the power of it in your life and relationships!

Lord, I don't want pride to keep me from you. I know the way of growing in wisdom is to remain humble and teachable. I humble myself before you, God. I am yours. Have your way in me today.

Don't Forget

Get wisdom and understanding.
Don't forget or ignore my words.
PROVERBS 4:5 NCV

The writer of Proverbs was Solomon the Wise. God asked him in a dream what he wanted, and Solomon asked for wisdom. God was so pleased Solomon did not ask for riches or longevity, he gave him all three: wisdom, riches, and a long life (1 Kings 3:11-15). Solomon ruled for forty years and had many great achievements. He displayed great wisdom in many things, so much so that the Queen of Sheba went to visit him and see it for herself (1 Kings 10 and 2 Chronicles 9). According to the Bible, she was impressed.

Solomon did not live a perfect life. He did not always choose wisdom's ways. He learned the lessons of foolishness by going through many himself. He wrote Proverbs to teach his sons. It doesn't matter how much we mess up, when we remember the wise thing, we can return to it. Don't forget that wisdom is always within reach. Ignoring wisdom will lead to heartbreak but embracing it will lead to peace.

Father, please give me wisdom. When I start to wander from it, show me. Open my ears to hear and my eyes to see.

Love Wisdom

Do not forsake wisdom, and she will protect you;
love her, and she will watch over you.
PROVERBS 4:6 NIV

Wisdom is not just a characteristic of God. It is a protection and a guard for those who heed her words. True wisdom can be found anywhere the fruit of God's Spirit is blossoming. It can be found in unexpected places, and it can be found in the spaces you know to look. Her voice calls out in every sector of society. No one person has a claim on wisdom. Remember that. God is the only perfect source of wisdom.

How do you love wisdom? Is it just by admiring her words, or by implementing them? Every day, practice what wisdom instructs you to do, and you will grow in both love and devotion to her cause. She will protect you as you follow her ways.

Dear God, thank you for the gift of wisdom in your Word. May I not take it for granted. I won't just be a hearer of your Word but a doer. Thank you for your watchful care over me as I follow you.

Get Wisdom

The beginning of wisdom is this: Get wisdom.
Though it cost all you have, get understanding.
PROVERBS 4:7 NIV

Have you ever thought about what the pursuit of wisdom might cost you? Since wisdom only comes from God, only by seeking God do we grow in wisdom. If we spend time seeking God, that's time spent not seeking something else. What activity in your life might need to take a backseat? You could spend your entire life seeking of God, and it would be a life well spent.

Whatever it may cost us in time or energy, pursuing God and growing in wisdom is worth it. There are no riches more worthy of our ambition. A wise person understands the worth of wisdom. More than knowledge, common sense, intuition, or raw intelligence, wisdom understands what the heart of God desires. There is nothing of greater value than that. How will you pursue wisdom today?

Holy Father, you are wise and understanding. Your ways and wisdom are infinitely greater than mine. Your words encourage me, and the time I spend with you strengthens and inspires me. Your wisdom is worth my time and attention.

Embrace Wisdom

"Prize her highly, and she will exalt you;
she will honor you if you embrace her."
PROVERBS 4:8 ESV

The return on investment with wisdom is clearly outlined in our verse today. Prize it, and you will be exalted. If you value the wisdom you gain by applying what you learn in the Word, you will be lifted up. You will reap the benefits of being wise by making good decisions, having a good reputation, and being respected. If you embrace your time given to gain wisdom and understanding, you will become honorable in your character and overall behavior. It's a more than fair return!

Though we may look for affirmation and encouragement in the eyes of those we esteem, God's view of us is even more important. When we align our values with God's ways of wisdom, we set ourselves up for success to live a life of integrity, peace, and purpose.

Keep me close to you, my Father, so I may learn from you. Be so close in Spirit that I sense your direction and grow in your wisdom every single day.

March

Every word of God proves true;
he is a shield to those who take
refuge in him.

PROVERBS 30:5 ESV

Beauty and Grace

"She will place on your head an ornament of grace;
A crown of glory she will deliver to you."
PROVERBS 4:9 NKJV

When we incorporate wisdom into how we go about our days, including how we interact with others and the decisions we make, Scripture says that we will be adorned with beauty and grace. Just as a diamond tiara evokes the image of royalty, wisdom is a sign that we are daughters of the King. It is a distinguishing mark. Why wouldn't we embrace wisdom in all of our ways, then, knowing it reflects our identity in Christ and reveals what the Father is like.

Wisdom is always the right choice. Don't be afraid to be set apart, for when you choose wisdom's ways, you stand in the confidence of who God is and who he has called you to be. It is a sign of glory and grace.

My Father and King, I am your daughter, and I never want to forget that. I want to make you proud by choosing to follow your wisdom. Help me remember that your ways are always the best, no matter how tempting it is to compromise.

My Child

My child, listen to me and do as I say,
and you will have a long, good life.
PROVERBS 4:10 NLT

For those of us who are or have been parents to young children, these are familiar words! We instruct our children to pay attention to what we say. We can't miss the point here; wisdom is a lifelong learning venture as children of God. He never stops teaching us. The reward is uplifting: adopt his ways and have a good, long life. When we read the Word and learn God's wisdom, there are blessings ahead for us.

The growth patterns of a child's character can teach us something. They aren't born with an inherent ability to recognize wise decisions. They learn what is wise by the example and repeated instruction of the adults in their lives. The amount of time invested in guiding and teaching our children is worth it. This is true with our Father, as well. Spend the time, daughter of God, with your heavenly Father, who teaches and guides us perfectly.

Dear God, open my eyes and ears to your wisdom. Teach and guide me as I seek you.

Instructed and Led

I have instructed you in the way of wisdom;
I have led you in upright paths.

PROVERBS 4:11 NASB

God is the perfect teacher and guide. The path to wisdom is in his living Word and through fellowship with his presence through prayer. He assures us the beautiful blessing of wisdom is available to us forever, and his promises never expire. May we soak our souls in his instruction and absorb wisdom directly from his Word. When we trust him fully, we will begin to see, feel, and know what he wants for us.

God doesn't impose himself on us. He opens the door for us to learn from all he has made available. We may choose to follow him, be instructed by his Word, and follow the narrow path set before us, but we can also choose to turn away. If we are willing to walk through the door of his fellowship, he is ready and delighted to instruct us in the way of wisdom and lead us along the upright path.

Jesus, you are my heart's desire. I open the door of my heart to you. Teach me to recognize the voice of the Father as he instructs and leads me toward everlasting life in your kingdom.

Balance

When you walk, you won't be held back;
when you run, you won't stumble.
PROVERBS 4:12 NLT

Having good balance means being able to control your body's posture, which is key to avoid stumbling. When children first learn to walk, they can only take a few steps before faltering. They may need a hand to help steady them or a support to help them balance. As they grow, they learn to balance their bodies, so they don't have to hold onto anything.

This is what growing in wisdom is like. You start out needing support and hands to help guide you. Then, the more confident you become, the surer your steps become. No matter where you are in your wisdom journey, you have the helping hand of your Father. As you grow in him, you will have more freedom to put his wisdom into practice without faltering. Never fear, though; God is a willing and helpful teacher in every stage of your spiritual development.

Father God, thank you for your guiding hand in my spiritual development. You are my confidence, and as I grow stronger in wisdom, I can walk without being held back and run without stumbling.

Daily Instruction

Hold on to instruction, do not let it go;
guard it well, for it is your life.

PROVERBS 4:13 NIV

The instruction of God, the wisdom of his Word, is easily accessible to us. We only need open the pages of the Bible and read. Let's not forget to invite the Spirit to instruct us, opening our hearts to him as we dive into the Word. He gives divine revelation and deep understanding of God's ways. We don't need to understand everything in the moment; that's a recipe for giving up before we even get started. Instead, let's embrace each daily lesson as it is given to us.

Opening the Bible and eagerly seeking a new message from God each day is a joy. It's a way for us to learn about the Creator of the universe. We hungrily look for instruction and a guiding hand, and God delivers. He is delighted to encounter us with his presence and teach us with his wisdom as we open our hearts to him each day.

Dear Lord, give me revelation of your ways through your living Word today and every day. Teach me, step by step, what you are like and how I can cling to you through the valleys and hills of this life.

What You Learned

Remember what you have been taught,
and don't let go of it.
Keep all that you have learned;
it is the most important thing in life.

PROVERBS 4:13 NCV

Without meditation and moments of remembrance built into our daily lives, we will forget the lessons of the past. History can teach us many profound lessons. It is important to remember what we have walked through as individuals, as well as greater humanity, so that we do not reiterate the mistakes of our past. Destructive cycles are repeated by small compromises at the start. Let's be fully aware of the lure of compromise in our lives. Change is not impossible with God's gracious help.

We grow in wisdom as we embrace the lessons that our failures taught us. There is always a way out. 1 Corinthians 10:13 reminds us of this: "When you are tempted, he [God] will also give you a way to escape so that you will be able to stand it." One way of escape is to consider the consequences of such a temptation. Be thoughtful and put the wisdom you have already gained to work in your life.

Dear Father, remind me of the lessons of wisdom you have already taught me and help me to walk in your ways. I don't want to repeat the destructive cycles of the past.

Light of Dawn

The way of the good person is like the light of dawn,
growing brighter and brighter until full daylight.

PROVERBS 4:18 NCV

A wise person is a bright spot on a dark day. When was the last time you watched the sun rise? It starts out with soft hints of light on the horizon. As the sun breaks, the darkness of the earth is lit up and everything that was hidden is easily perceivable again.

When we walk in wisdom with intention, we put Christ's laws into practice in our relationships and lives. As we do, our lives grow bright with his light radiating from our good deeds. When we choose to be peace makers, we reveal Jesus' wisdom in our lives. When we mourn with those who are grieving heavy losses, we shine with his love. If we want to be effective lights in this world, we cannot ignore taking the lessons of wisdom from our minds to our hearts, hands, and feet.

Jesus, you are the light of the world, and I am yours. May I reflect your light in my life as I partner with your ways and incorporate the wisdom of your love in every interaction I have today. I want to shine bright for you!

Pay Attention

Give attention to my words;
Incline your ear to my sayings.
Do not let them depart from your eyes;
Keep them in the midst of your heart.

PROVERBS 4:20-21 NKJV

Which voices are you heeding? Who influences you? The course of your life is unquestionably affected by the voices and issues you continually turn your attention to. Are the things you're putting before your eyes and ears positive influences? Taking time to block out the noise and listen to God is essential in our hectic, fast-paced world. God may be speaking, but are we listening? Are we even able to hear? It is important to deliberately step away from social media, the news, friends, music, and any noise that blocks out the sweet voice of our Savior.

Let's give our attention to God first and foremost. To incline our ears means we have to lean in and listen. God's words deserve a permanent spot on our hearts, in our ears, and before our eyes. There are so many voices vying for our attention, but only one voice deserves our full devotion.

What do you want to say to me today, Lord? I will take the time to find silence and listen. I will listen to your voice first.

Spilling Over

Above all else, guard your heart,
for everything you do flows from it.
PROVERBS 4:23 NIV

We must be careful what we invite into our hearts. We can't hide the contents of our hearts for long because words and actions flow out of them. As children of God, we are called to live with intentionality. God has a purpose for us, and when we allow ungodly influences into our hearts, they distort our purposes and cloud our judgment.

Let's take time to tend our hearts and be filled with God's love, joy, and generosity. These are attributes fitting for children of God. What if kindness, peace, and hope flowed from our hearts into our actions and words? What sort of impact would that have on those around us?

Lord, help me to keep a guard over my heart. I want to be so full of your joy, love, and mercy that they spill out to everyone around me. I rely on your wisdom to help me decipher the fruit of your Spirit from the fruit of this world. I want to reflect your compassion and truth more than the whims of self-satisfaction.

Listen to Wisdom

My son, pay attention to my wisdom,
Incline your ear to my understanding.
PROVERBS 5:1 NASB

Wisdom is meant to be shared. In Proverbs, we see chapters written by a father to his son. He implores his son to pay attention to the lessons that took him a lifetime to learn. Proverbs repeatedly states that a wise person takes such lessons to heart while fools choose to ignore them.

To gain wisdom, we don't just need to read Scripture and do the best we can to be good Christians; we need to listen to the people in our lives who have valuable guidance to share from their experiences. It's important to seek counsel from wise and godly people so we can grow, not just through the wisdom God reveals directly to us, but also through what he has revealed to others.

God, thank you for the wisdom of your ways that are available through your Word, but also through the lived experiences of those around me. I don't want to make avoidable mistakes. Help me to keep my heart open to the wisdom of others, while also sharing what I have learned. Make me discerning, Lord.

Lean on Grace

She does not ponder the path of life;
Her ways are unstable, she does not know it.
PROVERBS 5:6 NASB

The hardest people to reach are those who don't know they're in trouble. Where there is no knowledge of a shortcoming, it will never be rectified. A Christian's first order of business is to admit their need for a savior; they recognize they can't earn salvation and are entirely dependent on the mercy of God to be rid of sin.

When we ponder the path of life and consider what it means to live for the glory of God, we come to the realization that we don't have what it takes to do that on our own. This realization leads us to seek Christ and follow him. His grace is available, and it is our strength and our hope. We join with the apostle Paul who declared, "When I am weak, then I am strong" (2 Corinthians 12:10). We are strong, not because of what we can offer, but because God's grace shines through even our weakest offerings.

Lord, thank you for the grace you offer at all times. I don't take it for granted. I need you so much, Lord. You are my strength. Be glorified in my surrender and even in my weakness.

Choosing the Right Path

Listen to me
And do not depart from the words of my mouth.
PROVERBS 5:7 NASB

It can be hard to choose to do the right thing. Temptation tugs at us in its appealing compromise. But God's ways are always the best. Though at times choosing God's ways will feel easy, there will be times when it is the harder path to tread. There are no shortcuts to wisdom, just as there is no shortcut to success in life. The longer we live, and the more trial and error we experience, the more clearly we see this truth.

God's redemptive power is at work in our failures and in the cracks of this world. What a merciful God he is! Still, the more we know him and trust him, the more readily we follow his Word and stay on the path of his righteousness. It is the safest route to travel.

Merciful God, I am so grateful for your generous love and powerful redemption. You take ashes and use them to create beauty. Who else is like this? It is because of your merciful nature that I trust you. I trust your heart and that your ways are always for my good and for the good of the world.

Committed Love

Drink water from your own well—
share your love only with your wife.
PROVERBS 5:15 NLT

Proverbs was written from the point of view of a father to his son. We could use our imaginations a bit, though, and know that the reverse is also true. If a mother was giving this advice to her daughter, she may say is this way, "Drink water from your own well; share your love only with your husband." The principle remains the same.

We live in an age of instant gratification. We don't like waiting for our food, on hold, in lines, or for a package to come in the mail. If things don't happen the way we want, when we want them, we're likely to bail and find something or someone else. There are good reasons to leave an unhealthy relationship or work environment, but let's not jump to that conclusion without good cause. Anything or anyone worthwhile is going to require work. We can rejoice in that and stick with our commitments through easy and difficult days.

Heavenly Father, please teach me to love the way you love. Help me stay true to my commitments.

Fully Known and Loved

The ways of a man are before the eyes of the LORD,
And He watches all his paths.
PROVERBS 5:21 NASB

Integrity is doing what's right even when no one is looking. As Christians, we know God sees everything we do and knows why we do things. He knows our most secret thoughts and subconscious intentions. Selfish choices and failures to resist temptation are not hidden from the one who tests hearts. No one knows the true state of a human heart like the Lord, yet no one loves like the Lord does.

Our mistakes are not counted against us when we surrender our lives to the Lord. He is not surprised by even the things that bring us shame. He liberates us in his love and leads us from glory to glory by teaching us, guiding us, and never departing from us as we seek his face. He really is that good!

Father, you see all and know all, and still you love me. I will never understand this mystery, but I thank you for its reality. Your mercy is like a refreshing rain after a long drought. I soak it in and stand in awe of your love.

Careful Consideration

Be careful about giving a guarantee for somebody else's loan,
about promising to pay what someone else owes.
PROVERBS 6:1 NCV

There's plenty of advice about lending money that you can find
in the world. The Bible is not silent about it, either. Great care and
consideration must be taken before you give someone money.
Especially when it is a large sum. This verse specifically addresses
the issue of promising to pay someone's debt.

This verse directly after today's says, "You might get trapped by
what you say; you might be caught by your own words…under your
neighbor's control." You must be wise about making such decisions
hastily or thoughtlessly in the moment. Take the time to truly
consider what you are able and willing to do. Otherwise, you may
find yourself trapped. Be careful about your promises.

*Lord, help me to take my time in responding to requests for sacrificial
help. I don't want to overpromise and under deliver, but I also don't
want to be thoughtless. Help me to be careful about these kinds of
decisions, with my time, money, and resources.*

Wisdom in Nature

Go to the ant, you sluggard;
consider its ways and be wise!
PROVERBS 6:6 NIV

We shouldn't overlook nature when it comes to the lessons of wisdom. The ant, for instance, is upheld in this proverb as an example of diligence and hard work. God created both people and ants, so learning about the ant is a worthy pursuit! Ants are very industrious and work hard for their homes. Ants are also social creatures and live their whole lives in highly structured communities.

Working in groups is one of the ways they adapt to new challenges and threats to their communities. They work and travel together. They communicate with each other and hunt for prey together. Diligence and teamwork are lessons we can learn from the ant.

Dear Father, I don't want to be so blind as to think I can't learn from the examples of nature. Thank you for wisdom hidden within the details of creation. Help me to be diligent in my pursuits and to both help and lean on the help of others as we work toward a common goal.

Working Together

Ants have no commander,
no leader or ruler.
PROVERBS 6:7 NCV

The largest known ant colony in the world stretches 3,700 miles from northern Italy through the south of France and along to the Atlantic coast of Spain. This is a relatively young colony because the ant species, the Argentine, was only introduced to Europe about eighty years ago. The most noteworthy characteristic of ant colonies is that they have no leaders, so they are self-organized. They communicate clearly and work constantly together toward the building and maintenance of their colonies. 3,700 miles is a long line of community!

Could Christians organize and function as a unified whole to build community? Even though it won't be perfect, we can seek the Lord's guidance and emulate his path for community and fellowship. Each ant is driven to work, but they also work alongside each other in a specific locale. We can't personally take responsibility for the whole world; that rests upon our Creator. We can work together, however, to be unified in love and do the good work of the gospel.

Father God, give me the drive to do your will. Show me my part and help me keep love as my motivation with others.

Wisdom in Preparation

They labor hard all summer,
gathering food for the winter.
PROVERBS 6:8 NLT

Continuing with the example of the ant, we are told that they do the hard work of gathering food when it is in season so that they will not go hungry in the winter. In the same way, when we know what we are working for, it gives us the motivation to keep going. Just as the rhythms of this earth offer rest, so do our lives. If you are working hard in the fruit-bearing seasons, you will benefit in the off-seasons by having enough.

Let's not take our abundance for granted. It is both biblical and wise to set aside a portion for the inevitable winters of this life; times of barrenness and potential hardship. Foresight to prepare for the future is a gift of wisdom, so let's not ignore the power of storing a portion of our resources for tomorrow.

Dear Lord, give me wisdom and foresight to use what I have now to prepare for tomorrow. I don't want to waste my resources by spending them all today, and I don't want to miss opportunities to reap the reward of preparedness for the future.

Take Action

How long will you lie there, O sluggard?
When will you arise from your sleep?
PROVERBS 6:9 ESV

Laziness is not an admirable trait. This is not the same thing as rest; rest is necessary and holy. Laziness is having work to do and refusing to do it. When there are pressing needs and we allow others to do all the work while we do nothing, this is the epitome of laziness. It is a lack of active care for ourselves, the people around us, as well as our communities. We all have a part to play, and we must not opt out of the responsibilities of this life. We must take agency over what is ours to do, while also leaning into the grace of God that covers what we cannot.

Proverbs has many teachings about the sluggard, and 26:16 may offer the best definition: "The sluggard is wiser in his own eyes than seven men who can answer sensibly." Pride and laziness go hand in hand with the sluggard because they think about their own comfort more than the needs of others.

Dear Jesus, teach me the difference between laziness and rest. I don't want to miss out on the refreshing and restorative aspects of rest. Keep my eyes on what is mine to do and the part I have to play in my home, family, work, and community. I cannot do it all, but I also cannot sit back and do nothing.

Like a Drifter

"A little sleep, a little slumber,
A little folding of the hands to rest,"
Then your poverty will come in like a drifter,
And your need like an armed man.

PROVERBS 6:10-11 NASB

That word *drifter* is translated in other versions as robber, bandit, traveler, vagabond, thief, and plunderer. The phrase *armed man*, however, is pretty much the same throughout the various versions. Perhaps the best way to understand the meaning of *drifter* in this context is to consider the larger picture of the other translations.

Time is a gift. It is also important to recognize the wisest ways to engage in the exact season you are in. If you never do your work, your employer will find out. The value you add will be questioned, and you may find that your lack of engagement leaves you without a job. If you never engage in growing spiritually, this too will be affected by your lack of drive. This choice may rob you of purpose and joy. Look at your life and see if there are areas where you need to press in more. Self-control will help keep you moving in the direction you need to go, and God's grace will empower you!

Father, open my eyes to your opportunities. Give me a zest for life that can only come from you.

The Company You Keep

A worthless person, a wicked man
goes around speaking dishonestly.
PROVERBS 6:12 CSB

A person's character is displayed in the ways that they treat people, the seeds they sow in conversation, and in the fruit their actions and words produce. Where chaos, confusion, and destruction are left in their wake, you can be sure that their intentions are no good. Deceit and dishonesty are clear markers of someone who looks out for their own interests above all else.

Second Timothy 3:16-17 tells us that the Word is intended "for teaching, for reproof, for correction, and for training in righteousness, so that the man of God may be complete, equipped for every good work." God doesn't leave anything to chance. He fills in the blanks as to what is good and what is evil. Don't be deceived by a person known for their duplicity.

Lord, help me to have open eyes of wisdom and discernment to know the trustworthy people in my life. I don't want to be fooled by charm when it is not backed up by good character and honesty. Thank you for teaching me how to live with integrity.

Watch Out

These six things the LORD hates,
Yes, seven are an abomination to him:
A proud look,
A lying tongue,
Hands that shed blood,
A heart that devises wicked plans,
Feet that are swift in running to evil,
A false witness who speaks lies,
And one who sows discord among brethren.

PROVERBS 6:16-19 NKJV

There are things that God absolutely cannot stand, especially in those who claim to love and follow him. Those who put others down while considering themselves above reproach, spreading lies and rumors, violently harming the innocent, plotting evil toward someone, gloating over doing what is so clearly wrong, discrediting others with false testimonies, and stirring up strife among friends.

Repentance always begins with humility, admitting where we are wrong and asking forgiveness. It continues with changing those things and acting differently in the future. God's grace is available to help us in our weakness, but we first must acknowledge that we need it.

Dear Lord, I love the gift of your wisdom. Help me stay away from doing what you hate and treat others with the loving-kindness you so generously show me.

Parental Guidance

My son, keep your father's commandment,
and forsake not your mother's teaching.
Bind them on your heart always;
tie them around your neck.

PROVERBS 6:20-21 ESV

Most moms and dads are doing their best with what they have to parent their children well. God is kind to use our imperfections to reveal the grace of God to our children. No mother can be everything to their child, and there will be ways that we fail. It is important to remember that perfection is not the goal: love is. It undergirds wisdom with understanding and compassion. It helps repair relationships when they have been ruptured.

If we come from an abusive home, we may struggle with this. However, God is a loving God, and the lessons we take with us into adult life don't have to be all about the negatives of our upbringing. The heart of God can override the bad memories and give believers grace for those who raised them. We can see the life lessons when we look back. We can see the hand of God where once we would only see pain.

Dear Father, let me see my earthly parents through eyes of compassion. Help me, too, to be gracious with myself in my relationships, especially those with children.

Lifelong Guidance

When you walk, they will guide you;
when you sleep, they will watch over you;
when you awake, they will speak to you.
PROVERBS 6:22 NIV

Parental impact on a child's growth can't be underestimated. Whether mother and father are aware of it or not, they become a child's default thoughts often even into adulthood. If these lifelong lessons are of God, they are a balm to the soul. Even the ones that were taught to help us in the particulars of life are of great value that can guide us in unexpected ways.

God walks with his children no matter their age, and as our Father, he guides and directs us lovingly toward the paths of his righteousness. The Holy Spirit is with us, no matter what we are experiencing. No matter where we are in this world, no matter the circumstance, there he is too. What a blessing to know God brings us to places we will be protected and guided. There is power in our families, both those that reared us and those we choose for ourselves. Wisdom's words ring clear no matter where they come from.

Lord God, thank you for the gifts of guidance I had as a child. Even now, I am grateful for the spiritual mothers and fathers I have, as well as the friends who are as close as family. What a gift!

Light for Our Feet

These commands are like a lamp;
this teaching is like a light.
And the correction that comes from them
will help you have life.

PROVERBS 6:23 NCV

Psalm 119:105 famously says, "Your word is a lamp for my feet and a light for my path." The lamp in Psalms and the commands in today's verse provide an interesting study. God's Word, and wise direction given through the caregivers in our lives, provides direction for our feet. Even if we didn't have parents who gave us godly direction, chances are there were adults in our lives who helped us make decisions by their counsel, and even sometimes, their correction.

Without correction, we keep making the same mistakes. Correction is a key element of wisdom, for we need help to redirect and improve. Let's not forget that God's correction is laced with kindness (Romans 2:4). It is what leads us to repentance. He never shames, intimidates, or manipulates us. He is always full of patience, compassion, and peace with his children. Take heart, dear daughter, and do your best to do the same.

Lord, thank you for the light of your loving wisdom in my life. May I offer the kindness of that light of correction when it is my responsibility to do so.

Rhetorical Question

Can a man scoop a flame into his lap
and not have his clothes catch on fire?
PROVERBS 6:27 NLT

Sin, like a flame, can grow out of control quickly. It starts out small but gets to a point where it can't be controlled. It happens so quickly we tend to not pay attention until too late. If we keep in mind that sin is often clothed as selfishness, we can learn how to be alert to the little flame before it becomes a consuming fire. James 1:14-15 says, "Temptation comes from our own desires, which entice us and drag us away. These desires give birth to sinful actions. And when sin is allowed to grow, it gives birth to death." That is not the direction we want to go!

The good news is you serve a loving God. He has redeemed you through the blood of his perfect Son, and at any point during a fire of sin, you can turn to him and be brought back from death. May the God and Father of our Lord Jesus Christ "give you spiritual wisdom and insight so that you might grow in your knowledge of God" (Ephesians 1:17).

Dear Jesus, take my heart and my whole life too. Keep me alert to the little flames of sin in my life so the only consuming fire I experience is my love for you.

Treasure His Commands

Follow my advice, my son;
always treasure my commands.
PROVERBS 7:1 NLT

The Lord loves us more than we can imagine, and one of the great gifts of his love are the instructions for living we find in his Word. We can trust that he knows what is best for us, and we honor him when we treasure his commands. God is faithful, just, and true. He is full of loyal love and powerful redemption. He is merciful, kind, and strong. He clearly sees the things we do not even know how to consider.

Our hearts soften as we get to know the wonderful nature and the powerful faithfulness of our God. He does not demand that we listen to him without also showing up in real ways in our lives. He is not a tyrant. He is a kind Father, and he loves to lead us along the paths that lead us to abundant life in him.

Lord, thank you for the treasure of your priceless wisdom. I am astounded that you offer it so freely. Fill my life with the light of your Word as I humbly follow your leading. I love you!

Keep His Commands

Keep my commands and you will live;
guard my teachings as the apple of your eye.
Bind them on your fingers;
write them on the tablet of your heart.

PROVERBS 7:2-3 NIV

When we submit ourselves to God's ways, we experience the blessing of living under his watchful care. There is confidence in his leadership; we don't have to live in fear. As we learn to truly treasure God's wisdom, we will implement it in every area of our lives, not just talk about its benefits.

Keeping the commands of God requires trust in his character. It also requires our commitment to remain humble in his love. God delights in teaching us, so let's not feel the need to get it right on our own. It is through our close fellowship with God that we grow most organically in his wisdom. Keep his commands, yes, but don't forget to get to know him! He is kinder and more trustworthy than you may yet realize.

Father, I need your presence to transform my heart, mind, and life. Knowing you is such a great gift; I cannot thank you enough. I want to treasure your words as I do the people I respect. Speak to me and imprint your words upon my heart.

Seductive Flattery

Say to wisdom, "You are my sister,"
And call understanding your nearest kin,
That they may keep you from the immoral woman,
From the seductress who flatters with her words.

PROVERBS 7:4-5 NKJV

We need to keep God's wisdom close like a sister. A sister is someone we know and trust. She loves us and looks out for our best interest. She is honest with us, not mincing words. She doesn't care about flattering us. She tells us the truth, even the things we may not want to hear. She can see us clearly, and the same goes for how we see her. Wisdom's words can be trusted because they are true.

There are those who speak sweet, empty words that sound like good things, but they can't be trusted. They tell us things that make us feel good in the moment but harm us over time. Flattery is simply empty praise. It has little to do with you, but to advance the intentions of the one giving the over-the-top compliments. Flattery is not a tool of the wise, but of deceivers. There is depth to truth, but flattery floats only on the surface.

God, I trust your wisdom because it is like a sister I know well, and I can trust her words. Help me to keep my eyes open to the manipulation of flattery that cannot be trusted. With your guidance and help, I need not fear.

Two Women

Let not your heart turn aside to her ways;
do not stray into her paths.
PROVERBS 7:25 ESV

There are drastic differences between the adulterous woman portrayed in Proverbs 7 and the noble woman depicted in Proverbs 31. The former leads her victims to their destruction, whereas the latter brings her entire household honor and provision. The Proverbs 7 woman seeks only her own gratification and does not care about who she hurts; the Proverbs 31 woman works hard to care and provide for those she loves.

We get to choose which woman to model our lives after. We choose which woman we align with. Since God designed our hearts and created them to find full satisfaction only in him, any endeavors to find satisfaction in the world will lead to disappointment and emptiness. When we lose ourselves in loving service to God and others, we find ourselves, our purpose, and our satisfaction.

Oh God, I want my words and actions to bring blessing to others and not curses. I want to bring honor to you and encouragement to those I love. Help me choose the more noble way even when temptation pulls me. It is better to honor others than to seek to satisfy only my own whims.

Understanding's Voice

Listen as Wisdom calls out!
Hear as understanding raises her voice!
PROVERBS 8:1 NLT

Unlike the noisy gong or the clanging symbol, when Wisdom calls out, she has a compelling voice. Her tone is recognizable. Believers are drawn to her because she sounds like God himself. The wisdom of God is driven by his love. First Corinthians 13, the love chapter, tells us all the languages of the earth and the angels are useless without love. There is no meaning if love is not in it. Anything we do, say, or think is just a bunch of noise if we do it without love.

Wisdom and love are the outpouring of the Holy Spirit in our lives. We know we are in the presence of the Almighty God when our lives align with his Word. We know the Holy Spirit is working through us when we allow understanding and love to compel our thoughts, so we bless others rather than reject them. Familiarize yourself with wisdom by going straight to the source—the Son of God. There is so much to learn of wisdom's ways through the life and teachings of Christ.

Jesus, I listen for the voice of your wisdom calling out today. I know that wisdom is always speaking, ready to teach me. Open my ears to hear your voice as I press in to know you more.

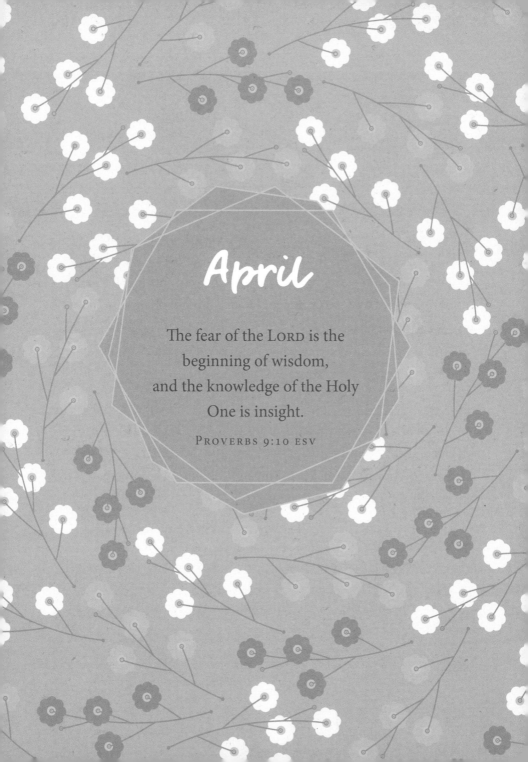

April

The fear of the LORD is the
beginning of wisdom,
and the knowledge of the Holy
One is insight.

PROVERBS 9:10 ESV

Excellent Things

Listen, for I will speak of excellent things,
And from the opening of my lips will come right things.
PROVERBS 8:6 NKJV

The literal translation of the Hebrew word presented as *excellent* in today's verse is *princely* or *noble*. Wisdom speaks of noble things, which are the very things that lead us to reign in this life. Christ said in John 16:33, "Be of good cheer, I have overcome the world." Jesus was encouraging his followers to trust him in the face of difficulties. The noble path is not an easy one, but it is one marked by the victory of our Savior.

The way of Christ is exemplary. It is filled with excellence and truth. It is marked by laid-down love and astonishing surrender. What kindness is found in his presence! What grace he offers, even still. Let's get to know the excellent things of wisdom by following the beautiful example of our loving Jesus. His way is life everlasting.

Lord, lead me in your way everlasting so that my lips will echo the profound truth of your wisdom. I heed Paul's wisdom in Philippians 4 that instructs, "Whatever things are true, noble, just, pure, lovely, of good report, meditate on these things."

The Truest Treasure

"Choose my instruction rather than silver,
and knowledge rather than pure gold."
PROVERBS 8:10 NLT

The most precious metals, owned by the wealthiest people with the most luxurious things and the most comfortable lives, are nothing, absolutely nothing, when compared to the glory that is ours in Christ. The Lord has given us his Word and paved the way to his throne. We have his presence as a guarantee of his goodness.

Clear instructions leave us with a solid knowledge of God's expectations. He elevates his instructions over the value of earth's precious metals, so we needn't guess or misunderstand how truly valuable God's Word is. We are told to choose him. This choice, when laid out plain before our eyes, is not a difficult one. His wisdom is precious! It is costly! It is worth more than millions in the bank. It is the very best investment we can make! What a precious treasure he has offered to everyone who takes him at his word.

Lord, I believe. My life is yours. Oh how I love your wisdom! Thank you for the clarity and beauty in your living Word. Reveal the incredible worth of your instruction as I continue to follow your ways.

Wisdom Plus Prudence

"I, wisdom, dwell together with prudence;
I possess knowledge and discretion."
PROVERBS 8:12 NIV

What an interesting picture we have in today's proverb. Wisdom lives with prudence. Knowledge and discretion are there, too, in the same dwelling. If we imagine wisdom as a person, we can picture prudence as her partner. Prudence helps us take care and be aware of the bigger picture. It slows reactions down, creating space to react, and increases prayer and relying on the Holy Spirit. We must remember to leave room for God's voice, and that requires space to think before responding. Prudence creates the room for wisdom to do its work.

God blesses his children when they pursue him and nourish on his Word. He fills us with insight, knowledge, and an ability to discern right from wrong. He equips us to be prepared for the next conversation or the next act of kindness. We can even gain insight into the way people think or what they need through his discerning Spirit. There is no limit to what we can receive as we grow in wisdom, prudence, knowledge, and discretion.

Lord, what wonders you reveal through your wisdom! Thank you for my place in your family as your daughter. Continue to guide me in your ways and counsel me by your instruction.

Take Account

> "If you respect the LORD, you will also hate evil.
> I hate pride and bragging,
> evil ways and lies."
>
> PROVERBS 8:13 NCV

The wisdom of God does not teach us to hate our neighbors. We cannot confuse the acts of pride, bragging, lies, or any other sin with imperfect people in need of grace, mercy, and peace. We are wise to consider the words of Jesus in Matthew, "Why do you notice the little piece of dust in your friend's eye, but you don't notice the big piece of wood in your own eye?" (7:3) We must learn to hate evil in our own lives, not leaving room for compromise.

The Holy Spirit convicts us of ways we allow sin to fester in our own hearts, and this is our chance to repent. Where there is pride, we must humble ourselves in his sight. We are no better than anyone else. We have access to the same overwhelming mercy to set us right and relieve our burdens. Take some time to take stock of the attitudes of your heart. Is there a piece of wood blocking your vision that needs to be dealt with?

Lord, help me to keep account of my own heart before I jump in to judge the faults I see in others. I humble myself before you. Have your way in me and revive my heart in your love.

Mutual Love

"I will show my love to those who passionately love me.
For they will search and search continually until they find me."
PROVERBS 8:17 TPT

When we are in love with someone, we crave time with them. In fact, we look for ways to be close to them. The same passion is true for lovers of God. And this can grow as we get to know him more. He certainly is worthy of our love; the more we get to know him, the more apparent that becomes. The more love we pour upon him, the more he lavishes on us. It is a glorious cycle of love that never ends!

When was the last time you spent time with God for the sheer delight of his presence? He is so very near, and he loves to draw close to you when you turn your attention to him. Even if it is only a few minutes today, search for him. He is easily found!

God, I will never stop pursuing you. Your love draws me in with cords of kindness. Thank you for everything you have and will share with me. I am excited to walk through this life with you and to fall more in love with you every step of the way.

Paths of Justice

"I walk in righteousness,
in paths of justice."
PROVERBS 8:20 NLT

Righteousness and justice are beautiful things, yet the world seems to be severely void of them. Injustices are all around us. It can be overwhelming and discouraging to hear of the ways in which people take advantage of, and harm, others. One thing is for sure; that is not the way of Christ or of his kingdom.

We can choose to walk according to God's ways, no matter what others are doing. God's ways are righteous, and his paths are just. Our souls rest in the confident security that God has won the war against evil already through the death and resurrection of his Son. His victory is our hope. We will one day live in a kingdom without pain, suffering, or injustice. Until that time comes, we serve a pure king who loves completely. As we follow in his footsteps, we walk in righteousness; we tread on paths of justice.

Thank you for your sacrifice, Jesus. I choose to follow your example. I'm so grateful you are righteous and just. I trust you.

Woven Together

"I, wisdom, was with the LORD when he began his work,
long before he made anything else."
PROVERBS 8:22 NCV

Wisdom was present with God at the beginning. We can't separate God from wisdom or wisdom from God. We can't deny that God is the source of wisdom; it was with him from the beginning and long before he created the heavens, the earth, and everything in them. The Father, Son, and Holy Spirit existed together with wisdom before the world began.

We serve an amazing God. We are products of his gloriously creative mind and exist by the compelling wonder of his resolve. We honor him with our love, loyalty, and obedience. What a true delight it is to serve this wonderful God who cares about every hair on our heads and every motive of our hearts.

Lord, it is my honor to know you. What a gift your wisdom is. Give me eyes to see it in places I might have otherwise missed it. There is no denying what you are like, and you are everywhere. Thank you for your great love, Father, that has been with wisdom since the beginning. I love you!

Earth's Foundation

"I was there when he ordered the sea
not to go beyond the borders he had set.
I was there when he laid the earth's foundation."

PROVERBS 8:29 NCV

With wisdom by his side, God constructed the planet. We are right to be awed by this. It's jaw-dropping to comprehend the ways of God throughout creation, but the steps of creation are literally amazing. In the Word, we have insight into our processes and purpose. The borders of the sea were set by the order of the Almighty, and wisdom was there. The foundations of the earth were laid. Wisdom was there.

Wisdom is a force. It's with God forever and always. It is ours to learn and discover by following and knowing God. Without wisdom, we are missing the Lord himself. Pursuing God brings wisdom into our lives in meaningful ways. What a wonder!

Lord, I have nothing to offer but your own creation: myself. Make me and mold me into your image. I willingly surrender to your wisdom for you are good!

Wisdom Rejoices

"I was constantly at his side.
I was filled with delight day after day,
rejoicing always in his presence,
rejoicing in his whole world
and delighting in mankind."
PROVERBS 8:30-31 NIV

In verse twenty-two of the same chapter, Wisdom declared she was "the first of his [the Lord's] works." In today's Scripture, she was *constantly* at God's side and *filled with delight day after day*. Now, she rejoices in his creation and delights in humankind.

God's wisdom sees us. Can we see her? Do we seek her and rejoice in her? Our beautiful world is not random or accidental; it is planned, orderly, and infused with wisdom. God, in his infinite understanding, created us according to his flawless plan and placed us in this stunning landscape. Although humanity has brought a lot of hate and destruction to our planet, God's mission is still in motion, and he's perfectly putting all pieces in place. Can you see it? Do you recognize his handiwork all around you?

Nature declares your glory, oh God! I see it in the changing seasons, the mountains and oceans, the sunrises and sunsets. Everywhere I look, I see your creativity, and I marvel at your majesty.

Eagerly Await Him

"Blessed is the one who listens to me,
watching daily at my gates,
waiting beside my doors."
PROVERBS 8:34 ESV

Walking with the Lord isn't a one-and-done activity. It's a lifelong commitment that is marked by constant communication and moment-by-moment loyalty. God is always available, and he is ready to speak to our circumstances. There are a few things we can do to keep God first in our lives so that we don't miss a word he says.

The only way to hear God's instructions is to be in his Word. Spending time in Scripture will help us learn the voice of the Lord. Nothing compares to daily time with our Maker to keep our priorities straight. The voice of the Lord draws us in, making the hunger of our hearts grow so we want more of him. Every little bit is a teaser for the taste, leading us to do what this proverb talks about: wait on God. Wait at his door and wait for him to speak. He will. He has things to tell us, ways to motivate us, and love to pour into us. We are his beloved, and he delights in our fellowship.

God, I love to hear from you and learn from you. I am overwhelmed by your love for me, yet I seek it more and more. Increase the hunger of my heart, even as you nourish me with your Word.

Lifegiving Love

"Whoever finds me finds life
and obtains favor from the LORD,
but he who fails to find me injures himself;
all who hate me love death."

PROVERBS 8:35-36 ESV

God created us for relationship with him. The path of getting to know him and trusting him with our lives leads to lifegiving revelation and understanding. His astounding love is never absent. It is ever present and overflowing in all that he does, even his correction.

Seeking wisdom is a worthy pursuit. Wisdom is a fountain of life that flows into our hearts, minds, and lives as we embrace her. Wisdom helps us avoid unnecessary pain and pitfalls. God's ways lead to life always, while ignoring his wisdom leads to destruction. Don't wait another moment to listen to the wisdom of God; it is there for your instruction. God's intentions for us are always good!

Lord, thank you for loving me to life with your wisdom. I won't waste my time ignoring what I already know to do. I choose to follow you, for you always know what is best.

Wisdom Personified

Wisdom has built her house,
She has hewn out her seven pillars.
PROVERBS 9:1 NKJV

Wisdom, personified here as a woman, has built a house for herself with seven pillars. Seven is a number that symbolizes completeness and perfection in the Bible. With that in mind, these seven pillars could mean that the house is in order and finished. It also hints that the house is well-supported and strong.

As we mature spiritually through different ages and stages of life, we discover deeper levels of understanding in the Bible as we dive into its depths. On its surface, it's interesting to think about the house as just a house. It's also interesting to think about Wisdom's house as an allegory for the creation of the world or the maturity of a believer's heart. God could very well mean every one of these explanations for this proverb. Ask the Lord to speak to you through this word picture today.

Dear Father, open my heart and mind to the messages in your Word and in Proverbs 9. I want to grow in understanding and wisdom. Teach me, Lord!

Accepting Rebuke

Do not rebuke mockers or they will hate you;
rebuke the wise and they will love you.
PROVERBS 9:8 NIV

How can you tell a wise person from a foolish one? One simple way is this: watch how they respond to correction. Some people are unwilling to listen to constructive criticism or loving rebuke. They care more about their pride and image than the truth. They don't want to improve or correct themselves; they want to feel good and avoid feeling bad. These people cower in the face of confrontation and are not up to the challenge of becoming better.

Save your correction for those who are willing to accept it, for they will love and appreciate you because you made the effort to help them grow. Those people are worth your input, and they will continue to great heights. Keep your heart humble toward those willing to help you grow and learn. Accept correction from the wise. Accept discipline from God. You grow in wisdom each time you do.

Lord, I don't want pride to keep me from growing in you or in wisdom. Please help me to keep my heart open when someone is willing to make the effort to help me grow. Give me the wisdom to keep from weighing in with those who will only be angry and reject it. Help me offer loving truth to those willing to appreciate and learn from it.

Wiser Still

Instruct the wise and they will be wiser still;
teach the righteous and they will add to their learning.

PROVERBS 9:9 NIV

Why does a wise person love constructive criticism? They know it will help them become even wiser. A teachable person cares more about the truth than their fragile image. Their pride does not block their view, for their eyes are set on God. To be corrected and learn encourages a wise person. Every opportunity to become better is a gift. They have no need to justify questionable behavior. A humble, wise person is willing to change and readjust their lifestyle. They learn from others, no matter their position, because they know all wisdom comes from God. God uses whomever he desires.

Instead of despising God's commands, a wise person embraces them gratefully because they understand they are guidelines to the best possible life. God offers us wisdom in all sorts of ways and through many different sources. Let's stay humble and open to receive it today.

I want to always grow in wisdom, Lord, and I realize that takes intentionality. I open my heart to the lessons of your wisdom today.

Beginning of Wisdom

The fear of the LORD is the beginning of wisdom,
and knowledge of the Holy One is understanding.
PROVERBS 9:10 NIV

Hopefully you understand that *fear* in this verse is not a feeling of terror but of awe. It's a dawning of understanding and an awakening of truth. When we receive revelation of who our holy God is, we cannot help but be consumed by awe. When we catch a glimpse of his glory, we do not stay the same.

If you ask for nothing else today, pray that the Lord will reveal himself to you in spirit and truth. We cannot see him fully, but glimpsing just one facet of his glorious nature can stop us in our tracks. He knows just what will speak to us in every moment. Don't hesitate to ask and wait on him until you feel time slowing down and your heart and mind expanding in his wonderful love.

Glorious One, I know my trust in you and my awe of you will only grow as I get to know you more. Show me your glory, Lord, and wisdom will meet me there.

Increased Awareness

"By me your days will be multiplied,
And years of life will be added to you."
PROVERBS 9:11 NKJV

We can trust God fully with the number of our days. We need not fear when it comes to how long or short our lives are. In the grand scheme of things, it is all too little. God is able, however, to multiply our time and bless each day we live, move, and breathe.

Have you ever had a day that felt like a week? Have you ever looked back over the passage of time and thought, *Where did the time go?* The passage of time is in large part in our perception of it. We cannot control what tomorrow will bring, but we can embrace each moment as it comes. Instead of worrying about how much time we do or do not have, we can focus on today and give it our all. God will meet us there!

Faithful One, I trust you with my days and with my future. I won't jump ahead and ignore the blessings and opportunities available today. Help me slow down and give my attention to the reality of my present moment and reveal where your wisdom is hidden in the details of my day.

Consequences

If you become wise, you will be the one to benefit.
If you scorn wisdom, you will be the one to suffer.
PROVERBS 9:12 NLT

Most often, a stable life can result from making good decisions, and poor choices will likely lead to more drama and upheaval. This isn't always the case, to be sure, but the importance of the principle should not be ignored. Blessings will abound for those who have eyes to see, and we can't see clearly without the wisdom God's truth thriving in our hearts.

On the other hand, turning away from God's wisdom leads to suffering. Ignoring it will lead us down a rough road. Still, there is good news to be found. No matter how long we have traveled the foolish road, ignoring God's ways, there is always an opportunity to change course. As we turn our hearts to the Lord and ask for his help, he is quick to come close. He is lavish in mercy and his grace is overwhelming. Every day is a good day to turn to him. He loves to redeem, restore, and refresh the weary!

Father, may I never hesitate to turn toward you, even when I realize how wrong and blind I have been. I will never stop coming to you for help and mercy. Empower me by your grace to live your wisdom out in my life!

Unwise Noise

Foolishness is like a loud woman;
she does not have wisdom or knowledge.
PROVERBS 9:13 NCV

This proverb shows the dichotomy between a loud fool and a quiet servant of the Lord. The loud and foolish woman doesn't have wisdom or knowledge. Proud people often say too much; they are defensive and overbearing. Humble people don't feel the need to defend themselves needlessly; they are open to criticism. Wisdom is often revealed in restraint. The quiet person seeking God puts their attention on trusting him, and he will defend them. Psalm 46:10-11 says, "'Be still and know that I am God. I will be praised in all the nations; I will be praised throughout the earth.' The Lord All-Powerful is with us; the God of Jacob is our defender." We are under God's protection, and as we seek him, we can find rest in his faithfulness.

A person of wisdom thinks before they speak and knows when to raise their voice. They have restraint when needed and allow the Lord to defend them.

God, teach me to be a wise woman. I trust you to defend me when needed. Help me to have a guard over my mouth when my words will be ignored or used as weapons against me. Above all, may humility reign in my heart and push out pride that seeks to drown out the voices of others.

No Need to Hide

"Come in with me," she urges the simple.
To those who lack good judgment, she says,
"Stolen water is refreshing;
food eaten in secret tastes the best!"
PROVERBS 9:16-17 NLT

There are plenty of things that thrive in the shadows, and we must be aware of them. We need to be alert to the temptation to compromise. Stealing is not better than earning what we have. There are always consequences to our actions. Especially in an age of instant gratification, we need to be on guard against shortcuts that lead us down shame-filled paths.

The foolish woman's invitation is not mysterious. We don't have to be so afraid of being duped by foolishness. Stealing is wrong. Even children know this. The lesson here is to not compromise in the little things. Even if we get away with it in the moment, it may lead us to compromising in bigger ways. This will lead to chaos and destruction, for we cannot hide forever. Choose wisdom from the start and stand strong in integrity.

Lord my God, I love you with my whole heart. I know your ways are best. Help me to stay free from compromise and to live honestly, openly, and in your light.

Wisdom for All

Wise children make their father happy,
but foolish children make their mother sad.
PROVERBS 10:1 NCV

We need God's wisdom as both children and parents. It is an important part of our development and our leadership. Thankfully, God's gracious wisdom is in everything he does. As we depend on him to father us well, we can emulate his character in the ways we relate to our own children. We can be merciful because he is merciful. We can be patient because he is patient. We can admit when we were wrong because God is not fooled by us. We can repair relationships and build trust because God does the same with us.

The only way to nurture wise children is to, purposefully and diligently, teach and train them in the ways of the Lord. Just as the Father willingly receives us as we are, we do the same with our children. Our greatest teaching tool is our example. They will see how we live, how we talk, and how we treat others.

Dear Father, may I reflect you in my words, actions, and attitude. And when I don't, may I be quick to admit it and change course.

Right Living

Riches gotten by doing wrong have no value,
but right living will save you from death.
PROVERBS 10:2 NCV

Solomon spoke on many topics, and how we deal with and pursue money is an important one. Proverbs 21:6 says, "Wealth that comes from telling lies vanishes like a mist and leads to death." As one of the wealthiest men to ever live, and the recipient of wisdom from God, Solomon is well-qualified to speak on the subject. Wealth in and of itself is not wrong, but ill-gotten wealth is a burden and a trap. Doing wrong is always wrong. Short-term gains achieved by lying will be lost.

It is not wrong to want to make a good living. This is not what Solomon is speaking to in this passage. He is admonishing the wise to focus on what truly matters—our character. If we live rightly, that is with integrity, we have nothing to hide. Everything we do will be enhanced by living this way, including how we make our living.

Oh Lord, help me to keep my focus on what truly matters. I want to grow strong in integrity. I know everything else will flow from that.

The Righteous Are Filled

The LORD does not let the righteous go hungry,
but he thwarts the craving of the wicked.
PROVERBS 10:3 ESV

We know that our needs matter to God. He gave manna to his people in the desert and provided water miraculously out of rocks. He took care of them. He provided what they needed. This is true for everyone who trusts in him. We may not have all that we desire, but that does not mean that we don't have enough.

Instead of looking through the lens of lack, determine to see through eyes of gratitude today. Do you have a roof over your head? Thank God! Do you have food to eat and fresh water to satisfy your thirst? That's wonderful. We often take for granted the abundance in our lives. When we train our hearts in gratitude, we more readily see gifts of grace and provision for what they are. What a way to grow in wisdom!

Dear Lord, thank you for your provision. Thank you for the little and big things that I so often take for granted. As I look for reasons to give thanks, open my heart to the wonders of your love at work in the details of my life!

Diligence Pays Off

Poor is one who works with a lazy hand,
But the hand of the diligent makes rich.
PROVERBS 10:4 NASB

If we work hard, we will do better than if we indulge in laziness. That is a life truth we can trust. It doesn't mean poverty necessarily points back to a person being lazy; there are many factors that can contribute to a person's financial status. It isn't something we can judge.

A lazy person has no drive to work at all. They only want to do what is comfortable, certainly not anything more. A person who lives this way will not be successful in life. Their relationships, finances, and life-satisfaction will suffer. We read in 1 Timothy 5:8 that "If anyone does not provide for his own, and especially for those of his household, he has denied the faith and is worse than an unbeliever." Keep going; be diligent; work hard. The consequences will be revealed over time.

Father God, keep me going. Please encourage me in the work I do and let me see your path so I will be encouraged to keep following in your purposes.

Work to Do

He who gathers in summer is prudent son,
but he who sleeps in harvest is a son who brings shame.
PROVERBS 10:5 ESV

A strong work ethic is a wise one. We must recognize the needs of the season we are in and do the work that is ours to do. As we do, we teach the next generation to do the same. We invite them into the process by giving them jobs to help. Every person plays a part in gathering in the summer. Reaping the rewards of hard work is a lesson only learned by doing.

Everyone has off days. That's not what this proverb addresses. It looks to the habitual behavior that is clearly seen over time. Whether we look at our own lives, our roles with our own parents, or to the younger ones we pour into, the impact of wisdom is clear through a strong character revealed through doing the work. We all have work to do, so let's be sure we aren't so busy watching the lives of others that we miss out on putting that energy toward our own fields.

Dear God, thank you for the gift of work. I know the satisfaction of hard work, and I don't take it for granted. Help me to include others in this work, trusting that teamwork is as important as tending my own part. A shared load is lighter!

Ready for Instruction

The wise of heart will receive commandments,
but a babbling fool will come to ruin.
PROVERBS 10:8 ESV

When we easily accept instruction, we reveal how hungry we are to learn. This is a marker of a wise heart. Learning means listening. If we are to receive commandments, we have to pay attention to them, looking for ways to incorporate them into our lives. A babbling fool is too busy talking to hear the instruction, or at the very least, to take it seriously.

The heart of a believer is fertile soil. We are softened by the Word of God moving within us like living water. It changes us from the inside out and allows us to be teachable, open, and changeable. The Holy Spirit speaks, and we listen. We need to be sure the ears of our hearts are attuned to his voice. We can be ready both in season and out of season by listening to the Holy Spirit and taking God's wisdom to heart.

Holy Spirit, tenderize my heart and open my eyes to the truth you reveal and my ears to the wisdom you speak. I am yours, and I am listening.

Walking Securely

Whoever walks in integrity walks securely,
but he who makes his ways crooked will be found out.
PROVERBS 10:9 ESV

Do you have secrets you think nobody notices? Our true nature is exposed when we think nobody is watching, but the effects are obvious whether we believe it or not. The value of a clear conscience can't be overstated. When your conscience is clean, your sleep is more peaceful, your mind less busy, your steps more secure, and your heart carries less fear and worry.

You never need to worry about being *found out* because there is nothing to hide. You can't be blackmailed, and your enemies have nothing to leverage against you. Any rumors or gossip formed at your expense will be proven wrong because your character will speak for itself. Dirty, little secrets are not worth the trouble. Besides, God always sees, and he cares too much about you to let your harm yourself like that. Anything hidden will be found out. It is better and simpler to live honorably and purely in public and in secret. Keep your conscience clear and get a good night's sleep.

Lord, I surrender everything in my life to you today. I need your help with some things. Thank you for giving me your strength to overcome.

Choose Wisely

Whoever winks maliciously causes grief,
and a chattering fool comes to ruin.
PROVERBS 10:10 NIV

The behavior of a child of God is unique, and we don't start out walking in the ways of God as new believers. Some changes are gradual, and some changes can be life-altering and sudden. The intentions of our hearts transform to treat others with love and respect. We can no longer make excuses for mean-spirited behavior or rants. Malicious behavior is self-serving and harmful to others. It stirs up trouble, and it is far from honest.

A fool thoughtlessly spews words about any and everything. They don't think about the effects of their words on others. They don't consider the consequences of what they say. Proverbs 17:28 says, "Even fools are thought wise if they keep silent, and discerning if they hold their tongues." Discretion is a powerful tool of wisdom. Let's not overlook its importance in our lives.

Father, thank you for the power of your redemption to change my heart! I know it's important to treat others graciously, as I hope to be treated. Help me guard my mouth when I would rather not be nice.

Fountain of Life

The mouth of the righteous is a fountain of life,
but the mouth of the wicked conceals violence.
PROVERBS 10:11 ESV

The book of James is only five chapters, but it is full of good direction for behavior. It is famous for the "faith without works is dead" sermon but also for its descriptions of the power of the tongue. Chapter 3 describes how the tongue is a fire and can set a whole forest ablaze. It compares the tongue to a bit in a horse's mouth and how the whole horse is steered by this little metal device. James also talks about the relatively small rudder of a ship, which moves the massive vessel with little movements.

We mustn't downplay the impact of our words. Today's verse was written almost a thousand years before the book of James was written. God has always warned his followers to use their speech carefully because it will reflect the true condition of the heart. It either builds others up or tears them down. There is so much good news to share. What if we prioritized speaking words of life?

Lord my God, be the director of my soul and the ruler of my heart so I can reflect your love with what I say. I want my heart to be like an overflowing fountain of your kindness, grace, and joy!

Love Versus Hate

Hatred stirs up strife,
But love covers all offenses.
PROVERBS 10:12 NASB

A plethora of relationship tips and advice can ease the sting of
conflict, but nothing can replace the tough labor of love. Only
love can heal wounds instead of covering them up. Only love can
counteract and overcome hate. Offenses may grow stronger or
fainter over time, but only love can put them to rest. Hatred and
apathy destroy and tear down but love fixes and builds up.

Within each of us is the potential for love or hate: for building up or
breaking down. When we are offended, we may be tempted to get even
and make the other person experience the same hurt we experienced.
This, however, is not how godly love works. We have been forgiven of
so much, and we have the amazing opportunity to now forgive others.
Extending forgiveness is one way of showing God how grateful we are
for the extravagant mercy he shows. Let's overcome hatred with love
and watch the world change before our eyes.

*Dearest Lord, help me not allow offense to grow a root of bitterness
in my heart. Give me the courage to respond with love, grace, and
forgiveness.*

Embrace Understanding

Wisdom is found on the lips of him who has understanding,
But a rod is for the back of him who is devoid of understanding.

PROVERBS 10:13 NKJV

Wisdom is applied in the same measure to everyone. For those who willingly receive wisdom's correction, it is a tool of life. For those who resist wisdom, it becomes like a rod that beats their back. In colloquial terms, we might say that it comes back to bite them in the rear. Wisdom's standards cannot be escaped, just as God's Spirit cannot. It is better to embrace wisdom from the start, then, so as not to feel the sharp rebuke of it when our compromise is found out.

God is a good father. He does not abuse his children. We have all learned lessons in life, and some were harder than others. Often, when we resist the right thing, we end up regretting it in the end. There are many paths of wisdom that have already been tread; we don't have to start from scratch. Listen to wisdom from trustworthy ones and put it into practice. Save yourself unnecessary trouble.

Lord God, thank you for accessible wisdom in your fellowship and in the life of Jesus. Thank you for the rich treasure of Proverbs. Give me ears to hear and a heart that understands so I can follow you with confidence.

May

Commit to the LORD
whatever you do,
and he will establish your plans.

PROVERBS 16:3 NIV

Don't Tell All

The wise don't tell everything they know,
but the foolish talk too much and are ruined.
PROVERBS 10:14 NCV

A common phrase is, "It's better to be thought a fool than to open your mouth and prove it." It's a spin on today's verse, although what people think about you isn't the most important point. It's more important to consider what God thinks about you. Seeking and knowing God leads to wisdom, and you learn from him when to be silent and when to speak. When you do speak, you will know what to say.

Ignoring God or walking past opportunities to learn more about him will result in foolishness. Not knowing your Maker will be revealed in what you say. This is not reason to fear, but reason to press in to know the overwhelming mercy of God. You can rarely fool people when your behavior reflects your heart. Wise people believe what people reveal through how their words and actions either align or don't.

Dear God, I'm so glad I'm not obligated to spill my heart to everyone. In fact, your Word says that is foolishness. I choose to trust you to teach me when to speak and when to refrain.

The Strong City

The wealth of the rich is their fortress;
the poverty of the poor is their destruction.
PROVERBS 10:15 NLT

*N*either of the options in today's verse is ideal. If a person's wealth offers them protection from the storms in life, they will have little reason to seek the Lord. Likewise, if a person is so poor that they succumb to stealing and other desperate behaviors, they rely on their own scheming rather than God's protection and provision. Both wealth and poverty offer flawed situations that can pull a person away from a healthy relationship with the Creator.

It is much better to pray for a balanced life. Pray for enough but not too much. Pray for bills to be paid and food on the table rather than fancy houses or vehicles. And when you do have more than enough, put God's generosity into practice and share what you have with others. Matthew 6:33 tells us to "Seek the Kingdom of God above all else, and live righteously, and he will give you everything you need."

Dear God, I don't want to be consumed with the need for more. Help me to use what I have wisely and to share where there is abundance.

Wages of Righteousness

The wages of the righteous is life,
but the earnings of the wicked are sin and death.
PROVERBS 10:16 NIV

All work leads to compensation. How we use the resources we are given is an important indicator of what our priorities are. If we squander what we have on things that don't last, we will regret it in the end. If, however, we use God's wisdom to put our energy and resources to the things that truly matter, we will experience the satisfaction of life.

Thoughtful investments of our time, our efforts, and our finances reflect the wisdom of God. Let's not ignore the example of Jesus, who did not have worldly wealth but was rich in wisdom, kindness, and peace. He was overflowing with patience, mercy, and forgiveness. Against these things, there is no law, but they do produce life and life everlasting.

Lead me, oh God, down your path of righteousness. I want to be wise with my resources and in my investments. May it all start in my heart and flow from there.

Correction and Discipline

Whoever heeds discipline shows the way to life,
but whoever ignores correction leads others astray.
PROVERBS 10:17 NIV

Living contrary to Gods instruction hurts not only us but those closest to us as well. Our family and friends experience the negative impacts when we ignore God's correction. Remember, God corrects us because he loves us and wants the best for us. Accepting discipline and correcting our ways will increase our spiritual maturity. Though it begins with us, its effects also flow to our loved ones.

Since we are in the body of Christ, we grow together, hurt together, and mature together. None of us are isolated in our pain; that's not how a body works. It's important for us to embrace correction so we can offer healing to others. We can also show others the way to life. Being able to share our faith and be a blessing to others is an incredible gift; let's not waste it.

Lord, when you correct me, please give me the wisdom to respond maturely. I know your correction is always from a place of love. What a witness of your care that you will not let me stay stuck in areas that are harmful.

Heart Condition

Whoever hides hatred has lying lips,
And whoever spreads slander is a fool.
PROVERBS 10:18 NKJV

The condition of the heart is a big deal to God. Honesty is necessary for us to recognize and repent of our flaws and failures. First John 3:15 says, "Whoever hates his brother is a murderer, and you know that no murderer has eternal life abiding in him." Solomon was also aware of the severe consequences of keeping hatred in your heart while professing otherwise with your mouth. If you have resentment in your heart against someone, come clean and confess it to God. He will walk you through the process of both forgiveness and repentance.

Some people make no effort to hide the condition of their hearts. These people slander and defame others without hesitation, and they are simply fools. Ultimately, Proverbs spells out the consequence of being a fool, and that is destruction. Wisdom is the path to life, so embrace it today!

Father, help me be completely honest with myself and also with you. I know you see me clearly anyway, and you love me completely. I don't want to harbor resentment in my heart. Help me to have an unoffendable heart filled with your love.

Talk Less

If you talk a lot, you are sure to sin;
if you are wise, you will keep quiet.
PROVERBS 10:19 NCV

We are told throughout Proverbs to be selective with our words. For those of us who are chatty, this can be a challenge, but it's an important discipline to cultivate. The more space we leave in conversation, the more we will hear. The more we hear, the more we will know the griefs and challenges of people around us. The more we know our people, the better we can show up to support them with wisdom.

Being quiet doesn't come naturally to us all. We have to cultivate the practice. Listening is a powerful tool for wisdom, not only in how it protects us, but also in how it grows our compassion for others. How amazing that we can learn a few simple disciplines that help develop our character in big ways.

Lord, I want to be a person that people feel safe to share their real struggles and victories with. Help me to listen well and lean in with wisdom in my relationships.

Tongue of Silver

The tongue of the righteous is choice silver;
the heart of the wicked is of little worth.
PROVERBS 10:20 ESV

There are four precious metals: gold, silver, platinum, and palladium. They are considered precious because of the way they maintain a consistently high value; they are in demand and relatively rare. Silver has unique qualities because it conducts electricity and heat best out of all the elements. It is also beautiful for making jewelry and antimicrobial for fighting bacteria. Isn't it fun that Solomon, not knowing all of this, compares the tongue of the righteous to this beautiful metal?

The righteous tongue speaks beautiful words that will fight the toxicity of sick words. We can't fake this; our words will reflect the condition of our hearts. They can be functional and beautiful like precious metal, silver, or they can be of little worth like the words of the unrighteous.

Lord, I want my words to be like silver, my speech like a precious offering to you. Grow me in your wisdom as I follow your ways, Father.

Nourishing Words

The lips of the righteous feed many,
but fools die for lack of sense.
PROVERBS 10:21 ESV

The words of the wise are not empty. They are nourishing to the soul and satisfying to the heart. They feed many, not just a few. This is evocative of both our physical and spiritual endeavors as Christians. We get to serve others in practical ways that reveal the love of Christ. This could be done through bringing a meal to a family in need. It could be through serving at a soup kitchen. There are many ways we can do this.

Spiritual nourishment happens in our hearts, but it is through loving words and acts of encouragement, wisdom, and support. We can feast on the words of righteous teachings and speak words of life to encourage others. Wisdom is not mysterious; it is full of practicality, sensibility, and compassion.

Holy Spirit, thank you for the nourishment of your Word. Fill me with your wisdom so that I have goodness to offer others. Thank you for the practicality of your wisdom at work in the world and in my life.

So Much Blessing

The blessing of the LORD makes rich,
and he adds no sorrow with it.
PROVERBS 10:22 ESV

The richness of knowing God is eternal. The glimpses of our future home through the blessings we already experience are beautiful and satisfying. The yearning in our hearts culminates in the wonders of heaven. This richness will add no sorrow to our lives. Although we will not know a flawless life on this side of things, we certainly can be thankful for every good and perfect gift that comes from our Father in heaven.

It is a blessing for our needs to be satisfied. It is also a blessing to not have too much wealth because of the amount of responsibility it entails. It is a blessing to walk in the light of day, and it is also a blessing to discover the treasures of darkness we uncover as we tread the darker times of grief and suffering. The presence of God is a blessing that goes with us, no matter what.

Wonderful Father, thank you for the blessings you have given me. I don't take them for granted today. Most of all, I'm thankful for your persistent presence that never leaves my side. I am yours!

Delight in Wisdom

A fool finds pleasure in wicked schemes,
but a person of understanding delights in wisdom.
PROVERBS 10:23 NIV

A fool finds it fun to make plans to do wrong. A person who has wisdom delights in discernment. They don't find these kinds of schemes fun at all. As daughters of the living God, we have received so much mercy to meet us in the messy parts of our lives. There is grace to empower us to change.

The more we walk in wisdom, the more we will delight in it. It really is full of benefits for our souls, bodies, and minds. It affects everything from our relationships to the plans we make for the future. There is love, grace, and renewal in the wisdom of God for us to both partake of and share with others. We can start by appreciating it in our lives right now.

Father, thank you. Thank you for showing me the light of your salvation and liberating me in your lavish love. Thank you for your lifegiving wisdom. I love it so!

What You Desire

What the wicked dreads will come upon him,
but the desire of the righteous will be granted.
PROVERBS 10:24 ESV

There is beauty in the pure desires of a believer. As we grow closer to God, our desires become more and more shaped by his desires. Our selfishness fades, and our awareness of others increases. We realize our part in the body of Christ. We are linked with other believers in the great family of God.

God loves us as his beloved children. He is even more delighted in you than you are with the young ones in your own life. You are unique, and that is not meant to change. As a good father, God likes you; he doesn't just love you because he has to. You are the apple of his eye. Don't be afraid of the desires of your heart. Lay them before your heavenly father and trust him with them. There is nothing to fear in his presence.

Father, I am so overwhelmed by your love for me. Thank you that I can come before you as a beloved daughter and know that you meet me with patience, kindness, and joy.

Standing Firm

When the storm has swept by, the wicked are gone,
but the righteous stand firm forever.

PROVERBS 10:25 NIV

We cannot escape the storms of life. Wars rage. Economic crises come and go. Illness brings us to our knees. To ignore the suffering in our lives and in the lives of others is to turn a blind eye to reality. However, God is with us in every storm. His perfect peace is available in his presence. He never leaves us. He never forsakes his children.

Today's verse is a promise. You don't have to do anything but trust God. Hold onto the hope of your Savior and don't let go of his love. He is ever so close, beloved. When the storm that has you quaking is over, you will see that his mercy remains. His grace and truth remain. His peace, his joy, and his wisdom remain. And so do you.

Precious Jesus, you are the rock of my salvation and my anchor of hope. Thank you for never ever leaving me in my need. I need you more than I can say. Refresh my heart in peace and hope today.

Vinegar and Smoke

Like vinegar to the teeth and smoke to the eyes,
so is the sluggard to those who send him.
PROVERBS 10:26 ESV

This proverb illustrates how trusting a lazy person to get a job done is irritating and annoying to the one waiting for it to happen. It's as enjoyable as a toothache! It's as vexing as smoke in your eyes!

We don't want to be people who don't follow through on our responsibilities. When we are consistent and do our work well, we will not leave those depending on us hanging. The demands of life are many. You are not lazy if you are overworked. You can't do everything. But you can do what is yours to do. Is there something you've been putting off doing that someone else is waiting on? Take the time and do it today. Or at least communicate with them and come up with a different plan, if needed. What trust you build when you do!

God, I'm so glad your wisdom is practical. You see the areas I've been struggling to tackle. Help me to stop making excuses and do what I need to.

Practices of Awe

The fear of the LORD prolongs life,
but the years of the wicked will be short.
PROVERBS 10:27 ESV

We were made to experience the awe of our God. It leads us to worship him. As we surrender our lives to our maker, following in his ways and growing in his wisdom, we will experience great contentment in our souls. Just consider how you approach life when your heart is overflowing with gratitude. Even the hardest trials are made easier by trusting God, for our hearts honor the glory and greatness of who he is.

If you want to experience awe more, there are practices that can help you. Paying attention is one way. Go on a walk in nature, looking for beauty. Don't overthink it. Let your attention be drawn by patterns and details. If music moves you, listen to an uplifting song. Ask the Lord to increase his felt presence as you pray. There are so many ways to find awe, but it starts with an intention. It continues with practice.

Creator, I love the way the bees buzz around flowers and rays of sunshine filter through clouds. There is so much to appreciate, and as I do, I feel the expanse of awe in my chest as my soul sings gratitude to the creator of it all.

Eternal Hope

The hope of the righteous brings joy,
but the expectation of the wicked will perish.
PROVERBS 10:28 ESV

As believers, our hope does not begin and end with this life. It lies in Christ, the author and finisher of our faith. Our true hope goes beyond the limits of this temporal life into the eternal realm of his kingdom. What a glorious hope we have!

The way we choose to live here and now echoes into eternity. We shouldn't take that for granted. When we align ourselves with the wisdom of God, we choose to love our enemies, forgive those who hurt us, and offer support to those who are suffering. We don't look for excuses for our apathy. The way of Christ is full of engaging love, and that includes sacrificing our own comfort. The more we follow him, the more we trust his heart and intentions. There is nothing he calls us to that he didn't first do or offer himself. He is the ultimate example, and our hopes are firm when they are set upon him.

My Lord and my God, my heart and life are yours. I trust you to lead me on the path that leads to everlasting life with you. Help me choose your wisdom at every turn.

Refuge of Rest

The way of the LORD is a refuge for the blameless,
but it is the ruin of those who do evil.
PROVERBS 10:29 NIV

The wisdom of God is like a refuge for those who embrace her. When we walk in God's ways, there is no reason to fear being found out. There is nothing shady or hidden in our lifestyles. Even our faults we openly admit. We don't wish for the downfall of our brothers and sisters. We lift them up and pray for their best.

God's ways are beautiful, and they are a safe place to rest. Think of the people you trust most in your life. What is it about them that makes them a safe landing place for you? Thank them for being refuges of wisdom in your life and ask the Lord to bless them. Continue to dwell in the wisdom of God, and you too will be a place of refuge for those seeking shelter.

Lord, I want to be found in the resting place of your wisdom. You have my surrendered heart. I choose to implement your wisdom in my life, knowing it is life, and joy, and peace!

The Righteous Stay

The righteous will never be removed,
but the wicked will not dwell in the land.
PROVERBS 10:30 ESV

There is only one way to be righteous: to submit our lives to God. It is not out of obligation that we surrender to him, but out of deep gratitude and the revelation of his overwhelming love. We grow to trust his nature as he faithfully leads us in mercy through the twists and turns of this life. He is always good. He is always reliable. He is always victorious.

When we remain humble before God, we are ready to learn from our mistakes and change when he shows us a better way. This journey will never end as long as we travel the roads of this life. God is the best guide, and we can trust his wisdom with every step. He knows the landscapes of his land, and he will not lead us astray. No matter or little or long it's been since we've checked in with him, he is available today. Let's turn our attention to him even now.

Father, I submit to your kind leadership today. Show me the steps I have to take today, and areas that need some attunement to your Spirit. I am yours!

Fruit of Wisdom

From the mouth of the righteous comes the fruit of wisdom,
but a perverse tongue will be silenced.

PROVERBS 10:31 NIV

The fruit of wisdom is made clear in the lives of those who follow God's way. Galatians 5:22-23 tells us what the fruit of God's Spirit looks like. It "is love, joy, peace, forbearance, kindness, goodness, faithfulness, gentleness, and self-control. Against such things," Scripture says, "there is no law."

We know that wisdom was with God from the beginning. We can be sure that wisdom's fruit looks like the fruit of the Spirit. Look at how uplifting that list is! It is full of reason to hope, not to despair. May we take heart in the overwhelming goodness that God's wisdom produces in the lives of those who choose to walk in it.

Spirit of wisdom, thank you for the goodness of your fruit. How enticing are your ways! As I follow you and incorporate your ways into my life, may my life brim with the appetizing fruit of your kingdom!

What Is Acceptable

The lips of the righteous know what is acceptable,
but the mouth of the wicked, what is perverse.
PROVERBS 10:32 ESV

When the wisdom of the Word is in our hearts, the right words will come out of our mouths. Empty platitudes are not the same thing as wisdom. God's Word is full of real wisdom to encourage, convict, and reveal the important things of life.

What is acceptable? It is acceptable to praise God. It is acceptable to edify and lift each other up. It is acceptable to speak the truth in kindness and love. May the Lord open our eyes to the things we speak that are not helpful and not reflective of his kingdom's wisdom. The Holy Spirit promises to guide and teach us as we seek to know our Father.

Lead me, God, to know your ways. Teach me about what is acceptable and pleasing to you. I want to reflect your wisdom in the way I talk to and about others. Help me, Spirit, and convict my heart when I need to align with your love.

Accurate Weights

The LORD detests the use of dishonest scales,
but he delights in accurate weights.
PROVERBS 11:1 NLT

*D*ishonesty is not the way of the Lord. He always calls us to be honest. When we are caught in a lie, it is we who will suffer for it. Wisdom is not found in duplicity. It is found shining brightly in a life filled with integrity. This does not mean we will never falter. But the wise are humble and set things straight, repenting and repairing as soon as they realize the fault of their ways.

It is pleasing to the Lord when we accurately record the numbers of our affairs, fair and generous with the wages we pay others, and when we are transparent, just, and true. It is always the right choice to use best practices in our business. We shouldn't blur lines or fudge numbers because we see others doing them. Our standard is not what is normal, but what is right. Thank God he helps us grow in integrity as we adopt his wisdom.

Father God, I don't want to compromise what is right for what is convenient. Help me to always choose accuracy and transparency. Then I will have nothing to hide.

Humble Heart

When pride comes, then comes disgrace,
but with humility comes wisdom.
PROVERBS 11:2 NIV

Every time we open our mouths, may our speech be laced with humility rather than pride. May the words we speak be edifying to God and uplifting to each other. Instead of stroking our egos and showing off our knowledge, let's listen to what others have to say and allow God to lift us up in his time and his way. Pride is detrimental to our faith and only leads to disgrace, but the words of the wise are humble, loving, patient, and praiseworthy.

Because we are daughters of God, others should feel comfortable and safe around us. But that means we have to do the work to build that trust. Let's not get caught up in trying to prove ourselves or by playing the comparison game. Instead, the endeavor of our lives ought to be to point others back to Christ. He is where all good things flow from. He is our source of life; all we are and all we have are gifts from him. Let's use our gifts to be a blessing to others.

I want to praise you in everything, dear Jesus. I don't want to become trapped in the ego game of trying to measure up against others. I know you love me the way I am, and you created me to bring you praise.

Integrity of the Upright

The integrity of the upright guides them,
but the crookedness of the treacherous destroys them.
PROVERBS 11:3 ESV

We are not born with integrity. We have to intentionally incorporate it into our lives. We have to choose to grow in it. It takes work and persistence. It is not always the quick or easy path; but it is the right one. The irony about shortcuts is they are not really time-savers at all; they work against us.

Integrity is a big word, so let's be clear about what it means. It is being consistent with what you say and what you do. Follow through on your commitments. Be sincere in your words to others (say what you mean and mean what you say). Don't lie or pretend to be something that you are not. Be honest, be true, and reliably do your part. This is a life of integrity that will lead you to success.

Lord, guide me so I learn what it means to truly walk in the way of integrity. Thank you for the practicality of your wisdom that I can adopt into my life today. I love you, and I choose you.

Righteousness Delivers

Wealth is worthless in the day of wrath,
but righteousness delivers from death.
PROVERBS 11:4 NIV

*A*t the end of days, *the day of wrath* this proverb speaks of, we will see the results of our earthly pursuits. The real meaning of life will play out before us in the ultimate judgment of what we gave weight to while we went about our daily lives. Eternity isn't trivial or distant. What we do now has weight whether we acknowledge it or not, so it's much better to acknowledge it.

That acknowledgement, although weighty, doesn't have to be a burden. The burden isn't ours. We are to seek first the kingdom of God and his righteousness. After that, everything we need and much of what we desire will be given to us. Check out Matthew 6:33. Eyes up and then, amazingly, the shackles of this life will loosen. As we gaze toward our King, we live with eternity in our sight, reminding us of what truly matters in the end. This gives us strength to choose God's ways over the ways of this world. It is always worth it.

Lord, my God, help me remember to look to you throughout my day. When I feel overwhelmed, come in close with your presence. I want to be grateful for every breath here on earth while also glimpsing the glory that awaits in your eternal kingdom.

The Smooth Way

The righteousness of the blameless will smooth his way,
But the wicked will fall by his own wickedness.

PROVERBS 11:5 NASB

We don't go through life without tripping. It's impossible. When we learn to walk, we fall often. Losing our balance can happen at any time. We all know the startling jolt a fall brings. This physical experience is a reminder of a spiritual reality.

A smooth path leads to an easier walk. Consider the difference between walking a paved path and hiking a steep, wooded trail. The latter is scattered with roots and rocks. You have to be much more aware of each step you take so that you don't trip and fall. When you walk on a smooth path, your mind can wander a bit more. When you walk in wisdom, you have more freedom of movement. It is an easier path, but the path of the wicked is scattered with roots and rocks that they have to dodge to stay upright.

Lord, I know that walking in your wisdom is the smoother path. It is a protection for my soul, and it truly makes walking through this life easier. Help me to resist the pull of deceit that only leads to stumbling.

Persevere in Goodness

The godliness of good people rescues them;
the ambition of treacherous people traps them.
PROVERBS 11:6 NLT

If we understand that the God who created us knows what's best, then we can more greatly trust his standard of behavior. God's requirement for his followers is clear: follow his ways. Behave as he would. He never asks us to do what he hasn't already done. God sent his Son who lived out his wisdom in flesh and blood. There is no question about what he wants us to do and how he wants us to live. He walked this planet. He knows.

Following God is not a trap. It is a setup for success. The rescue of the righteous is guaranteed. Why would we choose to follow bad advice that only promises to trap us? Lean on God for guidance and help when you need it. And continue to walk in his wisdom. It is so, so worth it! Let God be your confidence, for he is faithful and true, and he will never fail you.

Dear Jesus, teach me to live as you lived and base my decisions on the very heart of the Father.

Greater Hope

When the wicked die, hope dies with them;
their hope in riches will come to nothing.
PROVERBS 11:7 NCV

We each get one lifetime to figure out the purpose of life, and
we can enjoy the blessings both now and forever if we figure it out
earlier rather than later. If everything we hope for begins and ends in
this life, our vision is far too small. It is important to be engaged in
our communities and in our families, that is to be sure. But our hope
echoes into eternity. There is still more to look forward to, far more
satisfying and beautiful than we can even imagine.

There is resounding peace in fellowship with our heavenly father. We
experience his presence as it meets us in the moment, and we also
catch glimpses of the glory that awaits us. The love of God flows out
from his heart on every one of his children. Spend time soaking in
that love today, and let it motivate you in all that you do.

*Dear Father, thank you for your hope that does not end when my
breath does. Reveal your love to me in deeper ways that I may live
saturated and fueled by it. I fix my eyes on you!*

Heart Vision

The righteous is delivered from trouble,
And it comes to the wicked instead.
PROVERBS 11:8 NKJV

There is an old idiom that goes like this, "Don't trouble trouble till trouble troubles you." We don't need to worry about what we cannot anticipate. Trouble will come, but the grace of God empowers us in the moment. We always have what we need in his presence. His wisdom never fails!

We don't need to go looking for trouble. If we do, we will find it. It doesn't take much imagination to realize how this plays out in the world. A small compromise can lead to a cycle of sin, addiction, or worse. It is important to lean on God who promises to deliver the righteous from trouble. The love of God leaves no room for compromise in our hearts, so let's feast on it! His ways truly are the ways of life everlasting.

Lord God, keep me holy in heart, mind, and soul. Allow me the insight to see when trouble is coming my way and deliver me from it.

Resourcefulness

With words an evil person can destroy a neighbor,
but a good person will escape by being resourceful.
PROVERBS 11:9 NCV

Sometimes the best answer in a conflict is to say nothing at all. Scripture tells us to love our neighbor, and that is both literal and figurative. A person doesn't share living space with a neighbor, but we do share property lines, noise levels, and possibly even cooking smells. It's a close relationship. There will be conflicts, and today's verse tells us how to manage those difficulties.

The art of being resourceful can take on many forms. It can mean offering a smile to a neighbor who often scowls. It can be engaging our neighbors in uplifting ways, whether that's inviting them over for a bonfire, taking baked goods next door, or offering to help an elderly neighbor with their groceries. It can be doing extra yard work that ignores property lines. Resourcefulness puts kindness into action. It builds solutions with behaviors. Don't underestimate the power of acts of kindness to build bridges in your relationships with difficult people!

Lord, show me creative ways to build bridges with my neighbors. Help me to humble myself and stay compassionate and kind so your glory can show through.

A City Rejoices

When it goes well with the righteous, the city rejoices,
and when the wicked perish there are shouts of gladness.
PROVERBS 11:10 ESV

Why, might you think, would a city rejoice when the righteous are successful? When we take Proverbs into account and remember what God's wisdom entails, it is easy to see. The righteous are people who can be counted on. They are honest and fair. They don't deceive or try to trick their neighbors. They do good, and everyone benefits from that including the communities they reside in!

The standards of the righteous are high. They treat people with respect and kindness. In a culture of integrity, everyone is lifted up. Everyone benefits, except perhaps those who love to deceive and do wrong. We should never give up walking in the way of wisdom. It is a blessing for us and our loved ones, surely, but it is also a blessing to our communities.

Lord, thank you for your ways that cause everyone except the wicked to rejoice. I long to be an encouragement to those around me, but it always starts with knowing you, following you, and doing the right thing. Thank you for your priceless gift of wisdom!

Build the City

Good people bless and build up their city,
but the wicked can destroy it with their words.
PROVERBS 11:11 NCV

When we follow the ways of God, the goodness of his wisdom is evident in the fruit of our lives.

We bless and do not harm. We build and do not break down. We love and do not hate. At least, that's the goal. None of us can perfectly keep that standard. We can, however, aspire to it because the Holy Spirit is in us, motivating us, checking our hearts, and welcoming our repentance. The more we prioritize our relationship with God, the more readily we change our ways to line up with his.

Our words matter. We know this. Scripture says it over and over again, and today's verse is no different. The words of the wicked can destroy a city. That's because they don't care about the people, they aren't looking to do the right thing by the people they lead. God's heart always extends out to others. When we consider others and not just our own interests, we build our communities for good.

Lord, purify my heart. Teach me your ways so I may live according to your truth. Create in me a clean heart so I may honor you.

Nice to Neighbors

It is foolish to belittle one's neighbor;
a sensible person keeps quiet.
PROVERBS 11:12 NLT

It takes discipline to not speak when it's obvious you're right! But delusions of righteousness are not the same as God's righteousness, and God, through Solomon, says it's foolishness to belittle a neighbor. Conflict with those in our neighborhoods or workplaces is inevitable. Just because you share office space or a street doesn't mean you have anything else in common. Still, that does not mean that we should make others feel bad when we disagree. Differences are inevitable, and they don't have to be points of contention.

Kindness and respect are always the way we are to treat others. Consider the people Jesus encountered in his ministry days. He didn't belittle or ignore their humanity. He met them in it. He offered understanding and compassion, and he offered them loving truth. May we endeavor to do the same.

Dear Lord Almighty, when I am tempted to tear someone down with my words, help me to remain quiet. I want to be full of your compassion. Help me practice self-control in this area!

June

In their hearts
humans plan their course,
but the Lord establishes
their steps.

Proverbs 16:9 niv

Secrets

A gossip betrays a confidence,
but a trustworthy person keeps a secret.
PROVERBS 11:13 NIV

Are you a trustworthy person? Do other people know they are safe to share with you? Our integrity before God ought to matter more than our social standing. When someone confides in you, they are trusting you with a piece of themselves. Other people's secrets are never to be used to advance our reputations with others. When someone shares something with us in confidence, let's be sure that confidence is well-kept. There are few exceptions to this rule, though one is when someone is in danger. In this case, we share it with the appropriate parties, not with everyone.

Trustworthy people keep the secrets of others safe. Gossiping is sharing information that is not ours to share to build rapport with others. Let's be careful to love, care for, and protect others who have placed their trust and fragile secrets in our hands.

You are a safe place for me, God, and I want to be a safe place for others. When I am tempted to use someone's information for personal gain, remind me how precious trust is and help me keep my mouth shut. I want to be a trustworthy person who truly cares about others.

Don't Walk Alone

Where there is no guidance the people fall,
But in an abundance of counselors there is victory.
PROVERBS 11:14 NASB

God gives us each other to help us stay accountable, to encourage and motivate us so we can keep learning and growing, and so we never need to go through life alone. It is important we surround ourselves with people we can trust; people who love God and who will spur us on in wisdom.

Attempting to go through life isolated, depending only on our personal strength, is not what we were made for. Even the strongest among us need the blessing and support of fellowship. We smooth each other out as our rough edges rub against one another. We can only do that in community. The best way to ensure health and our victory is by working together and leaning on each other. Community and fellowship are two of God's great gifts.

Wonderful Counselor, when the day feels heavy, remind me to ask for help. Sometimes I don't want to burden others with my problems, but then I remember we are one body and one family under you. Thank you for your help in this.

Cautious Pledges

Whoever puts up security for a stranger will surely suffer,
but whoever refuses to shake hands in pledge is safe.

PROVERBS 11:15 NIV

In ancient Biblical cultures, a pledge was considered a legal contract. A handshake was a firm commitment. Numbers 30:2 says, "When a man makes a vow to the Lord or takes an oath to obligate himself by a pledge, he must not break his word but must do everything he said." Jesus also had something to say on this matter in Matthew 5:37, "All you need to say is simply 'Yes' or 'No'; anything beyond this comes from the evil one."

Solomon warned us not to engage in deep commitment to a stranger. It is best to not form a binding agreement with someone we do not know or trust. This is different from giving a gift of generosity. It is wise to go into legal contracts with open eyes, not with a wish and a prayer. Remember that wisdom is for our good and protection!

Lord, help me discern between the commitments you have called me to make and those which will burden me unnecessarily.

Respect or Wealth

A kind woman gets respect,
but cruel men get only wealth.
PROVERBS 11:16 NCV

Today's promise reminds us that kindness trumps wealth. The fact that Solomon, one of the wealthiest men to ever live, said this is powerful. It would be better to give up the riches of the world than to forfeit kindness. A cruel man may gain power, but he does not garner respect. We should endeavor to live as women worthy of honor.

Money comes and goes, but respect only grows over time. Kindness builds and uplifts people. It is worthy of our intention. Kindness makes connections while wealth can make people fend for themselves. No matter what your financial status, kindness is always a worthwhile pursuit. Don't forsake it.

Dear God, thank you for the reminder that kindness is powerful and always a worthy pursuit. I choose to treat people with respect and compassion, not playing favorites or excluding others. Even more than I seek to build my assets, I choose to build my character. Your wisdom is life and direction for me.

Benefits of Kindness

Those who are kind benefit themselves,
but the cruel bring ruin on themselves.
PROVERBS 11:17 NIV

Most of us know this proverb at a personal level. We have experienced both cruel and kind people in our lives. It is more than an academic lesson to consider what we are like to others. It's a simple step to move from how we think about the behavior of others to considering how others think about us. A bit of introspection is a good thing; curiosity is the first step toward change. It's not the same as self-absorption.

The balance between accountability and too much inward focus is tenuous. If we venture too far, we hold ourselves to impossible standards that not even God wants for us. Perfectionism is not godliness. Even so, doing the work to align ourselves in God's wisdom, empowered by his grace, is a worthy effort. Choosing to be kind rather than cruel is a clear indicator that we take God's Word seriously.

Dear Jesus, thank you for the kindness of your love. Your example is my motivation to honor people and treat them well. You are so wonderful, and I want to be just like you!

Sow Righteousness

The wicked man does deceptive work,
But he who sows righteousness will have a sure reward.
PROVERBS 11:18 NKJV

Each moment of our lives is an opportunity to choose God. Jesus said, "For he who is not against us is on our side" in Mark 9:40. Throughout Scripture, there are people who sow righteousness for God, and there are all the others. Living for God is a purpose that requires thoughtfulness and diligence. God promises a reward to those who follow in his ways.

The greatest of all griefs is to be separated from God; the greatest of all rewards is to spend eternity with God. He is the source of all love, all joy, all peace, and all hope. We are blessed to know him surely more than we can even perceive on this earth. Are you living for God? Dearest daughter, God took you seriously when he created you. He loves you thoroughly. Take him seriously as you read his Word and consider your eternity.

Father, keep my path straight and my work edifying to you. You are worth my pursuit and my surrender. Your ways are life to me, and I choose to follow them.

Life or Death

Godly people find life;
evil people find death.
PROVERBS 11:19 NLT

Just as our choices help to define our futures, so our paths are set by the values we uphold in our lives. We cannot ignore our character development if we want to find the life of God's wisdom. We have to be willing and intentional about growing as we humble ourselves before God and choose to follow on the path of Jesus' love.

First John 2:17 states, "And this world is fading away, along with everything that people crave. But anyone who does what pleases God will live forever." Cravings are temporary, but the wisdom of God is eternal. When we live in a way that pleases God, we *will* find life. Simply chasing our cravings is a vain pursuit. As you go about your day, invite God to lead you in the smallest ways. He is ever so close to the heart that looks for him.

Dear Father God, increase the hunger in my heart to know you. You are wonderful, and your ways are true and trustworthy. I know that walking in your wisdom is the best thing for me.

Innocent Hearts

The LORD hates those with evil hearts
but is pleased with those who are innocent.
PROVERBS 11:20 NCV

God knows us even in the deepest recesses of our hearts. He understands our motivations, he knows what triggers us, and he knows our strengths and weaknesses. He understands as only a Maker could what we need to be fulfilled. Our only true satisfaction comes from the one who knew us from the beginning.

At no point does God abandon us. Throughout life, we are welcome in his presence. When we choose to walk away from our Lord, he grieves. We cannot walk in the ways of wickedness and remain close to him. He hates injustice. He hates violence. Look at Jesus and you will find the heart of God on display in human form. Pay attention to what he spoke against and what he upheld with his lifestyle. Remain in him, follow his ways, and you will be innocent.

Dear Lord, I know there is no allowance for wickedness in your kingdom. Help me to forsake all things that go against your heart. I want to dwell in the richness of your love, living it out with every step I take and every conversation I have.

Generational Righteousness

Be assured, the evil person will not go unpunished,
But the descendants of the righteous will be rescued.
PROVERBS 11:21 NASB

From generation to generation, God remains the same. God promised Noah in Genesis 9:12, "This is the sign of the covenant which I am making between Me and you and every living creature that is with you, for all future generations." Every time you see a rainbow, it is a reminder of God's covenant. His promise will not change.

Revelation 21 also holds a hopeful promise that we can cling to when the storms of this world knock us off our feet. God will one day dwell with his people, and they with him, in unhindered unity. There will be no more tears, pain, or sorrow. Every generation can hold onto this promise. It is for all of the righteous ones: all the ones who yield their lives to Christ and follow his ways.

Oh God, thank you for rescuing me. Thank you for the promise of eternal life in your presence where there will be no more suffering or pain. When life is painful, pour your present love over me and remind me of your living hope.

Gold on a Pig

Like a gold ring in a pig's snout
is a beautiful woman without discretion.
PROVERBS 11:22 ESV

The image in this verse is intentionally shocking. No matter how beautiful someone is, if they can't control their mouth, they cannot hide their true nature. On top of the unflattering image of dressing up a pig, we can learn more from the meanings of pigs within the Jewish context.

Pigs are in the unclean animal category. Within the Jewish community that means they are not to be eaten, nor their carcasses touched, as noted in Deuteronomy 14:8. Matthew 7:6 records Jesus as saying, "Do not throw your pearls before pigs, lest they trample them underfoot and turn to attack you." This conjures up some rich imagery. A woman without strong morals or discretion with her words can become a burden to all who know her. She will be avoided at all costs.

Lord, I know that my character matters more than my physical appearance. Help me to prioritize the beauty of my soul.

Wish for Good

Those who do right only wish for good,
but the wicked can expect to be defeated by God's anger.
PROVERBS 11:23 NCV

The Hebrew word 'ap is used to describe both human and godly anger, and it refers to nostrils. People in biblical times thought the feeling of anger originated in the nose. The Hebrew word for God's anger is *anap* which means "to breathe hard." You can see God's flaring nostrils in this imagery!

When we follow Christ and do good, we have no reason to fear God's anger. We live with his love as our guiding light and our source. We choose to incorporate his wisdom in our relationships, our work, and our inner lives. We take our thoughts captive and humble our hearts before the Lord. When God's nostrils flare, we know that it is not directed at us.

Lord, transform the longings of my heart to reflect what is pleasing and good to you. I don't have to live with the threat of doom when I live in the light of your love.

One Who Scatters

There is one who scatters, and yet increases all the more,
and there is one who withholds what is justly due,
and yet it results only in poverty.

PROVERBS 11:24 NASB

The principle of generosity is woven throughout Scriptures. Jesus says in Matthew 10:8, "Freely you received, freely give." Scattering our possessions, food, time, and other resources to people around us is unbelievably freeing. God knew what he was doing when he instructed us to do so.

True generosity starts in our hearts. Matthew 6:21 tells us, "For where your treasure is, there your heart will be also." If our treasure is in God, then we value him above all else. We heed his wisdom, and we spend time in his presence. The more we behold what he is like, the more we become like him. This leads to giving freely, as we have so freely received from God's grace. There are endless resources in the kingdom of our God, so let's not hold back our generosity from others.

Jesus, I want to grow in generosity. I know this won't happen by accident. Move my heart so that it becomes an impulse that I follow. Even when it feels like sacrifice, help me to do it. The more I do, I know the more natural it will become. Thank you for being so generous with me!

Gratefulness and Generosity

The generous soul will be made rich,
And he who waters will also be watered himself.
PROVERBS 11:25 NKJV

When we give what we have, we acknowledge that we've been blessed enough to share with others. If we don't have much and still share, we acknowledge that we trust God to fulfill our needs. The most generous people are the most grateful. Realizing what God has given us and developing a spirit of gratefulness leads to generosity.

When we are thankful for what God has shared with us, we will want to share with others. It reflects our gratitude. What's more, when we give, more will be given back to us. We can't out-give God, and our heavenly Father promises to take care of us. This principle applies to areas outside of our finances too. Rest assured; he waters those who water others.

Lord God, help me to grow in gratitude. I know it begins with practice, and I choose to do that today! Thank you for opportunities to be generous with what you've given me.

Access for All

People curse those who keep all the grain,
but they bless the one who is willing to sell it.
PROVERBS 11:26 NCV

Hoarding resources while others go without is not the way of God. If we claim to follow God, we should act like him. When people are in need and we are able to help, we should not hesitate to do it. Reaching out, sharing what we have, and offering to sell our abundance at a reasonable price are all ways that we can reflect God's heart.

God is not stingy. Neither should we be. God is outrageously generous. Hoarding resources is not the same as preparing for a rainy day. Keeping all the grain is a much different picture than storing sufficient grain. Making sure others have access to needed resources is as important an act of wisdom as preparing for the future. Rely on the Holy Spirit, who will guide you in both self-restraint and generosity.

Generous One, I'm so grateful that you are not stingy with your resources. I want to reflect your wisdom and your generosity in my choices. Help me today.

Seek Favor

Whoever diligently seeks good seeks favor,
but evil comes to him who searches for it.
PROVERBS 11:27 ESV

We will find what we are looking for when we search with all our hearts. Jeremiah 29:13 promises that if God is the one we seek this way, we will find him. Today's proverb reminds us that the one who searches for evil will also find that.

It is wise to do an inventory of our hearts from time to time. Checking in with our motivations can open our eyes to what we are going after. If we find that we are tasting fruit that is bitter in our lives, perhaps it is time to look at what we give our time and attention to. Diligence is rewarded, and habits are built over time. If you diligently seek the wisdom of God, adopting his ways into your life, you will find favor. Take some time today to evaluate what you are searching for, and if the search is worth the effort.

Lord, show me the areas where I need to grow, and the places I need to focus in. I don't want to blindly go through my days and wake up one day to find myself somewhere I didn't intend to go. Help me be diligent in wisdom.

A Green Leaf

Those who trust in riches will be ruined,
but a good person will be healthy like a green leaf.
PROVERBS 11:28 NCV

*W*ho and what we trust informs the decisions we make. If we trust only in our own strength, when tragedy strikes, our hearts will be devastated. When our confidence is in our own abilities, as we reach their limits, we will find ourselves at a loss. We cannot put our trust in money. Economies change, job losses happen, and other influences can change our situations in just a moment.

When our confidence is rooted in the faithfulness of God, it doesn't matter what circumstances we find ourselves in. We will rise up like flowers in the springtime, like green leaves after a long winter. Put your trust in God, for he is good, and he is trustworthy. His life will infuse yours with strength!

Lord, you are trustworthy and good. I don't want to put my confidence in anything else over you. Thank you for sustaining me in every season.

Lasting Effects

Whoever brings trouble to his family
will be left with nothing but the wind.
A fool will be a servant to the wise.

PROVERBS 11:29 NCV

Bad decisions compound on each other, and the same is true of good decisions. God's guiding hand will steer us when we can't discern between the two. We have simply to trust him. He sees what we cannot. He knows what is best. The wonderful thing is that God can meet us wherever we are and lead us from that place.

Giving God authority over your life will bring the blessing of wisdom, which will not only bless you, but also those closest to you. Foolish behavior is refusing to learn from one's mistakes; it stays stuck in cycles of destruction. Wisdom is full of growth. When we mess up, wisdom helps us to make different choices in the future. Whether we choose wisdom or foolishness, the effects will spill into the lives of those around us. Let's choose to grow in wisdom for everyone's sake.

Spirit, I don't want to stay stuck in foolish cycles in my life. Help me grow in wisdom and change what I know needs to. Thank you for your grace that helps me change for my own good and for the good of my loved ones.

Lifegiving Fruit

The fruit of the righteous is a tree of life,
And one who is wise gains souls.
PROVERBS 11:30 NASB

The righteous love God and reveal it by how they live their lives. Every movement of mercy matters. Every act of surrender and sacrifice in the name of love is momentous. When we love God, we walk in his ways. We look like Jesus. Ephesians 2:10 tells us that "We are His workmanship, created in Christ Jesus for good works, which God prepared beforehand that we would walk in them." The fruit we bear when yielded to Jesus is a tree of life. May we be wise by walking in the Spirit and willing to gain souls by telling the good news of God's love.

True wisdom comes from God, and the only way we can know wisdom is to know God. We will bear the fruit of the tree of life by seeking his face and spending time with him. The only way to do that is to read the Word and pray to the living God. He is our righteousness and our all-in-all.

Lord, keep me on the narrow path of your love so I may bear fruit that displays your life at work in me.

God's Blessings

If the righteous is repaid on earth,
how much more the wicked and the sinner!
PROVERBS 11:31 ESV

If a believer is eternally minded, it changes their perspective so dramatically that others can see the difference. They care more about souls than houses or cars. They love people more than possessions or politics. They seek life-altering attitudes rather than feel-good times or momentary pleasures. This can't be hidden; the Light of the World shines brightly everywhere the Holy Spirit dwells.

Believers are not looking for instant gratification. Yes, it helps to collect a paycheck and have enough to maintain life and to bless others, but overall, God is what truly matters. Graciously, God often blesses us far beyond our hopes and dreams. When we experience the abundant blessing of God in our lives, it brings a rush of love and gratitude that fills our hearts. We serve such an amazing father.

Thank you, loving Father, for giving me so much now. I serve you openly and willingly in this lifetime. You are the bread of life and my true delight.

Loving Discipline

To learn, you must love discipline;
it is stupid to hate correction.
PROVERBS 12:1 NLT

It is important to know what God's discipline is like. If you have suffered abuse, it may be hard to decipher between what you picture when the term *discipline* is used and what Scripture means when talking about God's discipline. Romans 2:4 poses it this way, "Don't you see how wonderfully kind, tolerant, and patient God is with you; can't you see that his kindness is intended to turn you from your sin?"

God does not demean his children. He does not ridicule or shame them. He will never put you in your place out of spite. His heart for you is love. His way is kindness, patience, and gentleness. The fruit of the Spirit *is* the way of God. Correction builds you up and pulls you closer in connection to his heart. You learn to love God's correction when you realize how wonderful it is.

Lord my God, thank you for your correction when my behavior and attitude are out of line with your heart. Thank you for discipline that is full of kindness. Show me what you are like in love, Lord, even as you correct me.

Be Good

The LORD approves of those who are good,
but he condemns those who plan wickedness.
PROVERBS 12:2 NLT

When we walk in the ways of God's wisdom, making good choices and being a good person becomes more natural. It is an active walk. Seeking God is not a passive thing. It is an active choice. What habits do you have in place to help you grow in wisdom? Do you spend time in the Word? Do you have a practice of prayer? How about gratitude? There are many ways to seek God actively, and you can try many different forms. They all count.

Wisdom is won with foresight. It is not accidental. Don't leave knowing God or growing in wisdom to chance. Just as in all areas of life, you grow stronger in areas where you put the work. Every small step matters. Focus on today and do three things to bring the awareness of God into your routine.

Lord Jesus, thank you for your presence in my life. You are a close friend and a reliable help. I invite you into my day, even if that means you redirect it.

Deep Roots

Wickedness never brings stability,
but the godly have deep roots.
PROVERBS 12:3 NLT

First Peter 1:23 tells believers that we "have been born again, but not to a life that will quickly end. Your new life will last forever because it come from the eternal, living word of God." The Word of God is alive just like a seed is alive. It is perishable but enduring. That enduring quality means roots will grow. Give that seed water and sunlight, and it does grow. The roots sink deeply into the soul and send up shoots and fruits. We simply need to stay attentive to nurture it.

Jesus said that "Anyone who hears my teaching and doesn't obey it is foolish, like a person who builds a house on sand" (Matthew 7:26). Without a foundation, without roots in the ground, it will wash away when a storm comes through. There is no stability in that! We must, then, put God's wisdom into practice in our lives. That is how deep roots are formed. When storms come, we will not be moved.

Dear Lord, your Word is sweet and the seed obvious in my life. Thank you for the power of your wisdom that builds a firm foundation as I incorporate it into my life.

Be a Blessing

An excellent wife is the crown of her husband,
but she who brings shame is like rottenness in his bones.
PROVERBS 12:4 ESV

The Bible gives us many examples of how our behavior impacts others. When we act excellently, others are built up by it and blessed. When we act shamefully, others are negatively impacted. It can harm our relationships and break trust. This is true in marriages, but it is also true in friendships, parent-child relationships, in the workplace, and anywhere else we associate with others.

The simple question, "How can I be a blessing to this person?" can be a powerful tool in making us more aware of our impact on others. Instead of worrying about the possible negative effects of actions not yet taken, let's flip that and think of ways we can add value and blessing to the lives of those we love and interact with.

Father, thank you for the people in my life. I want to be a blessing to them. Show me ways I can build them up. Keep me close to your heart and reveal more of yourself as I do.

Plan With Godliness

The plans of the godly are just;
the advice of the wicked is treacherous.
PROVERBS 12:5 NLT

Before making plans, we show wisdom when we pray about it first. A prayerful heart is a considerate and wise one. Matthew 6:33 says, "Seek first the Kingdom of God above all else, and live righteously, and he will give you everything you need." When we pray, our hearts align with God's heart. When we humble ourselves before him, we become vessels for his will to be done, and our desires become his desires. This leads to greater satisfaction than we could attain living only by our own design.

When those who have rejected God give advice, they only have themselves to rely upon. They are not tapping into the wisdom of the ages, nor do they have the Spirit of the living God giving direction. It's not as dependable information or advice. It can be dangerous to follow the words of people who do not have solid character. Sink deeply into the Word, pray diligently, and listen to the Holy Spirit when you plan.

Father, thank you for your direction and wisdom. I am grateful I can depend on you in every detail of my life from little things to life-changing plans.

Serious Wisdom

The words of the wicked are like a murderous ambush,
but the words of the godly save lives.
PROVERBS 12:6 NLT

Christians are not to be passive in the advice they receive. Don't just take words, especially divisive ones, at face value. The most important decision Christians can make when listening to the advice of others is to prayerfully discern the heart of the speaker. Sometimes it's difficult to weed out wisdom from noise. Thankfully, we know the fruit of God's wisdom. When advice is laced with fear, a rush to conclusions, and encouragement to not test it out, these are red flags to look out for. God's wisdom does not use fear tactics or haste. It is marked by peace, clarity, and trust in the Father.

It is also wise to consider the source. Do you know the fruit of this person's life? How do they treat people? Do they have long-standing relationships with trusted people who vouch for them? It is important to not ignore the experiences of the people around them. The wisdom of God's Word stands. The words of the godly are life-giving. The words of the wicked harm others. Remember that, and it will help you.

Lord, give me discernment. Thank you that your wisdom doesn't breed fear; it liberates in its kind directives. I trust you!

Godly Family

The wicked die and disappear,
but the family of the godly stands firm.
PROVERBS 12:7 NLT

The family of God often includes blood-related family, but God calls all who follow him his children. We are brothers and sisters, and that means more than blood. Jesus declared in Matthew 12:50, "Anyone who does the will of my Father in heaven is my brother and sister and mother." These are close, important relationships. John later says in 1 John 2:9, "If anyone claims, 'I am living in the light,' but hates a fellow believer, that person is still living in darkness."

We need to take our relationships with other believers seriously. If we hate another believer, John says we're living in darkness. We cannot harbor hate and live in the fullness of God's love. We remain clouded by the intensity of our distaste, and that is not what God calls his children to. He wants us to live in the light as he is in the light. He wants us to be free in the expanse of his love. When we need help forgiving others and putting on love, let's lean on God. He is the source of it, after all.

Dear God, help me to clothe myself in your love every day. Wisdom walks in the light of your love, and that's where I want to be found. Help me to let go of any bitterness or hatred I might still have hidden in my heart.

Sensibility Wins Admiration

A sensible person wins admiration,
but a warped mind is despised.

PROVERBS 12:8 NLT

Solomon was known far and wide for his wisdom. The queen of Sheba even came to visit him, curious as to whether he could live up to his reputation. She tested him with riddles and was impressed by his answers. Wisdom is not out of touch with reality. It can be applied to any and every area of life, including every level of society.

Wisdom is no good to us if it is not practical. God's wisdom is not a mysterious cloud we cannot pin down. It is important that we don't over spiritualize our language and lose touch with wisdom that touches reality. God's wisdom is as practical as it is profound. Just as Solomon's sensibility won him the admiration of royalty, the guiding principles of God's wisdom can do the same for us.

Father, thank you for your powerful wisdom that applies to every area of life. Your principles and values guide me in my decisions and in my interactions. Thank you for the generosity and clarity of your wisdom that you reveal to those who seek you.

Embrace Your Life

Better to be an ordinary person with a servant
than to be self-important but have no food.
PROVERBS 12:9 NLT

There is beauty in simplicity, and there is certainly nothing wrong with an ordinary life. God is glorified in our surrendered lives, no matter what job we have. When we live authentically and do our work well, God is glorified. There's no need to pretend to be someone we are not. We don't have to strive for greatness at all. We can live simple, humble lives that radiate the peace, love, joy, and beauty of God.

Pride keeps us from admitting need when we have it. That arrogance can lead to downfall. In the extremity of today's verse, it can lead to starvation. Let's be real about where we are at, embracing our lives as they are. If that means humbling ourselves and asking for help, then we should do just that.

Lord, help me to embrace the simple and ordinary parts of my life. I don't want to live in pretense or denial. I want to enjoy what I have and live with your peace. Help me be real with those around me, to unashamedly be me.

Care for Animals

The godly care for their animals,
but the wicked are always cruel.
PROVERBS 12:10 NLT

A person's character is not only seen in how they treat people, but also the creatures in their care. It is wise to be wary of those who mistreat their animals. This reveals underlying cruelness that will someday spill out to the people in their lives. They cannot hide their character for long. We are wise to not overlook the little things.

A godly person doesn't just take care of the people in their lives, they also take care of their animals. Kindness is not only a trait to offer people, but any and every living thing we are responsible for.

Father, thank you for the creatures in my life. Whether I see birds, woodland creatures, or wildlife out my window, or I have pets or livestock on my property, help me care for them properly. I want to honor you by the way I treat them.

Rewards of Hard Work

A hard worker has plenty of food,
but a person who chases fantasies has no sense.
PROVERBS 12:11 NLT

There are many benefits to being a hard worker. In this verse, Solomon contrasts a hard worker to someone who chases fantasies. A hard worker doesn't avoid what is theirs to do. They do it well and consistently. Abundance and sufficiency are directly related to how hard a person is willing to work.

Fantasy-chasers live in the clouds. They don't put the consistent effort into making their dreams actually become a reality. Daydreaming slows work. There's no forward movement or income earned when people spend their time thinking and not putting those thoughts into actions. Paul put this principle into a personal perspective in 1 Corinthians 15:10, "But whatever I am now, it is all because God poured out his special favor on me—and not without results. For I have worked harder than any of the other apostles; yet it was not I but God who was working through me by his grace." Hard work is always rewarded.

Father, teach me the difference between hard work and doing too much. I want to consistently do what is mine and follow through on my responsibilities, but I don't want to never relax and enjoy my life. Show me the way your wisdom that allows for both.

July

A gentle answer deflects anger,
but harsh words make
tempers flare.

PROVERBS 15:1 NLT

Be Well Rooted

Thieves are jealous of each other's loot,
but the godly are well rooted and bear their own fruit.
PROVERBS 12:12 NLT

There's a lot to be said for being content in the Lord. When we get rid of the need to compare our lives with others, we grow in gratitude for what is ours. When we are grateful for what we have, we utilize it well. We become well rooted and bear fruit by tending to our own gardens.

Jealousy is a trap. It does nothing for our good. When we fix our eyes on God and what he has put in front of us, we keep the weeds of bitterness at bay. We all have gifts in our lives. It is always best to work with what we have, and to give thanks for it. The more we grow in wisdom, the more our lives will yield good fruit. We can be happy for others and what they have been given, celebrating their victories. We can share in their grief when they experience loss, too. We only have this one short life. Let's not waste it by being preoccupied or envious of others. There's too much goodness in our own lives we'll miss out on if we do.

Lord, teach me to be present with what I have available to me today, and help me cultivate what is already mine. I want to be well rooted and bear fruit, not distracted by what others have.

Escape a Trap

The wicked are trapped by their own words,
but the godly escape such trouble.
PROVERBS 12:13 NLT

How quickly we can get ourselves into hot water with our words! If we're quick to talk, we're not quick to listen. According to James 1:19, that's to our detriment, "Be quick to listen, slow to speak." And James doesn't stop there. In verses 22 and 25 he says, "Don't just listen to God's word. You must do what it says. Otherwise, you are only fooling yourselves. But if you look carefully into the perfect law that sets you free, and if you do what it says and don't forget what you heard, then God will bless you for doing it."

As we remain surrendered to God through prayer and reading his Word, it influences how we think. God's wisdom instructs our ways. We take the time to listen more because we know that is wisdom at work. This can keep us from falling into a trap of our own making.

Lord, I am still learning to listen more and talk less. Help me to be more intentional about that today. Spirit, I start right now by listening to you.

Wise Words

Wise words bring many benefits,
and hard work brings rewards.
PROVERBS 12:14 NLT

Since wisdom comes from God alone, we become wise by getting to know him through his Word and through fellowship with his Spirit. Just as a parent teaches their child what is right and wrong through relationship, so God does the same with us. There are many benefits to wise words. They instruct, encourage, and clarify. Wisdom does not leave us confused, so the wisdom we share also should be clear.

When we speak wise words, we share the wisdom God has given us with others. It's amazing that God's comfort and understanding can spread through us to others. Think about a time when a wise word from a friend set you straight, made you feel known, and encouraged you all at the same time. That kind of wisdom is heaven-sent.

Lord, thank you for the power of your wise words. I want to speak with clarity and kindness, just like you. May I speak words of encouragement today that bring people closer to you.

Gift of Advice

The way of fools seems right to them,
but the wise listen to advice.

PROVERBS 12:15 NIV

Pride can impede our ability to learn and grow. We should care more about learning the truth than self-image. With humility, we can take constructive criticism and weigh its wisdom in our lives. When others correct us or offer us advice, we can see it as a gift and an opportunity rather than an affront to our character. We always have more to learn, but only the humble will put the work in to change. Instead of being so insistent on our way that we refuse to listen to input from others, let's make a deliberate choice to remain approachable, teachable, and humble.

Ask for help when you need it. When someone disagrees with you, listen to what they are saying and consider their point of view. Put your pride aside and embrace learning. God designed us to support and sharpen each other.

Please help me stay humble, Father God. When I am given the gift of advice, give me ears to hear and a heart to receive. Although it's sometimes hard to put my pride aside, I want to continue to learn and grow.

Calm in the Storm

A fool is quick-tempered,
but a wise person stays calm when insulted.
PROVERBS 12:16 NLT

When we refuse to take offense when insulted, the strength of our character is revealed. It takes wisdom to shrug off insults. But oh how much better off we are for it! When we are easily offended, it could be an indicator that we have some insecurities that need to be dealt with. This isn't to say that we will never feel the sting of an insult. It just means that we choose not to carry it with us or to hold on to it for long. Forgiveness is both good for us and for the people we extend it to.

Try this today: choose calmness when someone throws a reckless word your way. Maybe you have a child in your life. If that's the case, this may be a practice you can do often. In any case, choose to not let bitterness grow in your heart by stopping it at the source. Refuse to take offense by realizing that angry words are less about you and more about the person spewing them.

Lord, help me to see others through eyes of compassion and curiosity today. Help me stay calm when others aren't. I release my hurt to you and leave it there.

Honest Witness

An honest witness tells the truth;
a false witness tells lies.
PROVERBS 12:17 NIV

Truth tellers are people who can be counted on. They are honest, telling the truth even when it is uncomfortable. They don't only tell stories that benefit themselves or impress others. They are people of integrity who answer honestly. There is no spin, no matter who their audience is.

We all know at least one person whose word cannot be trusted. They are habitual liars. You don't know whether to believe what they are saying at any given moment. The hard part about that is that there is probably some honesty sprinkled in with lies. You can't decipher between the two. When we choose to adopt honesty as a core value, we leave the messiness of lying behind. If we want to be trustworthy people, we have to have a high standard for the truth. Otherwise, people will not know when to believe what we say. God's wisdom is found in bearing an honest witness. The Spirit helps us grow, and as we are growing, to be honest even about when we mess up by admitting when we are wrong.

God of truth, strengthen me in your living Word. I want to be someone whose word can be counted on to be honest.

Words Can Heal

Some people make cutting remarks,
but the words of the wise bring healing.
PROVERBS 12:18 NLT

If our hearts are not aligned with God, it will be revealed by the words that come out of our mouths. People who aren't checking their hearts with the Word might as well give up watching their tongues. The condition of our hearts is revealed in the way we speak, how we go about our business, and the attitudes we show to others.

When God says the Word became flesh in John 1:14, we start to see how important words are. God chose words as the vehicle for his truth and salvation. Our words are not living; only his have that power. They do, however, have an effect on the people around us. God can speak through us to bring others to the kingdom. He can also use our words to bring wisdom, his perspective, and healing to the people in our lives. Words have the power of life or death, so we should be intentional about what kinds of words we speak, and even more, the attitudes of our hearts toward others.

Lord Jesus, speak through me. Soften my heart and use my words to bring healing to a hurting world. I am your vessel.

Truth Doesn't Need to Hide

Truthful words stand the test of time,
but lies are soon exposed.
PROVERBS 12:19 NLT

Shakespeare famously had a way with words. In *The Merchant of Venice*, the character Lancelot famously said in Act 2, Scene 2, "The truth will out." That is what today's verse said fifteen hundred years before Shakespeare did. Solomon also added that truthful words will stand the test of time.

There is no need to hide the truth, for it stands on its own. At the same time, you can be sure that no lie will stay hidden forever. This is really good news for any of us who have endured slander. The truth is liberating, and God will always defend the innocent and make what is right clear. You can trust him to do this for you. Stand in the light of his confident love, for he will not forsake you.

Lord, thank you for the truth of your Word that stands the test of time. When lies are hard to decipher in this world, I stand upon you and trust your wisdom to reveal what is right in the end.

Plan Peace

Deceit fills hearts that are plotting evil;
joy fills hearts that are planning peace!

PROVERBS 12:20 NLT

It's a chicken-or-egg situation when we consider our hearts versus what we plan. Does the condition of the heart come first, or do we start planning and that determines the path our hearts take? Both are true. The condition of our hearts feeds the things we plan which feed the condition of our hearts. We are synergistic creations, and the Lord intended that from the beginning.

Sometimes we don't feel like doing something, but we know that doing it can set our desire into motion. We realign ourselves with God when we plan peaceful endeavors with positive results. The more we pursue God and his wisdom, the more we readily make wise decisions and are spurred to pursue him with even more passion. What joy there is in his presence!

Purify my heart, Lord. When I get distracted or sidelined, remind me to make peace my priority and plan accordingly. I want to be a pursuer of peace for you and your kingdom.

Eternal Perspective

No harm comes to the godly,
but the wicked have their fill of trouble.
PROVERBS 12:21 NLT

This life is not the full picture of Scripture. It records and prophesies through generations and into eternity. So much of what Solomon discusses is in the realm of what is yet to come. The biblical principles remain true, regardless. When we have our focus on everlasting life and not just the temporal life, our perspective shifts. Verses like today's start to make sense, and they unleash greater hope and deeper joy.

We can, and likely will, experience hardship and harm in this lifetime. We may be misunderstood and mistreated. No matter what losses we endure in this life, including our very lives, we have a firm foothold in heaven. We know where we're going. The glorious eternal kingdom of our Savior is waiting for us, and it is far better than anything we can imagine. Until then, our Prince of Peace is present with us by his Spirit. What a glorious hope we have!

Dearest Lord, help me keep my perspective firmly rooted in your kingdom where I will sing praises and serve you forever. Thank you for your creation, but above all, I'm thankful for you.

God's Delight

Lying lips are detestable to the LORD,
but faithful people are his delight.
PROVERBS 12:22 CSB

We cannot escape the trap we lay when we spin webs of deceit. When we keep our promises, faithfully following through on our word, we move freely into the future. Honesty is the way of confidence in the wisdom of God. Lifestyles of reliability reflect the faithfulness of our God.

God delights when we live out his ways. He is filled with joy when we reveal what he is like through our habits. It's not always easy to tell the truth. It can cost us our comfort at the very least. But that doesn't mean it isn't worth it. When we promise to do something and fail to follow through, we break the trust of those relying on us. The simple, wise thing to do is to do the work: to be consistent and faithful. This also requires being selective with our promises. Thankfully, the Spirit helps us grow in this wisdom. We can only start where we are and be mindful going forward.

God, I want to be a person of my word. Help me to be discerning about what I promise to do and give me strength and self-control to follow through on what I vow to do.

No Show Needed

The wise don't make a show of their knowledge,
but fools broadcast their foolishness.

PROVERBS 12:23 NLT

At some point in our lives, we start to realize we might not be as smart as we once thought. It's not that we know nothing, but the fact that we know so little. There is so much knowledge and wisdom that we have not yet grasped. We are limited in our perspectives, and this is so important to admit. It is the humble heart that can see where there is room to grow in understanding. Doors open to those who are willing to keep learning from others.

The wisest among us have no need to tout their knowledge. They feel no need to impress others by making a show of their wisdom. They don't use their knowledge as a weapon. Truly wise people know that they do not know everything, and this is to their glory. May we choose the humble path rather than making sure everyone knows our opinions about various topics.

Jesus, thank you for the humility that accompanies your wisdom. I choose to follow your path. Keep me from being wowed by those who put their opinions above everyone else's. I know that I can trust your truth, and that it is often quiet in a loud world.

Diligence

Diligent hands will rule,
but laziness ends in forced labor.
PROVERBS 12:24 NIV

The Bible tells many stories of diligent, prayerful people who were lifted from humble places into roles of leadership. Think of David, Joseph, Gideon, and Mary. There are also examples of people who failed to use their gifts or positions of power faithfully, and they were brought to ruin. Saul, Samson, Herod, and the lazy servant in Matthew 25 are a few examples.

If we spend all our effort and time chasing self-indulgence, God will take what he has trusted us with and give the responsibility to someone else. We will end up working harder, chasing our tails, and getting nowhere. We do not know what our futures will bring, but we do have the wisdom of God to help us walk a path of success. This looks like integrity, hard work, and a nurturing a humble heart before God. Work is an opportunity to worship God with our actions. We get to partner with what he's doing in the world by adopting his nature in our own lives. No work is menial in the kingdom of God; it all serves a purpose. Let's remember that and do it for God, even as we put our hands to our tasks today.

I delight in the work you have given me today, dear God. May my actions and efforts bring you honor.

Cheerful Words

Anxiety in a person's heart weighs it down,
but a good word cheers it up.
PROVERBS 12:25 CSB

Have you ever seen someone who looked so despondent, you wanted to say something to encourage them? Sometimes a little compassion can go a long way. It may not fix the problem, but simply mentioning, "I really appreciated what you said the other day," or "That color looks really nice on you," may help them smile and add a little cheer.

Perhaps there is a lot of weight on them and reminding them of simple truths could make a difference: truths like, "If you need anything, just let me know. We are one family in Christ," or "If you're feeling all alone right now, remember how much God cares about you. He's always nearby." Some days are more difficult than others. When we notice each other, it reminds us that we're not alone in it. God has given us each other so we can pray for one another and offer cheerful words of encouragement.

Lord, I want to be a vessel of encouragement. Thank you for the support I have found in you and in the men and women in my life. Show me what encouragement I can offer to others today.

Give Good Advice

The godly give good advice to their friends;
the wicked lead them astray.

PROVERBS 12:26 NLT

What a responsibility it is to be consulted for advice, and as believers, we need to weigh our words well. We do well when we offer encouragement that points people to God and what he is like. Advice is just that; it is not a directive, and we cannot take full responsibility for others' actions. We do our best to offer sensible perspectives when asked. It is important, even when giving advice, to acknowledge our limitations.

Good advice reveals considerations that the asker may not have taken into account. It does not shy away from the truth. It comes from a place of love for the person, putting ourselves in their place for a moment. If nothing else, it should direct the person toward the loving embrace of their Father in heaven who wants what is best for them.

Lord, I don't want to confuse my opinion with your truth. Help me to consider your wisdom when asked for advice. Thank you for your Spirit that helps in all things.

Use Everything

Lazy people don't even cook the game they catch,
but the diligent make use of everything they find.
PROVERBS 12:27 NLT

Laziness keeps people from following through on their commitments and intentions. In today's verse, we are offered the example of people going through the work of hunting an animal, but it goes to waste because they don't dress it. The diligent don't just use the important parts of an animal, but they find a use for everything they find.

Some cultures wisely use most parts of a kill for something useful for their survival. Native people around the globe use all parts and pieces. They use the outside of an animal for things like leather for clothing and bowls, and the inside, like tendons and sinews, as thread and bowstrings. Nothing is wasted, and every bit is considered a precious resource. That level of diligence is what the Lord is asking of us. You will miss out on blessings when you are too lazy to put in the work to find them.

Lord, I know you reward the diligent. I don't want to be someone who starts things and then never follows through on them. Help me to stay focused on the task at hand and follow through on my commitments.

Leads to Life

The way of the godly leads to life;
that path does not lead to death.

PROVERBS 12:28 NLT

*E*very day is a blessing. Even the hardest days have hidden moments of beauty. There is life, even in the dark valleys of grief. As we follow the leadership of God, especially when we cannot see beyond the next right step, we trust him to sow the seeds of his goodness along the path. As we look back from the clearer vantage of the future, we will see that as we continued to trust the Lord in our pain and suffering, there were treasures along the path: treasures hidden in darkness (Isaiah 45:3).

The path of wisdom is the path that leads to life. This does not mean that it is easy or obvious. We have to lean on the Lord, especially when the storms of life come rushing in. We cannot rely on our own senses then. We have to cling to the Lord and trust that he will not let us go—not ever! He will give us direction and clarity. When things are overwhelming and unclear, Christ is the answer.

Dear God, I know that the path that leads to life is not easy, but I choose your way regardless. You are better than the ways of this world. Your love is my sustenance and strength!

A Parent's Discipline

A wise child accepts a parent's discipline;
a mocker refuses to listen to correction.
PROVERBS 13:1 NLT

Learning from our heavenly Father is the height of wisdom. Solomon knew God was his Father; he wasn't only speaking of human parents and children here. Proverbs 3:11-12 tells us everyone God loves is disciplined, and we're not to hate it or get tired of it. Discipline affirms we are God's children! His correction is always kind and clear.

King David is a great example to look at. He was loved by God, but he still messed up (many times over!). His reaction to God's discipline is a good lesson for us. In Psalm 38, he doesn't want to be disciplined, but he accepts it. Sometimes discipline is simply allowing natural consequences to play out. That seems to be the case here. When we are overwhelmed by suffering, it can feel like God has abandoned us. But he has not. He comes in close and brings relief, though we cannot escape the consequences of our harmful actions, God will help us repair, rebuild, and move on in his grace, just as he did with David.

Dear Lord, when the consequences of my actions come knocking on the door of my life, help me remember that it is an opportunity to humble myself, learn from my mistakes, and lean into the grace of your wisdom.

Guard the Mouth

Whoever guards his mouth preserves his life;
he who opens wide his lips comes to ruin.

PROVERBS 13:3 ESV

One of the primary lessons of godly wisdom we can adopt into our lives is to be quiet and listen. So much is gained if we wait to speak because there are many people we can learn from. Wisdom isn't just a quick dose of spirituality or a pat answer thrown over wounds like a band-aid. We don't understand God or his wisdom if we assume we are wise just because we are believers. Wisdom takes time and energy to acquire. Just as learning any subject or trade takes years of studying and practice, so does wisdom.

This should encourage us! It is a life-long pursuit. We grow in wisdom over time with concerted effort. We don't expect four-year-olds to be able to do algebra. We start with the building blocks of math. One of the building blocks of wisdom is to listen more than we talk. Even a four-year-old can practice being quiet.

Father God, thank you that I am on a journey of wisdom, not expected to know what I don't know. I put into practice what you are teaching me, knowing that will help me grow. I will choose to listen more today.

Lovers of Truth

The righteous hate what is false, but the wicked
make themselves a stench and bring shame on themselves.
PROVERBS 13:5 NIV

When we hunger and thirst for righteousness, Jesus says in Matthew 5:6 that he will fill us up. When we seek God and his goodness, we will have eternal satisfaction. When we refuse to compromise in our lives by covering lies, we live in the light of truth. It is good to love truth, both the truth of God's Word and living honestly before others.

We don't need to hide or do mental gymnastics in our relationships if we live by the truth. If we are honest with ourselves and others, we are not afraid to be found out. Liars are eventually found out. They break the trust of those who believed them. It is hard to rebuild trust from that place. It takes time, diligence, and an incredible amount of repair. We save ourselves from this shame when we commit to living honest and open lives.

Father, I'm so grateful that your truth sets people free. I know I feel more liberated when I have nothing to hide. Keep me on the path of your wisdom, where is the confident way. Help me be honest even when it is hard.

No Need to Pretend

Some people pretend to be rich but really have nothing.
Others pretend to be poor but really are wealthy.
PROVERBS 13:7 NCV

It is always best to be who you are. Pretending to be something you are not will hurt you in the end. Rich relationships are built on the foundation of honesty and trust. You cannot truly be known or accepted if you are pretending to be something else entirely. Phoniness leads to loneliness.

There's nothing more freeing or refreshing than living a transparent life. It's lovely to live with complete honesty, never needing to make excuses or worry how others perceive us. Honest living gives us time to focus on the needs of others. We can have long conversations or take meals to the sick and overwhelmed. When we live with eternity as our focus, all we are and have become resources for God's kingdom. It's a wonderful life when we know he has everything under control.

Lord, I know living an honest life begins with accepting you into the reality of my life. I don't want to pretend or keep people or you at a distance. Meet me here and help me live honestly and openly before you.

The Ransom

The ransom of a man's life is his wealth,
but a poor man hears no threat.
PROVERBS 13:8 ESV

When we own a lot of stuff, it may begin to feel as if it owns us. Cleaning and maintenance take up time and money. We need to spend time maintaining it, or it will depreciate or collect dust. Though it is not wrong to appreciate our belongings, it is detrimental when we are limited in other areas because of them. If we don't have time and energy to invest in our relationships, we have some reevaluating to do. Relationships are a gift and a blessing; they offer what stuff cannot. We were made for fellowship, not for living isolated and surrounded by empty objects.

Beyond the essentials of life, we need to sincerely evaluate what is a blessing and what is a burden. Where we are pulled away from what we truly want, where we are overwhelmed by the demands of our stuff that doesn't allow us to engage in important and meaningful ways in our communities, where we are held captive by the demands of others because of what we own, these are areas where perhaps we need to let go to make space for better things.

Lord, my God, I want to live a life of balance and beauty. Thank you for providing for my needs. Help me let go of things that don't serve me, my family, or your purposes well.

Light and Joy

The life of the godly is full of light and joy,
but the light of the wicked will be snuffed out.
PROVERBS 13:9 NLT

The promise of heaven is incredible. If the world is a glimpse of glory, we're in for a treat in eternity. We get to live now with the abundant life of the Holy Spirit in us, and together with Jesus, and we get to spend forever in the presence of God. We read in Revelation 21:4 that we will live without tears, pain, or death. God's house has many rooms, and Revelation 4:6 tell of a sea of glass that is near God's throne. Heaven will be beautiful beyond our wildest dreams.

Not everyone has this living hope. Scripture says, "The light of the wicked will be snuffed out." There is no light or joy in that. There is no sea of glass or a house with many rooms. Like a candle whose flame has been snuffed, a wicked person's life will go out and that's it. With the help of the Holy Spirit, we can reach out to them with the power of the gospel and the light of God's truth.

Lord, may my life be full of light, joy, and purpose driven by your Holy Spirit. May I be a bright candle for others to find their way to you.

Wisdom Accepts Advice

Where there is strife, there is pride,
but wisdom is found in those who take advice.
PROVERBS 13:10 NIV

It's an old saying; a person has two ears, two eyes, and one mouth for a reason. We should speak half as much, or less, as we look or listen. Eyes and ears are open; mouth is closed. That's the right position for us to learn humility; we hear others speak, and we find out how much they know. We hear about other experiences, lives lived far away, and different family and relationship dynamics. We learn about career moves and job experiences we will never experience, and we learn. We hear how people think and communicate differently. This is a gift to us!

Listening to others is a good way to avoid pride. When we are observant enough to witness the pain, joy, and stress of others, we practice wisdom. When we realize everyone has a story and there's a lesson in each one, we become students. We don't add unnecessary conflict to relationships when we are truly hearing the one who speaks.

Speak through me, God, and keep me humble. Open my ears so I can hear what is truly going on in other lives.

Easy Come Easy Go

Money that comes easily disappears quickly,
but money that is gathered little by little will grow.
PROVERBS 13:11 NCV

It would be less challenging a life if money didn't exist, but that's not reality. We need money to live. Money, in and of itself, is simply a tool. It is not bad or good. It can be used to bless, and it can be used to harm. Today's verse tells us a simple fact about money; if it comes easily, it will also go easily. A slow, determined path to increasing our wealth assures growth. That's God's wisdom through the very wealthy King Solomon, and we would do well to listen.

Hard work teaches us the value of what we earn. Getting rich quickly leads to even quicker poverty. Think of all the lottery winners who went on later to declare bankruptcy, for instance. It is important to put the work in so that we grow in wisdom. If we build wealth over time, we will respect it and use it wisely and generously. Focus on your relationship with money today, no

Lord, I want to manage my money well. I know I can't ignore my financial habits and wish for them to change. I have to put the work in. Help me, grow me in wisdom, and teach me the power of temperance.

Tree of Life

Hope deferred makes the heart sick,
but a desire fulfilled is a tree of life.
PROVERBS 13:12 ESV

We all know the power of this sentiment. When a long-awaited desire drags on, it can feel disheartening. When our hopes are dashed, it weighs down our hearts. The opposite is true; when our dreams come true at last, the sweetness of its fruit is satisfying to the soul. This proverb is less a directive and more an observation of the truth.

It is not wrong to hold out hope for something that seems long past due. God knows the desires of your heart, and he honors them. He doesn't ignore them. He will satisfy your longings with the power of his presence. Perhaps you have experienced the fulfillment of a long-held desire, but over time forgot its poignancy. Go back, go over your history with God, and ask him to encourage you, even as you hold on to him with all that you are for the desires that are yet to be filled. He is faithful.

Thank you for your presence, Lord. Remind me of the ways you have satisfied my soul and my longings with the gifts of your grace. Encourage my heart in hope today!

Avoid Snares

The instruction of the wise is like a life-giving fountain;
those who accept it avoid the snares of death.
PROVERBS 13:14 NLT

In the book of John, Jesus encountered a Samaritan woman at a well. Since she came from a people despised by the Jews, she did not expect Jesus to talk to her, let alone have a conversation. By showing her acceptance and love despite her sinful life and the stigma she endured within an ostracized group, Jesus gave her an important message. The water she hauled up from the well would still leave a person thirsty sometime after drinking; Jesus is the eternal spring of water, and no one will thirst again if they drink from the living water of his truth.

Wisdom comes from God. There is no true wisdom without him, and therefore we can trust him to be the lifegiving fountain. His living water gives us the one and only path to avoid the snares of death. He is truth and love.

Jesus, thank you for the power of your living water that satisfies my soul. You are where true life is found; I want to dwell in your love all the days of my life. Fill me up to overflowing with your presence today!

Good Understanding

People with good understanding will be well liked,
but the lives of those who are not trustworthy are hard.
PROVERBS 13:15 NCV

When we lean into the Almighty, we tap into the truth and light he offers. Our dependency on God allows truth and light to shine through our own lives. We should not be surprised when people appreciate the wisdom we practice. God's wisdom is practical, it is sensible, and it is kind. It is what doing good and being good looks like. They might not choose to live like we do, but they cannot deny that we are trustworthy. It doesn't matter what a person professes to believe or not, it is the way they treat others, how they do their dealings, and the ways in which they follow through that reveals what they truly believe.

Those who hide in shadows and deceive others for their own gain make their own lives hard. True wisdom is revealed in the fruit of our lives, and this includes how we make others feel, the promises we keep, and our diligent pursuit of love, truth, and peace.

Thank you, God, that I don't have to fear when I live in the light of your love. Help me to adopt your practical wisdom in my life so others may see and know I belong to you.

Prudent Knowledge

All who are prudent act with knowledge,
but fools expose their folly.
PROVERBS 13:16 NIV

*A*s the saying goes, it pays to be informed. A prudent person spends time learning. They wisely choose where they direct their time and energy. There's purpose and reservation behind their choices. This all leads to a person that acts with wisdom; the Holy Spirit moves through their careful decisions.

You could choose to hide your light under a bushel as Jesus said in Matthew 15:15, but it's near impossible to hide that you're a fool. It seeps out the way that sweat drips from pores. Without discretion, a fool says things they shouldn't, their behavior is questionable, or their life is on a clear downward spiral. Believers would do well to study the Word as an effective way to avoid this. Prudence is a practice of building wisdom. That's what we should give our energy to today.

Lord, I humble myself before you today. I won't make quick and mindless decisions. I choose to take my time before I commit myself so that I can choose well. Thank you for your help as I do.

Reliable Messenger

An unreliable messenger stumbles into trouble,
but a reliable messenger brings healing.
PROVERBS 13:17 NLT

A reliable messenger knows that the information they've been given is important. They do not get distracted along the way to deliver it. They take the message seriously and pass it on quickly and clearly. Weighty matters are shared with reliable messengers. We have to build up to that place of honor. This is why we should never overlook the importance of the small things we've been entrusted with. They matter.

When we follow through on any given task, it is like a balm. When we share the good news of Christ with the suffering, it is a salve of healing. When we are reliable messengers, peace is promoted, and anxiety diminished. Ephesians 2:10 reminds us that "We are God's masterpiece. He has created us anew in Christ Jesus, so we can do the good things he planned for us long ago." We can be reliable messengers because he equipped us to be so, but only if we rely on him and follow through in even the little things.

Dear Lord, thank you for the gifts of your grace. I want to represent you well, and I know that looks like following through in my responsibilities. Open my eyes to the important messages and tasks of today so I can give them my attention.

Honorable Correction

Whoever disregards discipline comes to poverty and shame,
but whoever heeds correction is honored.

PROVERBS 13:18 NIV

The posture of our hearts is revealed in our willingness or refusal to accept correction. It's important to realize that strangers don't have the same authority to weigh in on our lives as trusted mentors, friends, and family. They do not know us. They don't see the fruit of our lives. Sure, we can consider the advice that a random person offers, but correction comes through close relationship, not through casual encounters.

This is why it is important to be honest and open with the people we trust. We give them access to parts of us others don't get because they have earned it. Para-social relationships may encourage us in some ways, but we need flesh and blood friends. We need to sit around tables, sharing our hearts and lives with those around us. Let's not forget the power of community, dear ones. We are made for it.

Father, thank you for the discernment of your wisdom that reminds me that not everyone who chooses to speak to my life and situation has the right to do so. Thank you for the power of community that does correct, edify, and clarify.

August

A friend is always loyal,
and a brother is born
to help in time of need.

PROVERBS 17:17 NLT

Wishes Come True

It is so good when wishes come true,
but fools hate to stop doing evil.
PROVERBS 13:19 NCV

As we give our hearts to the Lord, we are transformed. Second Corinthians 5:17 puts it this way, "If anyone belongs to Christ, there is a new creation. The old things have gone; everything is made new!" We are new in Jesus! His desires for us become clearer, transforming our own motivations.

When we are aligned in the love of Christ, we can rest in the assurance that our deepest desires are seen. When they come true, it is like life to our souls! It is good to remember the overwhelming and generous gifts of God. Let's take time to reflect on what he has already done in our lives. As we do, we are encouraged to continue yielding to his ways and trusting him every step of the way.

Holy Spirit, thank you for your work in my heart and life. Open my eyes to the goodness of God and remind me of promises already fulfilled so I may be encouraged to keep walking your way in confidence.

Righteous Rewarded

Disaster pursues sinners,
but the righteous are rewarded with good.
PROVERBS 13:21 ESV

*R*ighteousness is not the same thing as perfection. Even as followers of Christ, we will make mistakes. We will sometimes make selfish choices that we regret. The difference between a *sinner* and the *righteous* is in their response after they err. The righteous repent, and they are forgiven. They submit their hearts to the Lord and live their lives according to his wisdom. Though not perfect, their lives are marked by mercy, integrity, and the peace of God.

God blesses us when we pursue him. This is really good news! You have no need to fear disaster overcoming your life when you live in the light of God's mercy. He is a good father who offers good gifts, including the wealth of his wisdom, to his children. Keep chasing after God, and he will overwhelm you with his goodness.

Dearest Father, I am so glad I can run to you anytime. Every time I catch a glimpse of your love, it overwhelms me with goodness. I can't help but chase after you and walk in your ways, for you are better than anything else I've ever tasted or seen!

Generational Blessings

Good people leave their wealth to their grandchildren,
but a sinner's wealth is stored up for good people.

PROVERBS 13:22 NCV

Scripture says that good people have the foresight to not squander their resources. They have generational vision to plan for their kids and their kid's kids. However, it's important to remember that wealth is not a sign of godliness. You could gain the whole world but lose your soul, as Jesus warned in Matthew 16:26.

If we live only for ourselves, it will all be meaningless in the end. We cannot take our stuff into the next life. It is much better that we sow with the kingdom of God in mind. That means we consider others, even in our wealth. We live with generosity, kindness, and peace. Whatever your resources, daughter of God, submit them to God, just as you submit your heart to him.

Father, I offer you what I have—no matter how little or much—and invite your wisdom to guide me in my use and plans for it. Thank you for wisdom that really helps and gives me greater vision than my own life.

An Unplowed Field

An unplowed field produces food for the poor,
but injustice sweeps it away.
PROVERBS 13:23 NIV

It's grievous to see the abundance from our work go to waste.
It's even worse to see it swept away in purposeful disregard for the
money, time, and effort spent tending to and producing it. What we
worked so hard for out of love and devotion is gone; our efforts may
seem meaningless altogether. Injustice takes advantage of others'
worth and work and sweeps it away. It is as if they don't matter at all.

When we have an abundance to share with others, what joy we find
in generously spreading it out. We feel God's grace washing through
us and into the lives of those around us. We feel grateful to be vessels
for God. He reveals his loving pursuit of those who don't yet know
him through us. God is so good in his tenderness and care. What a
blessing it is to partner with his purposes and bless others!

*Lord, thank you for using me and my abundance for your glory.
Reveal your generosity through my own and draw others to your
kindness and thoughtful care.*

Always Enough in Christ

The godly eat to their hearts' content,
but the belly of the wicked goes hungry.
PROVERBS 13:25 NLT

When we join God's family, we eat at the table with him. We gather and share our blessings, and they are more than enough to feed each other. Our hearts are full when we do God's work. He cares for and nurtures us as he moves us toward eternity with him. Contentment in God is not something we can imagine before we experience it as his children. He fills us up. He is our all in all.

The gnawing hunger as an unbeliever is irrepressible. It cannot be satisfied. We do not know what we crave, so how can we be filled? Unbelievers keep reaching for and not quite grasping something they can't recognize. May we patiently and persistently share the living Word to those who are seeking. Jesus is the bread of life, and he is the water that never runs dry. In him, our souls find satisfaction.

Jesus, thank you for the satisfaction of your merciful truth: the satisfaction of who you are, and who you are in me! May I be generous as you are generous, Lord.

Honor the Word

He who despises the word will be destroyed,
But he who fears the commandment will be rewarded.
PROVERBS 13:13 NKJV

If we don't take God's wisdom seriously, we may disregard it altogether. Ignoring God's Word is dangerous. It may lead to dire consequences. Today's verse holds two very strong statements. The person who *despises* the word will be destroyed. The one who *fears* the commandment will be rewarded.

When we respect the Word of God, we put it into practice. Otherwise, why believe it at all? There are always rewards to wisdom. There are always consequences to ignoring it. We have to choose how we want to live and whom will we serve. Our own interests, or God's? God is gracious, kind, and merciful. He is trustworthy and true. He does not threaten us. The one who despises the word will be destroyed because they refuse to act justly, love mercy, and humble themselves.

God, thank you for your mercy that revives my heart and my life. Help me to love your ways so much that honoring them is easy. Your wisdom is light, life, and goodness!

Life Companions

He who walks with wise men will be wise,
But the companion of fools will be destroyed.
PROVERBS 13:20 NKJV

There is a difference between loving all people in the name of Christ and choosing with whom we share our lives. We should be wise in choosing the people we walk through life with. The people we listen to, those we spend time with, the people we check in with every day or week, these are the people who influence us. If your closest companions are making bad choices, complaining and cursing, and studying the world instead of the Word, you may find yourself doing the same over time. We rub off on each other, so it's important to think about who you want to be, and what you want your life to look like.

It is paramount to surround yourself with wise people who will challenge you, hold you accountable to your goals and morals, and get you excited about the things of God. The Bible warns us, "Evil company corrupts good habits" (1 Corinthians 15:33), so make sure the company you keep feeds your good habits and not your bad ones.

God, thank you for friends. They are a gift from you. Please bring wise people into my life who will help me keep growing in you and your ways.

Discipline

Whoever spares the rod hates his son,
but he who loves him is diligent to discipline him.
PROVERBS 13:24 ESV

How we respond to discipline or correction says a lot about our maturity. Children tend to disrespect parents or teachers who won't discipline them. Even though they fight discipline when it's enforced, they tend to gravitate to, trust, and respect the adults who encourage good behavior. When rules and consequences are insisted upon, children know they are safe, they matter, and they're capable of rising to the occasion.

As God's children, we know he disciplines us because he loves us and is calling us to a higher level of expectation. Like children, we flourish under loving discipline because it matures us and teaches us the best way to live. With God's help and humble hearts, let's respond positively and faithfully both in receiving and giving discipline.

Your righteous discipline, Father, helps me grow in your wisdom and in your love. May I embrace correction when it comes and not despise it.

Seems Right

There is a way that seems right to a man,
but its end is the way of death.
PROVERBS 14:12 ESV

It is good for believers to acknowledge early on that we can be easily led astray if we do not remain humble and teachable. Something may look right and good on the surface, but travel a little way, and we will start to see signs that all is not as it seems. Instead of doubling down on the error of our ways and justifying the wrong path, it is wise to reconsider and change course. It is never too late to turn to God and follow his ways.

The way of the Lord leads to life; the way of self-deception leads to death. When God is intimately involved in our every step, we don't have to worry. When we start to wander, God guides us back to the right way. Our confidence is in the one who can see what we cannot. He knows all the details that are hidden. Let's trust him with our lives as we follow him every step of the way.

Father, thank you for always being so accessible through Christ. I humble myself before you today and ask you to guide me. Show me if there are paths I need to turn around on. I trust you.

Stay Out of Trouble

Wise people are careful and stay out of trouble,
but fools are careless and quick to act.
PROVERBS 14:16 NCV

Being careful takes work and attention. Avoiding trouble is a purposeful decision, and it can't be done haphazardly. Trouble happens when little or no effort is put into the little choices, we make each day. Big trouble happens when we let life just happen without any thought about potential outcomes.

Diligent, thoughtful planning is required when we surrender our lives to Jesus. It is a big decision. The Holy Spirit nudges and guides us in wisdom as we yield to God's leadership. When we keep our focus fixed on Jesus, we reap the rewards, not the least of which is wisdom and peace in his guidance. The wide path and its inherent troubles await us when we are careless and quick to act without listening to our loving Lord. The narrow path and its amazing blessings are ours if we look to the Word and our amazing Father for deliverance and guidance.

Dear Lord, please teach me how to lean on you. Show me your ways of caution and thoughtfulness. I follow you!

Quick Tempers

A man of quick temper acts foolishly,
and a man of evil devices is hated.
PROVERBS 14:17 ESV

Not everything we see is beneficial. Not all that is popular is good for us, either. Modern culture is full of convenient information, entertainment, and opinions. We are practically bombarded with it. We need to be wise in what we watch, especially when we don't know the character of those we are listening to. The online sphere is filled with angry voices spouting their opinions. Let's not join the fray but turn our attention to the fruit of the Spirit and its work in our real lives and relationships.

The Word of God is a gift to help teach us. As our hearts become fertile soil for the Word of God to sprout and grow, we learn God's expectations, which are the same now as they always have been and will be. It's comforting to know the King of eternity tells us everything we need to know.

My King and God, I don't want to be influenced by the ways of this world that lead to anger, pride, and a disregard for others. I want to be so full of your love and wisdom that it seeps out of my every action.

Prudent Crowned

Simpletons are clothed with foolishness,
but the prudent are crowned with knowledge.
PROVERBS 14:18 NLT

Today's verse is not speaking to IQ levels. A better way to think about it might be naiveté. That is, refusing to look beyond the surface of our decisions to the possible repercussions they may bring. It doesn't matter how smart we are, if we don't act with prudence, we leave wisdom out of the equation.

The longer we live, the more easily we can decipher possible outcomes. However, we should not rely on our own understanding. We should seek the Lord and ask him to open our eyes to what is worth our time and investment, and what is not. As we take time and are diligent in our relationship with God, he gives us his prudence, promising a crown of knowledge as our reward. What grace!

Lord, I don't want to be naïve in my decisions. Please ground me in your wisdom and give me understanding. I trust your leadership.

Good Neighbors

He who despises his neighbor sins;
But he who has mercy on the poor, happy is he.
PROVERBS 14:21 NKJV

It's a good decision to do our best to get along with our neighbors. Proximity can be a blessing in daily life as well as in times of trouble. Solomon goes a step further and tells us it's a sin to hate our neighbors. We know hating anyone is a sin, but hating a neighbor is highlighted in today's proverb. Solomon focused on neighbors for the role they play in our lives.

Neighbors are an interesting relationship; they are not family, and they are not necessarily friends. No matter, we can share our resources with our neighbors, or offer a thoughtful gift from our abundance. It can be an amazing avenue for revealing the care of God when we offer to lend a neighbor a helping hand. It is good to look out for one another. This is the way of God. Jesus said the whole of the law could be summed up in our wholehearted love for God and for our neighbor.

Thank you for my neighbors, Lord Jesus. Help me show them your love through my resources and time.

Loved and Trusted

Those who make evil plans will be ruined,
but those who plan to do good will be loved and trusted.
PROVERBS 14:22 NCV

No one wishes to be treated poorly. On a personal level, there are few who would choose a slap in the face over receiving a sweet `. Still, there are those who treat others poorly while expecting to be treated with generosity.

The discrepancy conjures up the Golden Rule: "Do to others what you would want them to do to you" (Luke 6:31). Abiding by the Golden Rule levels the playing field, but Jesus wants us to take it even further. In Matthew 5, he says to turn the other cheek if someone slaps us; if someone wants our shirt, we should give them our coat too; if someone wants us to go a mile with them, we should go two. Going the extra mile is indicative of a heart surrendered to Christ. Kindness is the way of Christ even kindness to those who don't deserve it. The way of mercy is not easy, but it is the better path.

Lord Jesus, thank you for the example of your mercy. I have known its redemptive power in my own life. Help me to be gracious and kind to those who don't make the same effort. I choose your ways over my own!

Put in the Work

Work brings profit,
but mere talk leads to poverty!
PROVERBS 14:23 NLT

As much as many people like to talk, few make a living at it. Most of us need to work other jobs to live well. Good work engages body and soul. Whether it's a desk job with lots of repetition or complex thinking, or a physical job with lots of activity and required physical strength, work is a blessing. The apostle Paul instructed the people in the church in Ephesus, "Use your hands for good hard work, and then give generously to others in need." Work is not only valuable for sustaining our lifestyles; it is an opportunity to show Jesus' love and generosity to others.

People who talk but never get down to their work won't have resources to spare. This principle is true across the board. If all we ever do is talk about what we will do, but we never follow through, we will have nothing to show for it. Mere talk doesn't mean a thing without work to back it up.

Thank you, Lord, for the work that is mine to do. Help me home in on the ways I can make actionable change in my life and stop merely talking about it.

Wealth of Wisdom

Wise people are rewarded with wealth,
but fools only get more foolishness.
PROVERBS 14:24 NCV

Wisdom sets us on an upward trajectory. It builds upon itself, lifting us to higher places. Foolishness is like a downward cycle. It takes more from us than it offers. The choices we make throughout our lives matter. The fruit of them will be revealed with some time and distance.

God doesn't leave us in the dark as to what is right and what is wrong. His wisdom is full of guiding values that direct our choices. Wisdom takes consequences into account; it requires foresight. Foolishness is often based on spur of the moment decisions that lack thoughtfulness. Let's be sure to lean into the Lord every day, for the more we get to know him and trust his leadership, the wiser our decisions will be.

Father, sharpen my mind and soften my heart so I can hear and know your Word. I'm ever so grateful to have your presence guiding me.

Safety and Security

Those who fear the LORD are secure;
he will be a refuge for their children.
PROVERBS 14:26 NLT

The fear God wants us to feel for him is a respect that sends us running to him when times are tough. It's not fear that drives us to hide from him and try our luck in this world alone. He is a loving Father. When we truly understand how great he is, how wonderfully unending his love and how powerful his grace, we will run to him willingly. He is a place of shelter and strength.

God is our refuge and peace. He offers clear direction and clarity for our confusion. His commandments were written to help guide and teach us. They are for our protection and our good. The things that go against the ways of God try to confuse, tempt, and ultimately destroy us. God offers us safety and security in his generous mercy. Let's stick with him all the way!

God, you have put rules in place for my benefit: for my safety, growth, and potential. Thank you for being the perfect Father and for leading me in love.

Fountain of Life

The fear of the LORD is a fountain of life,
that one may turn away from the snares of death.
PROVERBS 14:27 ESV

The way of the Lord leads to a fountain that promises eternal life; it is not a trail riddled with deadly snares. It's a joy to follow God. He brings out beauty in the world around us and gives us eyes to see its intricate majesty. He uses creation in all its seasonal glory to show us glimpses of his beauty. How can we but stand in awe of him? We catch glimpses of who God is and what heaven is like as we observe this earth with eternity in mind. We can see his fingerprints as we behold his creation.

God is greater than what he has made. He is mightier than all that exists. He is our omniscient Father, and he is our perfect Savior. We can take him at his Word because he is faithful and true. He always follows through on his promises. Keep honoring the Lord, for he is the fountain of life.

Oh Father, I am in awe of your power and might. As I go through my day with curious eyes to spot you in creation, open my vision to see your merciful marks everywhere around me.

Power in Patience

Whoever is patient has great understanding,
but one who is quick-tempered displays folly.
PROVERBS 14:29 NIV

When we act hastily, we often make decisions not aligned with the heart of God. Sarah desperately gave Hagar to Abraham to have a son instead of waiting for God to fulfill his promise in Genesis 16:1-2. Hungry Esau impulsively traded away his birthright for a bowl of stew in Genesis 25:29-34. Moses impatiently struck a rock when God told him only to speak to it in Numbers 20:7-12. All these hasty decisions led to complicated outcomes which ran contrary to God's plan. He still weaved his mercy into their stories but think of the trouble they could have avoided if they had waited and trusted God.

Impatience reveals a lack of trust; patience leads to understanding and favorable outcomes. Christ displayed incredible patience, and he still does with us today. Practicing patience is honoring to God, beneficial for us, and leads to breakthrough in our faith and lives. Let's practice patience today.

When I feel worried or impatient, Lord God, please remind me of your faithfulness. Teach me to trust you more.

A Sound Heart

A sound heart is life to the body,
But envy is rottenness to the bones.
PROVERBS 14:30 NKJV

*P*hysical health is important. In the mainstream, there is a lot of time, energy, and attention spent on the health of our bodies. As Christians, it's important that we are also aware of our soul health. Our belief systems have eternal consequences, but they also affect us here and now. It's important that we clothe ourselves in the love of God beginning in our minds and hearts.

When we place God first, we calm our nervous systems, become more aware of our surroundings, and become focused on the well-being of others. These decisions lead to a longer life. If we are consumed by greed and envy, we bring anger and negativity into our thoughts. That will shorten our breath, tighten our chests, and increase stress. This will, according to today's verse, be rottenness to the bones. This is a poetic way of saying ill thoughts can make us sick.

Dear God, give me a healthy body so I can serve you longer and bring joy to those around me. I know my thoughts and stress levels can affect this, too, so help me lean on you in trust. I give you my worries and my dissatisfaction.

Help the Poor

Those who oppress the poor insult their Maker,
but helping the poor honors him.
PROVERBS 14:31 NLT

We honor God when we help the poor. It really is that simple. Those who oppress the poor insult the one who thoughtfully created them. God is the maker of young and old, rich and poor alike. When we dishonor the people God made, we dishonor him. We are all precious to God, and he wants us to treat each other as precious as well.

Helping the poor is not necessarily a demand on the wallet. We can help in soup kitchens, donate clean clothing, or teach a skill that could lead to employment. We can hire people who don't have an income or give rides to those who can't afford a vehicle. These purposeful and kind acts honor God because they honor the people who need help the most.

Maker, make me aware of people who need a helping hand. Keep me prepared and willing, both in my schedule and in my heart.

Even in Death

The wicked are ruined by their own evil,
but those who do right are protected even in death.
PROVERBS 14:32 NCV

Christians know there is an afterlife, and we know where we will spend it. God's design protects us both now and eternally. Evil will not overcome us for God's mercy already has. Death is not a punishment in this life; it is an eventuality. Even then, even in death, we know the overwhelming victory of Christ's own death and resurrection. There is hope. There is life everlasting. There is love that never ends.

Redemption is alive in the resurrection of Christ. It is our living hope. Jesus walks with us through life, and he will usher us into his eternal kingdom as we follow his ways. Wisdom keeps us close to him. Let's never forsake doing what is right, for it keeps us on the path of righteousness.

May my life be for your glory, God. I choose to walk in your practical wisdom every day, for it is life and breath to me. Be exalted in my surrender, Father. Be honored in my life, and even in my death.

Where Wisdom Rests

Wisdom rests in the heart of him who has understanding,
But what is in the heart of fools is made known.
PROVERBS 14:33 NKJV

We reflect God when we speak to people with kindness and understanding. We can't hide the presence of the Holy Spirit when he dwells in us. He breathes through the words we speak and is revealed through our behavior. True understanding is rooted in care and concern for others. Those we speak to will find out about Jesus as they pursue the power behind our words.

The Lord is the source of wisdom. We tap into that wisdom as we learn more about him and his Word. What a blessing it is to belong to him! Our lives reflect the King of kings because of our yielded hearts. This is something we grow in as we nurture our relationship with God. This is true for anyone who seeks him. What is in our hearts will not remain hidden. Wisdom heals our broken mindsets and soothes our worries. Foolishness only continues to foster them. Let's clothe ourselves in kindness and humbly share the wisdom that has changed our hearts and revived our hope with others.

Father, fill my heart with understanding. May the words of wisdom I share with others be laced with kindness and draw people to you. Open my heart to your Spirit moving though me.

Reflections of Honor

Righteousness exalts a nation,
but sin is a reproach to any people.
PROVERBS 14:34 ESV

Doing right is the way to more blessings than we can imagine. We are blessed when we prioritize integrity. Our families are blessed with our wisdom and diligence. Our communities are blessed with the presence of strong family units and healthy, trustworthy people. Nations are blessed with communities that have strong economies and generous, hard-working citizens.

Sin erodes such blessings. It decreases any effective work we may do. Compromise undermines relationships, trust, and even our witness for the Lord. God's way is the best way on so many levels of society, but it starts with individual people deciding to put God first in their lives. It's important to keep our eyes on God and make each decision to please him.

Lord, I don't want to be undermined by compromise. I want to walk in the confidence of your wisdom that helps build up the people around me. Help me stay on the right path.

Gentle Answer

A gentle answer will calm a person's anger,
but an unkind answer will cause more anger.
PROVERBS 15:1 NCV

When Daniel and his three friends were forced into slavery, their morals were tested. They did not believe it was right for them to eat the king's meat or delicacies. Instead of stubbornly refusing, they petitioned to eat their own, healthier food and explained how it would help them serve the king better. Because of their humble attitude and well-crafted rationale, their request was granted.

The health and strength of Daniel and his friends proved that God's way was the best way. These men were able to follow God's commands, bring positive attention to God's better way of doing things, and not incite the king's rage, all because they employed a kind and gentle answer. Choosing to speak to others with gentleness and kindness, even those we inherently disagree with, is always the best way.

Lord, I love your wisdom. Help me to be gentle and kind in the way I talk to others, even in disagreement. Help me be someone who offers peace and generosity where others may spew anger and jump to conclusions.

Joy and Sorrow

A glad heart makes a cheerful face,
but by sorrow of heart the spirit is crushed.
PROVERBS 15:13 ESV

In this life, we experience joy, and we experience sorrow. There are times to celebrate and times to mourn. We are wise when we don't force happiness on those in deep grief. We are also wise when we don't try to lessen the incredible joy of a victorious moment. Romans 12:15 advises that we "Rejoice with those who rejoice, weep with those who weep." This is the way of wisdom.

If we see sorrow as something to escape, we may recoil from the encouragement to sit in it. Yet it is graciously what God does with us. He is our comforter, after all. Instead of trying to convince someone out of their very real heartbreak, we do well to mourn with them. We don't have to have the right words. Our presence or thoughtful gifts can be enough to bring comfort in the moment. There is so much joy to share, too. Let's remember there's a time for both.

Holy Spirit, I have known joy and I have experienced sorrow. Help me to not run from uncomfortable feelings in others. I want to be one who shares in joys and sorrows both, just as your wisdom does.

Live Simply

Better is a little with the fear of the LORD,
Than great treasure with trouble.

PROVERBS 15:16 NKJV

A simple, peaceful life is better than a lot of wealth with just as much conflict. We appreciate what we have when we take stock of our blessings. We can be generous with our overflow as we are efficient with taking care of the necessities.

Have you ever shopped for something out of compulsion and then found that the feeling of satisfaction was gone quickly? If we are continually reaching for the next thing, we miss out on the beauty of what already is ours. It is so much better to learn to sink into the present, to worship the Lord for the ways he takes care of us today, and to live open-heartedly and at peace with those around us. Let's come home to what truly matters today. As we honor God, honor the people in our lives, and honor the beauty of the present, we will experience greater satisfaction than if we continually reach for more.

Lord, I worship you today for all that you are, and I'm so grateful for all that you have blessed me with. Open my eyes to your hand of provision and use my open heart as a vehicle for your generosity.

Humble but Satisfying

It is better to eat vegetables with those who love you
than to eat meat with those who hate you.

PROVERBS 15:17 NCV

We all know that we should eat our vegetables. But a meal only of vegetables, to some, can seem lacking. The lesson we are presented with in this proverb is that it is better to have a humble meal with those who love and care for us than to eat a costly feast with someone who wishes us harm.

Status can come and go, but the love of our dear friends will not. It is important to put our priorities in order. Let's not be wowed by the lifestyles of those we barely know and leave our loyal and true friends behind. Love is not a commodity; it is a gift and a strong support. It is better to eat a humble meal with trustworthy people than to feast with unpredictable people.

Teach me to embrace a simple life, Lord, if that is what you give me. Give me an eternal perspective so I can focus on what is important. May your kingdom ways remain to me more impressive than the wealth or status of this world.

Slow to Anger

A hot-tempered man stirs up strife,
but he who is slow to anger quiets contention.
PROVERBS 15:18 ESV

It's not pleasant to be in the company of someone who is easy to anger with the smallest provocation. They are unpredictable and often unkind. Believers are instructed to keep an even temper and to think before responding, especially before reacting to people who create conflict or look for arguments. We don't have to react to every jab that's offered. Instead, we can cultivate peace and patience in our own hearts and lives.

There are some tools that can help us in our endeavor to be more temperate in the face of potential conflict. We can listen to the words spoken and consider the tone of voice offered. We can think about the motivation of the speaker, stepping outside of our own worldview. We can get curious about the background of a situation. We can pause to see if there is more of the story to be revealed. All these options offer a path through a bad situation and a way to emulate Jesus.

Father, I want to reflect your Word and your ways. Help me stay quiet when needed and give me a way through hot-tempered moments by contemplating words, considering motivations, seeking more information, and pausing in the moment.

The Highway

The way of the lazy man is like a hedge of thorns,
But the way of the upright is a highway.
PROVERBS 15:19 NKJV

The word picture of a hedge of thorns reveals what it is like for the lazy person in this life. Without the willingness to put in the necessary labor to work with, or around, obstacles, they will recoil at the first challenge on their path. Everything becomes an excuse, and therefore they do not succeed simply because they do not try.

Laziness is not the same thing as being overwhelmed or tired. A lazy person doesn't do anything more than what is absolutely necessary. A person who tries and keeps persevering may experience setbacks, but they will make a way through. The Lord is full of wisdom and direction for those who look to him as their leader. He will not do everything for us, but he will show us the way to move forward. Let's look to him!

Thank you, Father, for your help on the highway of righteousness. When I cannot see a way forward, guide me with the next right step.

Be Sensible

Sensible children bring joy to their father;
foolish children despise their mother.
PROVERBS 15:20 NLT

The Holy Spirit transforms our hearts and minds with the truth of God's Word as we submit to his leadership. With God as our guide, our steps become more confident and clear. The more we seek the Word and truth, the more sensible we become. Common sense and holy sense become part of our thinking. We plan and act in submission to God and his will. Everything starts to make spiritual sense. The Holy Spirit refines and improves us because he dwells in us and directs us with wisdom. What joy this brings to the Father.

When we reject the wisdom of the Spirit, we cause him grief. When we make our way through life without considering God and his ways, we will also experience the grief of our own foolishness. Instead of insisting on our own way, let's yield to the great wisdom of our Creator. He always wants what is best for us.

Lord, I humble myself before you today. Thank you for your wise guidance that leads me through life. I will not give up your way, for you are better than life itself.

September

The highway of the upright
is to depart from evil;
He who keeps his way
preserves his soul.

PROVERBS 16:17 NKJV

Do Right

A person without wisdom enjoys being foolish,
but someone with understanding does what is right.
PROVERBS 15:21 NCV

When we live with God's wisdom as our guide, there will be things we miss out on. We know when to accept an invitation and when to turn it down. We may feel discouraged by watching the quick success of those who compromise their values, while we still hold strong to our own decisions to walk in integrity.

It is important to keep our eyes on the one who is above the fray, the one who never changes and is always faithful to his Word. As we surrender our hearts to his love and captivate our thoughts with his goodness, we keep ourselves fixed on the immoveable rock of our salvation. What delight we can find in him today, no matter what is going on in the world around us. Let's keep doing good, knowing it will be rewarded one day.

I love you, Father, and I love your wisdom and understanding.
Give me persistence to stay in your Word and pray without ceasing,
choosing to stay close to you and to do what is right no matter what.

Consultation

Without consultation, plans are frustrated,
But with many counselors they succeed.
PROVERBS 15:22 NASB

Do you listen to the input of trusted friends and family before making important plans? Are you in a position to share your strengths and perspectives with others in a respectful way? God is the only omniscient one; we cannot know the full picture on our own. We need each other, including each other's input. God doesn't need to consult anyone before enacting his plans, but it is wise for us to do so. Our perspective is limited, so asking others for their help and opinions is crucial for success.

Let's not allow arrogance to come between us and seeing our plans accomplished; we will only be left frustrated if we do. Instead, let's offer help, work together, love each other, find ways to help others succeed, and give God the credit he is due.

God, in your wisdom and according to your perfect plan, you created each of us differently so we would work better together than on our own. Please set good counselors in my path and show me where to offer my help.

A Timely Word

A person finds joy in giving an apt reply
and how good is a timely word!
PROVERBS 15:23 NIV

Has someone ever spoken a wise word to you just when you needed it, and it was so fitting you knew it had to be the voice of God at work in that person? This sort of wisdom may seem like a sudden burst of inspiration or breakthrough. However, it comes through a life of walking alongside God, hand in hand, and listening to the prompting of the Holy Spirit.

There is joy in being used by God to bless others, and it is always according to his perfect timing. As we spend time with God and fill our hearts with him, we will feel his nudging and be able to offer a timely word of encouragement (or caution) precisely when someone needs it. Often God's chosen method for accomplishing his will is to use us, his children, when we submit ourselves to him. What an honor it is to partner with his purposes!

The answers to all problems are found in you, God. Please hold my hand as I walk through life and use me to encourage others along the way.

Life Winds Upward

The way of life winds upward for the wise,
That he may turn away from hell below.
PROVERBS 15:24 NKJV

The wise take paths that continually teach and refine them. They are willing to put in the work to change when presented with a better way. When we refuse to change, we stay stuck in cycles that will eventually bring us down.

We cannot ignore the implications of refusing to follow the wisdom of God. We are not wise when we think we have already understood all there is to know about God, how he works in this world, and what his love looks like. We are wise when we use prudence, love others well, pursue peace, and build others up as often as we look to improve ourselves. When we remain yielded to the Holy Spirit, it leads to everlasting life. The upward path doesn't mean a perfect path void of pain, it means with each cycle of the seasons, we are closer to God, living according to his truth. Let's remember that.

God, I love your upward way of life. I love where you take me and how blessed I am to know you. Keep my faith strong in you as I travel through this life.

Gracious Words

The thoughts of the wicked are an abomination to the LORD,
but gracious words are pure.

PROVERBS 15:26 ESV

When the Holy Spirit dwells in us, we have direct access to the Lord within us. He alerts us when we mess up. He teaches us to watch our words. He directs us to think purposefully about goodness and light. God infuses us with holy sensibilities, which are higher than common ones. We become one with God and his eternal purpose.

Without the Holy Spirit, we do not have the wisdom of God's ways instructing our minds and hearts. There is no law of love to direct how we talk or what we think about. We have no vision for eternal purposes when we live for ourselves. Foolish words and choices characterize people who don't know wisdom, and it may be coupled with misplaced definitions of success and worthiness as well. A gracious spirit starts with the Spirit in us. Then we can be gracious to others as God is gracious with us. It is a beautifully symbiotic relationship played out in the encouragement and lifegiving love we dwell in and offer to those around us.

My Lord, you are worthy of everything gracious and pure. Direct my thoughts and words so they reflect a pure heart.

Trickle Effect

Greed brings grief to the whole family,
but those who hate bribes will live.
PROVERBS 15:27 NLT

None of us lives in a bubble. What we do and how we think affects everyone around us. At the same time, we are not victims of our environment. Nature and nurture do play a big part in how we think, but once we repent, our hearts belong to the Lord. We start to see his presence in our lives as we allow the Holy Spirit to do his work.

When we open our hearts to the Holy Spirit, our family and friends are affected, as well. How we act begins to reflect what God is like. We speak in an intentional and kinder way. We pause for the Spirit's feedback and become vessels for the Word. As the Spirit moves through us, our homes reflect a brighter light and a holier foundation. The Lord doesn't promise life will get easier, but it becomes much more meaningful. Our perspective changes the path we take, and God's righteousness touches the lives of everyone around us.

Lord, allow me to be a vessel for you within my family. Even if they are not followers of you, I know you can use me to shine your light into their lives.

Righteous Hearts

The heart of the righteous studies how to answer,
But the mouth of the wicked pours forth evil.

PROVERBS 15:28 NKJV

The Holy Spirit often gives us pause before we react to others. When we take the time to listen before responding, the Holy Spirit can have a voice in our responses. Much can be done when we allow the Lord to speak through us. As our hearts submit to him, we will marvel at the divinely inspired words that come out of our mouths. The Holy Spirit's voice brings a heavenly perspective into a moment where we had no capability to do so.

The presence of God at work in our hearts is life changing. The transformation is amazing to witness because God's presence is both gentle and a force to be reckoned with. We walk through conversations and situations differently when the Holy Spirit directs our words. Every time we recognize his work in us, let us remember to give glory to the one who changes us from the inside out.

Thank you, Holy Spirit, for your presence alive in my heart. You bring beauty out of the messes of life, and you transform disappointment into places of praise. Speak through me as I yield to, and listen for, your voice.

Righteous Prayers

The LORD does not listen to the wicked,
but he hears the prayers of those who do right.
PROVERBS 15:29 NCV

As daughters of God, we have the ear of our heavenly Father! He listens to us and hears our prayers. He delights when we focus our attention on him and ask for his direction. If we intentionally look to God for all that we need, including direction, love, patience, and grace, he is there. Sometimes his answer is immediate. Sometimes we need to wait for it, but even that is God directing us toward growth in patience and trust. He is loyal, trustworthy, and true.

The closer we are to the Lord, the more readily we recognize our voice. Let's go to him at all times with all things. He is a wise father, teacher, and guide. He will not let us down. Why rely on our own strength when we have the power of God available to us through the Holy Spirit?

Lord, thank you for listening to me whenever I come to you. You are my good Father, and I trust you. I will not walk the way of foolishness or selfishness that only looks out for my good. I will do what is right because it is the right thing to do, and it is what you would do.

Lifegiving Reproof

If you listen to constructive criticism,
you will be at home among the wise.
If you reject discipline, you only harm yourself.
PROVERBS 15:31-32 NLT

Constructive criticism does not point out flaws just for the sake of it. It is not cruel. It is helpful and kind. If we are open to receiving helpful input, we will not be offended by it, for we cannot escape blind spots or flaws in ourselves. Let's reject the pull of perfectionism and instead look for ways to grow at every opportunity.

If we want to "be at home among the wise," we must be willing to stay humble and open to feedback. Through discipline, we develop healthy habits; through constructive criticism, we can learn and grow. The more we embrace helpful correction, the more we can become like Christ, and what a beautiful transformation that is!

Lord, your correction is lifegiving, and I accept it. I pray for wisdom to make the most of the opportunities that feedback from others offer me so I may mature into who you want me to be. I want to glorify you in the process.

Kind Correction

If you listen to correction,
you grow in understanding.
PROVERBS 15:32 NLT

It does not feel good to have our shortcomings pointed out and addressed, but praise God for the person who cares enough to do it! Let's recognize this as the loving gift that it is and learn from any truth spoken. This is the process of growing in understanding. This is what maturity looks like.

We can also offer loving correction to those who need it and are wise enough to listen. Knowing how difficult it is to receive correction, it is always best to deliver it in gentleness and kindness. The point of correction should always be growth and understanding and never to put someone else down or puff ourselves up. Self-advancing criticism is nether caring nor honoring to God. Any correction ought to be helpful, not harmful, to the other person. When someone else corrects us, let's be hungry to learn and mature, our ears open to truth and graciously disregarding anything that does not align with God's heart or ways. Then we are sure to become more like Christ.

Jesus, give me a heart like yours both to receive and deliver correction. My goal in both is a better understanding of you.

Humility Precedes Honor

Fear of the LORD teaches wisdom;
humility precedes honor.
PROVERBS 15:33 NLT

There's a process to acquiring wisdom. The Lord knows the best way for us to learn, and he knows what we can absorb and when we are ready to receive it. When we lean into him and concern ourselves with his processes, the blessing is a righteous path.

It all begins with humility. It isn't inherent in the human spirit to be humble. We tend to justify ourselves and defend our choices, but those reactions don't open the door to understanding and humility. Once we recognize how much we lack, we can then receive from God's great abundance. Pride is a wall that keeps us from growing, but humility is an open door that leads us to greater understanding. When we start to listen to God's voice, things change. Our words have more intention and honesty. We reflect more on the larger meaning of what is going on rather than our limited understanding of it. We have eyes that see and hearts that move with the compassion of the Holy Spirit dwelling in us. This is wisdom, and it leads to honor.

Lord, let me walk in your wisdom. Keep my heart in check with humility and put me on a path that will lead to an honorable character.

Commit to the Lord

Commit your work to the LORD,
and your plans will be established.
PROVERBS 16:3 ESV

When something is "established," it is already successful. It has already been arranged and the plans put into motion. Although we can't always see where the path of faith is leading, we can be certain that God's plans are good and cannot be undone.

True success can only be found when we are rooted and established in God. When we read his Word, learn his heart, and follow his ways, nothing and no one can thwart the good plans he has in store for us. They have already been established! The deed is signed, and the outcome secured.

I commit everything I do to you, dear Lord. I place in your gracious hands all that concerns me and all my plans for the future. Please take my aspirations, hopes, and dreams and mold them to match yours. You are committed to me, I am committed to you, and nothing can come between us.

On Purpose

The LORD has made everything for its purpose,
even the wicked for the day of trouble.
PROVERBS 16:4 ESV

God does not make mistakes. God created you! You are an original, uniquely designed, intentionally put together, and made with profound purpose. Whatever decisions are confronting you today, remember who you are and whose you are. Commit your decisions to God because he is trustworthy and good. Trust him with the outcome because he is faithful and wise, and he always wants what is best for you.

Everything has a purpose, so even if it doesn't make sense to you today, rest assured that your loving Father has it under control. You do not need to worry about a future God has already written. You do not need to live as anything less than the masterpiece he lovingly designed.

Lord, you have a purpose for everything you have created, and that includes me. I find fulfillment in this purpose even when it is unpleasant or painful. I will find my purpose in you and strive to be faithful to your calling.

The Lord Directs

A man's heart plans his way,
But the LORD directs his steps.
PROVERBS 16:9 NKJV

When was the last time you asked for God's blessing on your schedule? Do you pray over your calendar? Are you emotionally open to God intervening and switching things around? Is the first thing you think about in the morning the King who created you, or is it your daily to-do list?

We make all sorts of plans, but we can't take a single step without the grace of God guiding us forward. God paves our paths, God can turn our stress into joy, and God holds the future in his hands. When we make our plans, we can consider what God may be saying to us. Let's never forget to factor in the most important things. Nothing happens apart from God, so instead of wrestling with him, let's align with him and trust him with the unknown.

Everything I do is for your glory, dear God. Please take my agenda and make it what you want. Keep me flexible and reverent before you. Your ways are greater than my ways, and I choose to follow you.

Watch Your Actions

Good people stay away from evil.
By watching what they do, they protect their lives.
PROVERBS 16:17 NCV

It's not difficult to formulate a response in the heat of the moment. We are full of feelings and opinions. What requires insight and effort is crafting a response that holds goodness and mercy. That kind of response isn't always easy or intuitive. Much of humanity veers toward negativity and criticism. It takes intention to do it differently.

As Christians, we are instructed to love God and others. We have the most incredible example: the sacrificial love of Jesus Christ. When Jesus died on the cross after being beaten and abused for the sake of every sin across time, he went through a horrific death. He spent three days in the in the depths of hell so we would never have to go there. He loved us first, and now we can love others rather than partake in the evil of this world. We are assured of our futures; we know where we're going. It is loving to show others the path of Christ.

Father, I love your presence and power in my life, and I would love to lead others into your unfailing and powerful love. Show me how.

Pride Before Destruction

Pride goes before destruction,
and a haughty spirit before a fall.
PROVERBS 16:18 ESV

Haughtiness is another way to describe pride or arrogance. Conceit is consumed with its own vanity. A self-important person cares more about their appearance than they do the state of their heart. An arrogant spirit leads to destruction. A humble heart is ready to change when they stumble, but a proud person refuses to admit that they have any faults at all. Of course they will fall—we all do—but the higher they lift themselves, the further they have to fall. Then they will know the disgrace of their folly.

God's wisdom is not just a bunch of rules. They are eternal values that play out both in the world and in the kingdom of heaven. God's ways are infinitely better than the ways of the world. The way of love, peace, joy, patience, kindness, gentleness, and temperance are beautiful, even when they are disregarded by others.

Dear Father, I humble myself before you. Help me to remain humble in my relationships, as well. I don't want to be so proud to refuse help, guidance, or correction. Thank you that I can remain flexible and moving in the ways of your grace by your Spirit.

Live Humbly

Better to live humbly with the poor
than to share plunder with the proud.
PROVERBS 16:19 NLT

Throughout the Word, we are taught to store our treasures in heaven and live focused on what matters. Fame, wealth, comfort, and ease are all treasures of this life that pass away when we do. We should not aspire to these things for the sake of our own image. When we follow God on the path of his righteousness, we may or may not become known in our sphere of influence. The thing that truly matters is the things for which we are known.

If we aspire to anything, let it be to be known as people who love others well, to be people who follow through on our word. Let us be trustworthy ones who are safe places for others to land. May we listen well and offer our words thoughtfully. Let us admit when we are wrong and have done wrong and repair those relationships with perseverance and grace. Let's follow the example of Christ who lived humbly with the poor, rejecting the lifestyles of the proud. We honor God, and we build an honorable legacy for ourselves, when we do.

Move through me, Holy Spirit, and teach me the wisdom of humble living. Move me with your compassion and help me to choose the narrow path of your love at every turn.

Happy to Trust

He who heeds the word wisely will find good,
And whoever trusts in the LORD, happy is he.
PROVERBS 16:20 NKJV

What God says matters. Scripture is filled with the revelations of who God is and what he is like. The truth and love contained within those pages are the entire reason we exist. They are not just the goal; they are everything from initial purpose, to path, to plan. We will find the whys, the hows, the whats, and the whos in the Word of God.

People who release the self-preserving default of their ways and submit to God start to understand the power now living in them. The resources of God provide all we need to live for him. He is endless in love and power. Wisdom is infused within our hearts and souls, and the glory and wonder we experience because of this is beyond description. We listen to him, and he fills us up. We follow him, and he provides the plan. We submit our hearts, and he gives us supernatural joy. What glorious good we find in walking in fellowship with our Maker and Lord.

God, I need your purpose in my life. I need you to provide the power and the plan. Thank you for giving me all the amazing feelings that come with knowing and serving you.

Lifegiving Fountain

Understanding is like a fountain which gives life to those who use it,
but foolishness brings punishment to fools.

PROVERBS 16:22 NCV

A fountain splashes and flows from its beautiful height to refresh
and relax those around it. It gives life, it reflects light, and it calms
the soul with its beauty. Solomon says that's what understanding
does to those who use it.

Where do we get understanding? It comes from the Holy Spirit
as he dwells within our hearts and directs our paths toward God's
kingdom. We keep our eyes on God, and we fill up on his living
Word, and we gain understanding. With understanding, we splash
beauty and light to others around us. Foolishness is the direct result
of not following the directions of the Holy Spirit, but the guidance of
the Holy Spirit brings life to all who follow in his ways.

*Lord, make me a fountain of understanding. Help me comprehend
what your Word says and follow your wisdom. I want to bring beauty
and light to everyone I know and meet.*

Teach My Mouth

The heart of the wise teaches his mouth,
And adds learning to his lips.
PROVERBS 16:23 NKJV

Out of the mouth the heart speaks. Our hearts hold our attitudes and our beliefs about life and other people. Where we invest our time, learning, and relationships informs the direction our hearts take. If we want to speak with wisdom, we have to learn to treasure wisdom in our hearts. We have to let it instruct our thoughts and perceptions.

When we reflect the Holy Spirit dwelling in our hearts, aligning with his direction, we start to acquire the wisdom God speaks about throughout Scripture. God blessed Solomon with wisdom, not just for his time and place, but also to instruct all who read Scripture throughout time. Wisdom can instruct every person who follows it, first in our hearts and then, reflecting through our words and actions. Is wisdom flowing from your heart through your lips?

Help me learn, oh God. Fill my heart with your wisdom and teach me your understanding. I know that what is in my heart will come out, so fill me with you.

Powerful Words

Kind words are like honey
sweet to the soul and healthy for the body.
PROVERBS 16:24 NLT

Demoralization doesn't just affect one's mind; it affects their whole being. Scientific studies have shown the effect a person's emotional wellbeing has on their physical health. It can work for good or to our detriment. Kindness is like a balm to a wounded soul; it does good to their whole being.

Do you speak up when you have a kind word for someone, or do you keep silent? A kind word is always welcome. When someone knows they're appreciated or accepted, they are less likely to be anxious. When someone knows they're loved, they tend to be less worried. A word spoken in love can bring someone's defenses down and cool their anger. Both kind and cruel words are powerful, and both tend to spread like wildfire. Choose which fire you stoke with the words you use.

Words hold power, and I want to use my words to glorify you, God. I will speak words of life to bring healing to those around me. Please keep my heart pure and my tongue kind.

See the Signs

Whoever winks his eyes plans dishonest things;
he who purses his lips brings evil to pass.
PROVERBS 16:30 ESV

Wickedness cannot be hidden on the face of those who plan it. That is what today's verse says. We can look for signs, for red flags, to discern when we should trust someone and when we should be wary of them. Discernment is a gift of wisdom. It helps us to avoid unnecessary trouble.

Have you ever looked back after a betrayal and thought to yourself, why didn't I pick up on the signs before? The clarity of hindsight allows us to see what we could not in the fog of the moment. Still, the more we grow in wisdom, the more signs we learn to pay attention to and discern the intent and the possibilities before us. Let's not ignore the red flags by sticking our heads in the sand. Discernment is a powerful gift to those who use it!

God Almighty, I submit my heart, mind, and mouth to your wonderfully wise ways. Help me be diligent and discerning in my relationships and in my trust.

Well-earned Crown

Gray hair is like a crown of honor;
it is earned by living a good life.
PROVERBS 16:31 NCV

Our culture is youth obsessed. It discredits age unnecessarily and unfairly. However, the Bible tells us a good life earns us honor in old age. There is so much beauty in growing older. There will always be fools at any age, but those who have spent their lives listening to the voice of God and learning his Word have also learned wisdom, and with wisdom comes honor.

Giving respect to older believers opens doors to experiences and opportunities we would otherwise not know about. We ourselves show wisdom when we respect and honor the people who did so much before we arrived on the scene. We can listen to their stories and strengthen our own faith through the lived experience of seasoned saints. There is no reason to fear aging, for gray hair is like a crown of honor. Let's give ourselves to continuing to live a good life and stay connected to the older generations as we do.

Open my eyes and ears, Lord, so I can hear the wisdom of the saints who have done your work for many years more than I have. Let me humbly approach your kingdom with a thirst for knowing you and the stories of your people.

Strength in Self Control

One who is slow to anger is better than the mighty,
And one who rules his spirit, than one who captures a city.
PROVERBS 16:32 NASB

We cannot control our circumstances, but we can learn how to control ourselves. Left undisturbed, most of us are decent and kind people, but how do we respond when someone or something disrupts us? How do we handle being treated unfairly? When our sense of control is threatened, do we exercise self-control, or do we lash out? Being slow to anger is more impressive than brute strength. It is more difficult to rule our impulses than it is to rule a city.

Self-control is a sign of wisdom and maturity. It demonstrates our reliance on God to do what we cannot. It offers safety and stability to our loved ones, and it's a leadership quality others will notice and learn from. Let's practice ruling our spirits every day until we have learned to control our reactions.

God, help me control my spirit so I am not subject to impulsive feelings. Instead of lashing out, teach me to be patient and long-suffering. I rely on you to help me!

Forgiveness

Love overlooks the mistakes of others,
but dwelling on the failures of others devastates friendships.
PROVERBS 17:9 TPT

How can we forgive someone who hasn't asked to be forgiven? It starts in our hearts. The offender may be blessed and relieved by receiving forgiveness, or they may never know the difference. In either case, forgiveness starts between our hearts and the heart of God.

When we dwell on how others have failed us, it erodes the relationship between us. We cannot grow in trust or in love when we harbor bitterness against them. Some friendships cannot weather the big storms of betrayal. However, even small hiccups can be gathered as ammunition against each other if we do not overlook each other's mistakes with gracious love. It is wise to acknowledge our own hurt, but we cannot stop there. We must be willing to let love guide us forward, and the only path forward is through forgiveness. God does not want our hearts to be burdened with unresolved pain, and unforgiveness is just that. Give him your hurt, your frustrations—all of it. His love will cover and fill you. Mercy is a road marked by forgiveness.

Dear Lord, make me a person of integrity who does not hold on to bitter roots. I don't want to be ruled by offense or pain. I will not ignore the wound, but I will also not let it fester. Lord, help me forgive.

Keep Peace

Don't be one who is quick to quarrel,
for an argument is hard to stop,
and you never know how it will end,
so don't even start down that road!
PROVERBS 17:14 TPT

As children of God, it is important to work for peace and refuse to let anger get the best of us. Hasty responses often lead to regret and the need for repair. Wisdom helps us stave this off by taking space to calm down and thinking before we speak. One way we can practice this is by refusing to engage in a meaningless argument.

God doesn't want us to live frustrated or combative lives. An argument can quickly spin out of control when anger is steering it, so it's better to stay calm and refuse to continue when the disagreement no longer holds hope of growth and maturity. The more anger it draws out, the faster it grows. Soon it controls us instead of us controlling it. Children of God are supposed to be known by their peace. That's an easy calling when everyone is getting along, but it's much more hard-won when we are on edge. Let's tend to our own hearts, and as we do, we will be able to pursue peace whether or not others do the same.

Prince of Peace, I want to be a person of your peace. Help me to stay out of arguments and seek to understand first.

True Friendship

A friend loves at all times,
and a brother is born for a time of adversity.
PROVERBS 17:17 NIV

Tough times have the capacity to bond people closely. Have you had difficult days which produced mature friendships? Often rough roads reveal your real friends. Fair weather friends are nowhere to be found when trouble comes, but loyal friends show up when everything is falling apart. God promises to be with us in good and bad times, and that's the kind of friendship we should also look for and emulate.

Bad days cannot be avoided in life. They will come. When a friend is going through something difficult, let's put our agendas aside, remember we're all part of God's family, and be there for them when they need it most. Adversity should not scare us away from being a good friend. Jesus is there for us in our adversity; let's do the same for our loved ones.

Father God, thank you for the friends you have given me who stand with me through thick and thin. I'm so grateful for deep friendships that are a gift from you.

Judge Wisely

It's poor judgment to guarantee another person's debt
or put up security for a friend.
PROVERBS 17:18 NLT

*O*nce money gets involved in any relationship, things can quickly
get complicated. If we owe each other, there is now something other
than care between us. The Lord structured the family to be a safe
place for money to exist, and there are governmental and corporate
laws in place for the interchanging of money to be legal and safe.
There are good reasons for God to tell us not to get involved with
anyone else's debt.

There are ways to be kind to our friends that don't involve money.
We can give them a gift. We can intervene with other services like
providing meals, childcare, or housekeeping. This can free up more
time for our friends to earn the money to repay their debt. If asked
and if we are qualified, we can provide some advice. There are many
ways to help people without assuming responsibility for their debts.
If we have the resources and the inclination to pay their debt, then
it is in our best interest and theirs if we offer it as a gift and don't
require repayment. Otherwise, there will be a gulf between us.

*Lord, allow me to discern wisely when people, especially friends, ask me
for help. Let me be generous in ways that make sense and honor you.*

Word Restraint

The one who has knowledge uses words with restraint,
and whoever has understanding is even-tempered.

PROVERBS 17:27 NIV

*E*very believer hopes to be the person who controls their tongue and temper. It is an admirable quality to be able to rein in inappropriate speech and misplaced anger. What if we could only say things that respect God and feel angry only about things God is angry about? That would be perfection.

But we're not perfect. We're products of a fallen world. There are opportunities to compromise every day, but that's where God meets us. We need his help to follow his path of love. We rely on him to guide us in wisdom. We can't experience a healthy dependency on God, nor the love and grace he has for us, if we don't first understand our need for him. When we fail, we get back up, ask for forgiveness, receive grace, and do better. It's a beautiful dance as we get closer and closer to knowing our precious Redeemer.

Lord, each time I miss the mark, let me know. Please accept my repentance again and again and as many times as it takes for me to know you better. I'm grateful that you are full of loyal love every time I come to you. May my heart and words reflect the power of your mercy.

Fruit of Our Hearts

A man of crooked heart does not discover good,
and one with a dishonest tongue falls into calamity.
PROVERBS 17:20 ESV

We have all heard that we should not judge a book by its cover; this is true of people. If we make the effort to really get to know a person, we may find that our first impressions were far from the real picture. We have to take time to get to know the hearts of the people around us. The fruit will be revealed in due course. We must be willing to acknowledge what we observe, matching actions to words, and be honest about it. Hope doesn't have to die when we see bad fruit and constant calamity. Hope is needed most in dire places. This is where the Lord can shine his light and chase out darkness.

God's mercy meets us in the messes of life. Without need of his help, we may never experience the power of his redemption and love. He is a faithful guard and leads us in truth. Let's be honest with ourselves and with others, and lean on the help of God's gracious Spirit, who is our teacher in all things.

Thank you, God, for being good. I discover every good thing when I discover you.

October

Wisdom is the principal thing;
Therefore get wisdom.
And in all your getting,
get understanding.

PROVERBS 4:7 NKJV

Joyful Heart

A joyful, cheerful heart brings healing to both body and soul.
But the one whose heart is crushed
struggles with sickness and depression.
PROVERBS 17:22 TPT

God wants the best for us. This includes his delight! This is why he offers us his joy. His joy is greater than our situations and problems because it points us toward an eternity with him. It puts our temporary trials into proper perspective. Still, we need to nourish and care for both our bodies and souls. It is not more spiritual to ignore our physical wellbeing; he created our bodies to house our souls.

When Elijah was depressed and cried out that he wanted to die, God answered by having him take a nap and sending an angel to bake bread. See 1 Kings 19:4-6. Our loving Creator knows we're physical and spiritual beings, and he cares for our physical and spiritual needs. One way he does this is by filling us with his joy. Ask him for that today.

Your joy is nothing like what the world offers, dear Lord. It surpasses physical conditions and goes beyond circumstances. Please fill my heart with your everlasting joy and show me by your wisdom what I need to do to cultivate it today.

Fools Wander

The person with understanding is always looking for wisdom,
but the mind of a fool wanders everywhere.
PROVERBS 17:24 NCV

When the Lord directs our paths, he offers us his clear direction.
Sometimes, especially during transitional times, the view of the path
may appear little by little. We don't have to see the whole path to see
where we should plan our next step. When we graduate from school,
get married, have a baby, find a new job, retire: all these seasons are
critical for dependency on God. When we lean into his wisdom,
God shows us the way to move through transition. We see the next
step, gain clarity on issues, and can move ahead with confidence.

When we depend only on ourselves and whatever knowledge
we possess in the moment, we aren't tapping into the greatest
intelligence and wisdom in existence. We're caught in this place and
time, and that's the extent of our resources. We may look for wisdom
everywhere but where it actually resides. This is the foolish path.
Wisdom is knowing and relying on the source of wisdom itself: the
Almighty.

*Father, guide my steps as I look to you. You are the author of wisdom,
and I depend on you to direct me. Help me trust you when I can only
see one step ahead.*

He Holds Our Grief

Foolish children bring grief to their father
and bitterness to the one who gave them birth.
PROVERBS 17:25 NLT

God is a loving Father. Imagine the grief God must feel on our behalf when we, his beloved creation, choose to reject his love and live foolishly. Let's be wise, reject foolishness, and return again and again to God. He is always there to welcome us, just like the generous and loving father of the prodigal son. There is no joy like a reunion with those we deeply love.

How, then, do we deal with the grief of our loved ones walking away from us? We can pray for those wavering or wandering, even those who have rejected the truth, so they might return to their awaiting Creator. We can remain safe places for them to land when they walk the path back. Give everything to the Lord. He knows the pain and loss you feel, and he also knows the way to stay soft and centered in compassion. Prayer is critical, and love is the guide.

Lord, help me love the people in my family no matter what. Teach me to be like you and to keep coming back to you in my grief and pain.

Beaten Leaders

It is not good to punish the innocent
or to beat leaders for being honest.
PROVERBS 17:26 NCV

It's an injustice to punish people who are innocent, and it is a travesty to attack the honest as if they were liars. Still, we know history proves this can happen all too easily. When perceptions become more trusted than facts, we must rely even more on God. God is the origin of truth. He is the Creator of goodness, and he ordained our salvation in love.

God did not promise us a life of ease, never being misunderstood by others. There will be people who misalign our reputation. When the going gets tough, let's start praying and trusting God. He knows the truth, even when others miss it. It is critical to understand that all things are for God's glory. Let's not give up seeking the Lord and doing his will as best we can. There will be innocent people punished and honest leaders beaten, but we live to help any who are persecuted when they are within our reach. Let's stand on the side of truth, mercy, and justice, just as our heavenly Advocate does.

Let me be a light, Father, for those who are unjustly punished or persecuted. Help me see where I can help and move quickly to serve. And when I am misunderstood, help me to trust you as my defender and advocate.

Even Tempered

The one who has knowledge uses words with restraint,
and whoever has understanding is even-tempered.

PROVERBS 17:27 NIV

It is a miracle to witness how the Lord changes us once we follow and seek him. What a powerful transformation to behold in our own lives, and in the lives of those around us. Our bad behavior is corrected, and our words become encouraging. Love motivates us. Sincere care and concern emulate from God's people as they become vessels of his limitless love.

As we yield our lives to him, the Holy Spirit gives us an awareness of how we speak and act, as well as the impact we have on other people. We begin to care about God's love shining through our actions to others. We show restraint in what we say because we realize that our words are powerful. God's peace is our portion, and this is revealed as we stay unfettered by what others may say or do to us. There is great understanding in standing firm in peace and choosing the way of love in the face of chaos.

Lord, make me more like you. Give me your wise and caring character and let your words flow from my heart and through my mouth.

Silence Seems Wise

Even a fool who keeps silent is considered wise;
when he closes his lips, he is deemed intelligent.
PROVERBS 17:28 ESV

Learning how to listen well is an important part of growing in wisdom. Even a fool may seem wise when they learn to control their tongue. If we are to be like Christ, then we need to follow his example. Learning starts by listening and observing, always. If we are too busy doing our own thing, we may miss out on a major lesson.

Are you known for how much you talk? Or are you someone people go to when they need someone to listen? There is wisdom in silence, though of course that doesn't mean you should never share your own perspective. The more you bite your tongue under pressure, refusing to engage in pointless arguments, the wiser you become.

Lord, help me to measure my words well. May I not run my mouth around untrustworthy people, and may I be a safe space for others to tell me what's going on in their lives.

Better Together

Whoever isolates himself seeks his own desire;
he breaks out against all sound judgment.
PROVERBS 18:1 ESV

Isolation can lead to questionable judgment. Doing life with other people is challenging, but it's healthy and necessary. We are not meant to walk this life alone. We sharpen each other, support one another, and encourage each other in love. Being vulnerable with others keeps us accountable and honest. We won't stray off the path of God's wisdom when we walk hand in hand with sensible and committed brothers and sisters in Christ.

The importance of community cannot be overstated. Relationships are a gift from God to be treasured and fought for. Working through disagreements teaches us to care for others and set aside our pride. In the moment, it may seem easier to withdraw from the necessary work of relationships, but in the end, it is harder because none of us were meant to walk alone.

Lord, please remind me to prioritize fellowship with other believers so I don't bear unnecessary burdens on my own. Thank you for the power of community and for the way it lightens loads, encourages hope, and refines character.

Bridges Instead of Walls

A brother who has been insulted
is harder to win back than a walled city,
and arguments separate people
like the barred gates of a palace.
PROVERBS 18:19 NCV

Insults can be stronger than a fortified city. Once an emotional wall is put up, it's challenging to bring the relationship back to a place of trust and vulnerability. As ambassadors of Christ, it is important we think before we speak, avoid foolish talk, and use wise words. We don't want to ostracize others, but rather bring them in close. Love covers a multitude of sins, so let's not overlook its power in restoration. It builds bridges where indifference can put up walls.

The closer we are to someone, the deeper the insult may run if we hurt them. We care about the opinions of those we are closest to, so let's be especially loving and honoring within our closest relationships. It's easier to work on being kind at the start than it is to repair a wound already inflicted.

God, I don't want to hurt anyone, but sometimes offense occurs. Please teach me to speak wisely, forgive completely, and fight for the relationships worth fighting for. Keep me humble and kind and please broaden my perspective so I can better consider the feelings of others.

A Fruitful Harvest

From the fruit of their mouth a person's stomach is filled;
with the harvest of their lips they are satisfied.

PROVERBS 18:20 NIV

Short of medical intervention, nothing reaches the belly without first going through the mouth. Today's verse speaks about the fruit of the mouth, and it offers a quick leap to the fruit of the Spirit. To recap, Galatians 5:22-23 outlines the fruit of the Spirit as love, joy, peace, patience, kindness, goodness, faithfulness, gentleness, and self-control. Every one of these qualities can be made evident in our speech.

We speak out of our hearts; our mouths are just the vehicles. When we emulate the Holy Spirit, our thoughts, words, and actions reveal the fruit of his presence. When our hearts are infused with the fruit of the Spirit, thanks to the Spirit working in us, we feel fulfilled; we are satisfied, and we have much to offer others. We gratefully give more control to the Holy Spirit as we learn to trust him with every detail of our lives.

Holy Spirit, I welcome your presence in my heart. I am grateful for the work you are doing to produce the good fruit of the kingdom in my heart and life.

Spoken Word

Your words are so powerful
that they will kill or give life.
PROVERBS 18:21 TPT

Words hold a lot of power. God's written Word gives us life; the devil's wicked whisperings bring destruction and death. When we speak, it reflects what is in our hearts and spreads that message to others. What message have we hidden in our hearts? Whose words are we spreading? Both God and the devil have plans for our lives and the lives of those we impact. Let's refuse to complain, gossip, slander others, or be insulting with our words. Our words can further the plan of God which leads to life.

Speak encouraging words, words that cause people to think about things from a higher perspective. Words that give life are words sprinkled with the seasoning of wisdom. Let love compel you, and let peace be your guide. Healing words can bind up wounds, and gracious words can give hope. Choose well what words you speak.

Lord, make me aware of the power of my words. Please fill my heart with love and joy so it pours from my mouth. Teach me to be measured and tempered in all the words I speak.

Poor Versus Rich

The poor use entreaties,
but the rich answer roughly.
PROVERBS 18:23 ESV

So much of our time and energy is spent trying to change the behavior, decisions, or paths of other people. The two methods in today's verse give us insight into a heart's motivation. People who are poor have few resources and often little confidence from either failures or a lack of positive results for their efforts. Rich people have loads of confidence but little patience, so they don't always concern themselves with the impact their words are having on others. Both methods of getting changes lack one thing: God.

God doesn't beg or speak roughly. God stands righteously above the circumstances we find ourselves in, and he offers us a beautiful eternity by the repentance of our sins in the sacrificial blood of Christ. God wants each one of us to accept his love and grace, but he won't beg, and he won't force us.

Thank you, God, for your beautiful ways. Thank you for coming into my life and speaking to me with so much love and respect that there's no room for coercion or aggression. I love you deeply.

Friend of God

One who has unreliable friends soon comes to ruin,
but there is a friend who sticks closer than a brother.
PROVERBS 18:24 NIV

We are blessed when we have close friends, though that doesn't mean we haven't faced sticky situations with some of them. Even our closest friends sometimes fail us, but Jesus never will. He is the perfect friend, and he sticks closer than our closest friends and relatives. He never leaves us even when the days grow dark, and times are tough. He does not use us for his own gain but instead left his throne in heaven to come and save us.

He truly loves us for who we are and not who we could be. He's not interested in our wealth or fame; he wants a relationship. He cares about what we care about even if it seems unimportant to others. If it's important to us, then it's important to him. He is patient, caring, understanding, and always nearby when we need him. He is the perfect friend. Let's learn from his example and be good friends too.

Jesus, thank you for being my friend. Thank you for giving me other friends and for teaching me how to be a good friend. Friendship is valuable, and I don't take it for granted.

Do Yourself a Favor

Those who get wisdom do themselves a favor,
and those who love learning will succeed.
PROVERBS 19:8 NCV

*A*re you succeeding at life? What does that even mean? Would you measure on a scale of poor to rich? Failure to fame? Detestable to holy? We can look at how the Lord measures success. Consider Jesus' words in Matthew 16:26-27, "It is worthless to have the whole world if they lose their souls. They could never pay enough to buy back their souls. The Son of Man will come again with his Father's glory and with his angels. At that time, he will reward them for what they have done."

God does not care about the fame or fortune we accumulate; he doesn't even care about our "Good Christian Checklists." He wants us to take what he says to heart and live it out. He wants us to love others honestly and deeply. Without love, 1 Corinthians 13:1 describes our efforts as nothing more than a bunch of noise. We need his wisdom to know how to succeed, and we need to spend time with him to obtain it because true wisdom comes only from him.

Your Word, dear God, is rich in teaching. It is packed with wisdom and insight. Let love be the deep motivation in all I do, as it is for you.

Discretion

A person's insight gives him patience,
and his virtue is to overlook an offense.
PROVERBS 19:11 CSB

We know how difficult it is to rebuild trust and openness in a relationship once an insult has caused a wall to be built in the relationship. It's important to not only watch what we say and how we act toward others; it's also important to recognize the offense we hold on to in our own hearts. We can't control the actions, feelings, or decisions of others, but we can control our own. Nobody can build a wall in our hearts for us, and nobody else can speak from our mouth.

Offense is an easy snare to fall into because, in some backwards way, it can feel good. Do you know what feels better and is healthier and more beneficial? Forgiveness. Self-control. Love. Instead of being quick to anger and holding on to offense, let's remember how much grace, patience, and forgiveness God has shown us. That should spur us on to be gracious, patient, and forgiving with others, generously sharing what we have already received.

When I am tempted to be offended, Lord, remind me of the grace you have shown me. I want to live in love and not offense.

Accepting Correction

Listen to advice and accept discipline,
So that you may be wise the rest of your days.
PROVERBS 19:20 NASB

God uses many methods to teach and nurture us; he nudges our conscience through the Holy Spirit, he speaks to us through Scripture, and he places wise people around us to offer encouragement and counsel. It is up to us to accept or reject counsel and correction, but we will be wiser and our lives more blessed if we humbly listen and receive it.

Correction may not feel good in the moment, but it helps to refine our character. We are told in Hebrews 12:6 that God disciplines us because he loves us. The next time you are called to accountability, someone wise offers you correction, or God turns the tables on your plans, instead of rebelling, quiet your heart and listen. God loves you, and he does not want you to keep going down a path that will lead to harm.

Lord, thank you for your truth and your love. Thank you for being a caring father who doesn't leave me to my destructive tendencies. Thank you for the people you have put in my life who call me to a higher standard and help me grow.

By Design

A person may have many ideas concerning God's plan for his life,
but only the designs of God's purpose will succeed in the end.
PROVERBS 19:21 TPT

Are you a visionary, making constant plans for the future, or
do you let it unfold while pressing into the present? Perhaps you
find yourself somewhere in the middle. Whatever your persona,
you probably have some ideas as to how your future will unfold.
It's important to plan, but it's even more vital to stay flexible and
available to God's interventions. We may feel as if we can control
our futures, but the truth is that we cannot predict what will happen
tomorrow with certainty. Rest assured: God has a perfect plan in
place. He has proper perspective and knows what is coming down
the road.

What has God laid on your heart to accomplish? If this is a difficult
question to answer, imagine what you would spend your time doing
if money were not an issue and you knew you wouldn't fail. God has
designed you with a purpose. You can partner with him by doing
your best and trusting him with the rest. What ideas has God put in
your heart, and how are you aligning your life with them today?

*God, thank you for using my surrendered heart and life to further
your purposes. I want to glorify you!*

Loyalty Is Attractive

Loyalty makes a person attractive.
It is better to be poor than dishonest.
PROVERBS 19:22 NLT

It doesn't take long to learn that the character of a person matters more than physical looks. The way we treat others matters more than how put-together we appear. It's also amazing how our looks are affected by the condition of our hearts: the kindness we show to others, the way we speak, and our loyalty. If we show up for our friends, that means something. If we defend people when others speak poorly about them, that can change hearts and increase trust. People who stand up for others in the face of derision or conflict show they are not intimidated by oppressive voices or cruel intentions.

At no point does God want us to forfeit our integrity. Loyalty to our word and to our loved ones matters. Honesty is a confident way of life. We can live like an open book, with nothing to hide. Even when we face poverty, discrimination, or persecution, nothing is worth wavering from the truth and beauty of our wise, loving, and gracious God.

Give me strength, oh Father, to say what needs to be said when it needs to be said. Help me not waver in the moment that matters. Help me stay true to you and others.

Good Fear

The fear of the LORD leads to life,
and whoever has it rests satisfied;
he will not be visited by harm.

PROVERBS 19:23 ESV

To fear God is to be awed by him. When we live surrendered to God's great love, letting awe of his majestic mercy move us, we will experience the satisfaction of his abundant life in ours. We will know the continual protection of his presence. We will taste and see that the Lord is indeed good!

God is our Maker, and he knows us better than anyone else. He delights in us discovering his goodness as he sows seeds of mercy and kindness into our lives. Following in his wise ways proves to be a continual feast of joy, even when we walk through the shadows of this life. He is always near, always ready to help, and full of life-giving peace for all who seek him!

Dear Lord, lead me in your way and teach me to rest in the plan you have made for me. Every time I catch a glimpse of your glorious love, I am filled with awe for who you are. You are better than the best of men!

Food Not Eaten

Lazy people take food in their hand
but don't even lift it to their mouth.
PROVERBS 19:24 NIV

Psalm 34:8 says, "Taste and see that the Lord is good; blessed is the one who takes refuge in him." In John 6:35, Jesus declared, "I am the bread of life. Whoever comes to me will never go hungry, and whoever believes in me will never be thirsty." We taste and see that the Lord is good when we come to Jesus and surrender our hearts and lives to him. He invites us to know him, to be filled on the goodness of his presence, to drink from the wells of his living waters and never thirst again.

Spiritual laziness is something we can choose to change. How often do we hear the Word of the Lord but don't put it into practice in our lives? Hearing the Word and then doing what it says is like taking the food in hand and then chewing and swallowing it. Wisdom is found in incorporating the wisdom of Jesus into our lives.

Thank you, Jesus, for your satisfying Word that meets my hunger and the living water of your presence that satisfies my soul. I will not only be a hearer of your Word today, but also a doer.

Listen Closely

If you stop listening to instruction, my child,
you will turn your back on knowledge.
PROVERBS 19:27 NLT

Wisdom requires a life-long venture of learning. When we enter young adulthood, we may feel as if we've passed the test and no longer need to actively learn. This is foolish, however. We will soon realize, through trial and error, how little we know. God's wisdom is infinite. There is always more for us to learn from him. Let's give up the pride of thinking we have already arrived and instead lean into the humble attitude of a student.

Surely, there are different lessons to learn as we mature. The tactics of learning are not the same in high school as they are in kindergarten, and that is for good reason. We progress through developmental stages, and this is true in our spiritual journey, as well. In all things, let's trust God to teach us the appropriate lesson. If we keep our hearts humble and our minds open to him, there's no doubt that we will continue to learn all the days of our lives!

Father, thank you for teaching me and guiding me through every stage of my life. I know there is still so much room to grow and to mature in your wisdom. I am listening and watching today, Lord.

Be Careful

Wine is a mocker and beer a brawler;
whoever is led astray by them is not wise.
PROVERBS 20:1 NIV

The effects of substance abuse are not limited to the one caught in addiction. It affects everyone in their lives, from family, friends, to those in their workplace. It's no laughing matter when addiction tears at our loved ones and leaves them unrecognizable and unpredictable. It is a heavy weight of grief for everyone involved. At some point and on some level, this behavior was a choice. It's never our place to judge someone who struggles with addiction, but we do well to be wary of our own tendencies and reach out for help as soon as we need it. These cycles cannot be broken on our own or by sheer strength of will. Support and intervention are necessary to experience freedom.

There are some behaviors that do little to add value to our lives, but they offer many opportunities to harm us. Let's be careful about moderation, about what activities we participate in, and keep God at the center of our lives. Wisdom keeps us from overindulgence and on a path that leads to a peaceful life.

Lord, you are my Lord and King. I am grateful for your standards and instructions because you are the source of wisdom. Show me when my likes become addictions before it goes too far.

True Friends

Many will say they are loyal friends,
but who can find one who is truly reliable?
The godly walk with integrity;
blessed are their children who follow them.

PROVERBS 20:6-7 NLT

True friends show each other respect, and they don't let petty things build between them. They overlook the little annoyances, though they do address with clarity real areas of hurt. Loyal friends want the best for each other and don't disappear when life gets tough. There's an old African proverb that says, "If you want to go fast, go alone. If you want to go far, go together."

God did not design us to walk through life alone, so take time to slow down and help your friends. If you need help, reach out, ask for it, and find out who your loyal friends are. Jesus showed us through his own life what it means to be a true friend, so let's follow his example. Truly loyal friends are rare, so hold on to them and do your best to be one yourself.

Lord, teach me to walk with integrity and be a loyal friend. I want to be someone my friends can trust and count on to be there for them. Thank you for being my friend and giving me friends I can turn to.

Work for Wealth

Wealth inherited quickly in the beginning
will do you no good in the end.
PROVERBS 20:21 NCV

Having wealth handed to us might be a common fantasy, but it will not do us any good in the end. Paul wrote to the Ephesians about the God-given need we have to work. "God has made us what we are. In Christ Jesus, God made us to do good works, which God planned in advance for us to live our lives doing," according to Ephesians 2:10. The essence of work didn't start with people; it started with God.

After working for six days to create all we know and love, God rested. We read in Genesis 2:2, "By the seventh day God finished the work he had been doing, so he rested from all his work." Since we are created in his image, and the first activity we know God did was work, it's logical to assume we will be happy and fulfilled behaving as our Maker did. Work gives us a purpose and a sense of satisfaction. When we earn what we have, we value it more. We can use wisdom with our earnings and build toward a brighter future, but let's not sit around and wish our well-earned lessons away just for money!

Thank you, Father, for the work that is mine to do. I am grateful to know it can bring me closer to you. I offer you all the work of my hands today, and I ask for you wisdom to guide and teach me.

Wait on the Lord

Don't say, "I will get even for this wrong."
Wait for the LORD to handle the matter.
PROVERBS 20:22 NLT

In a moment of attack or persecution, it may take supernatural power to refuse to retaliate. How do we not slap the person who slaps us? Retaliation is reactionary and based in self-protection and pride. This is not the way of the cross. Jesus instructs us to follow his example. "You have heard the law that says the punishment must match the injury: 'An eye for an eye, and a tooth for a tooth.' But I say, do not resist an evil person! If someone slaps you on the right cheek, offer the other cheek also" (Matthew 5:38-39).

It takes intention and strength to let offenses go. This is a supernatural act of grace and mercy. It helps when we humble ourselves and remember how much we have already been forgiven. When we focus on God's saving grace, we pull from that resource to offer others. When we are filled to overflow with the love of God, we can more freely give that love away. Jesus' way is paved with kindness, and he helps us to follow in his footsteps.

Lord, I don't want to hastily retaliate against those who hurt me. I know that is a fool's errand that only escalates harm. Help me to be wise and to be gracious with others, waiting on you to handle it rightly.

Dishonest Scales

The LORD detests double standards;
he is not pleased by dishonest scales.
PROVERBS 20:23 NLT

It's arguably harder today to skew a scale than it was in biblical times, but that means people have just become more creative in their efforts to cheat and steal. The problem hasn't gone away; it's simply different. The point is the same: God hates double standards and dishonest forms of measurement.

Integrity is a hard-earned quality. Paul prophesied about people abandoning integrity in 2 Timothy 3:2-5, "For people will love only themselves and their money. They will be boastful and proud, scoffing at God, disobedient to their parents, and ungrateful. They will consider nothing sacred. They will be unloving and unforgiving; they will slander others and have no self-control. They will be cruel and hate what is good. They will betray their friends, be reckless, be puffed up with pride, and love pleasure rather than God. They will act religious, but they will reject the power that could make them godly. Stay away from people like that!" What more is there to say?

Jesus, thank you for a measure of what not to do so that I can stick close to integrity. I choose your wise ways instead of seeking shortcuts and pride that puffs up.

Trust God

A person's steps are directed by the LORD.
How then can anyone understand their own way?
PROVERBS 20:24 NIV

Independence is highly valued, so it can be difficult for believers to understand what a healthy dependence on God looks like. Jesus called himself the vine and his people the branches (John 15:5). We understand that the branches are dependent upon the vine for their lives, and we should consider our relationship to God nothing less. When we depend on God, spending time in his Word plays an important role. We'll find wisdom and direction for much of what we need in daily life there.

Prayer is another vital step in depending on God. There is no magic formula to praying, though if we need a place to start, Jesus showed us what that looks like in Matthew 6:9-13. Prayer is simply conversing with God. Still, there are times when we have no words. In this case, Romans 8:26 says, "The Spirit helps us…We do not know what we ought to pray for, but the Spirit himself intercedes for us through wordless groans." Dependence on God is a beautiful thing, and it reminds us that we are never alone. Spend time in his Word and in prayer today, and you will cultivate greater trust in him as you do.

Jesus, I depend on you today. Thank you for directing me in wisdom.

A Wise King

A wise king sorts out the evil people,
and he punishes them as they deserve.
PROVERBS 20:26 NCV

We aren't guaranteed wise leaders over our nations, in our workplaces, or even in our churches, but we are told what they act like. Today, we read that the bad guys don't get a pass. Wise leaders do not cover up corruption or abuse. Everyone is accountable for their choices, and they are held to a high standard. So, what do we do when our leaders aren't so wise?

There are a couple things to keep in mind. First, God puts leadership in place, and we are to respect it for that reason as Paul reminds us in Romans 13:1, "All of you must yield to the government rulers. No one rules unless God has given him the power to rule, and no one rules now without that power from God." Second, God is the ultimate authority: "The Lord has set his throne in heaven, and his kingdom rules over everything," as the psalmist declares in Psalm 103:19. At the end of the day, a human ruler is put in place for now, but whether they are good or evil, God is the ultimate ruler over all eternity and throughout the universe. We can trust him to hold all people accountable.

Lord, I praise you for your power and dominion. Thank you for your righteous standards. I trust you.

Steadfast Love

Steadfast love and faithfulness preserve the king,
and by steadfast love his throne is upheld.
PROVERBS 20:28 ESV

Of the thirty-nine books in the Old Testament, over half of them talk about steadfast love. Over a third of the chapters in Psalms discuss it. Each of the twenty-six verses in Psalm 136 tells us that God's steadfast love endures forever. Along with God's steadfast love are his mercy and grace. "The Lord is gracious and merciful, slow to anger and abounding in steadfast love" (Psalm 145:8). All good leadership is built on love and truth, and God is the greatest leader of them all.

Jesus Christ is our almighty and worthy king. His steadfast love and faithfulness preserve his nature, and he will never change! We can trust his loyal love at every turn. He will continue to faithfully follow through on all that he has promised, and he will not let up in grace, peace, and mercy. Every time we come to him, we find the same benevolent king! Run into his presence and feast on his unchanging love today.

Mighty King, I'm so grateful your nature is unchanging and that your love is steadfast through the ages. I come to you with my heart humble and my arms wide open to receive from your loving and wise truth. I am yours!

Experience Is an Honor

The young glory in their strength,
and the old are honored for their gray hair.
PROVERBS 20:29 NCV

Gray hair is often equated to experience or wisdom in Scripture. While the young are admired for their youthful vigor and beauty, the older generations are honored for their experience and well-earned wisdom. There is something in every generation and age to admire and honor. Don't let anyone convince you that your value is a thing of the past.

The different generations need each other. The younger ones have so much to learn from those who have gone before, and the older generation can be rejuvenated by the energy of the younger ones. Let's not neglect intergenerational friendships, for they add so much value to our lives and help us see from different perspectives. The more we lean on the lived wisdom of older women, we can save ourselves from the trouble of making unnecessary mistakes. Also, our perceptions are widened to see how faithfully God works through the generations and it can inspire and encourage us in our own walks with the Lord today.

Lord, what a gift it is to know people from different generations. Help me to honor and really listen to the wisdom of those older than me. Help me, too, to remember to sow into the lives of younger women.

A King's Heart

The king's heart is like a stream of water directed by the LORD;
he guides it wherever he pleases.

PROVERBS 21:1 NLT

Today's verse may sound mysterious, but it is actually simple. The Lord can direct a king's heart as easily as he can steer the course of a stream. It is not difficult for him. This is really good news for those of us who are children of the King of kings!

First Peter 2:9 tells us, "You are royal priests, a holy nation, God's very own possession. As a result, you can show others the goodness of God." In Christ, we are royal children—kings and priests. With that in mind, let's trust that, as we continue to yield to the wise leadership of our Father, he directs our hearts wherever he pleases. His wisdom moves us where he wants us to go. We can trust him, for it is not difficult for him! Let's rest in the confidence that God is at work in our hearts, and we don't have to strive today. We get to rest in the flow of the river of his goodness.

Father, thank you for moving in my heart. I am yours, and I depend on you. Give me confidence to trust you more today.

God's Standard

Every person's way is right in his own eyes,
But the LORD examines the hearts.

PROVERBS 21:2 NASB

Although a person may be able to live a double life for a while and get away with it, nobody can fool God for a moment. There are many excuses we can make for our foolish choices, making them seem right in our own eyes, but the Lord examines the truth of our hearts. It is important that we remain humble under his leadership and allow him to reveal the truth hidden in our hearts.

The Holy Spirit leads us into righteousness. As John 16:13 says, "When…the Spirit of truth comes, He will guide you into all the truth." We can trust that with the Holy Spirit leading us in life, the truth of our hearts will be revealed. God's standard is higher than man's, but it is also better. The prophet Amos said God holds the plumb line (see Amos 7:7-8). A plumb line is a tool that sets the standard for a straight line by which an entire building is constructed. If we measure each area of a building by a separate standard, it will not align perfectly and will fall apart. In the same way, God holds the standard for our lives. The Holy Spirit keeps us in alignment with God's standard.

Father God, I can't hide anything from you; you see what lies in my heart. Your standard is perfect, and I choose to align myself with you today.

November

Get wisdom and understanding.
Don't forget or ignore my words.

PROVERBS 4:5 NCV

Diligent Plans

The plans of the diligent lead surely to plenty,
But those of everyone who is hasty, surely to poverty.
PROVERBS 21:5 NKJV

God does not intend for us to live in a *feast or famine* way. Some life seasons are more difficult than others, but he wants us to create healthy habits to live by. He wants us to spend time with him even if we're extremely busy. He wants us to be generous even if money is tight. He wants us to depend on him even if it seems like we have everything under control.

If we don't intentionally spend time with him when our schedules are open, then our time with him will be the first thing we neglect when our calendar is packed full. If we aren't in the habit of living generously when we have extra, then we'll hoard even more when we're barely making ends meet. If we wait until we're in a difficult season to ask him for help, then we fail to reap the benefits of his generosity in times of calm. Let's nurture his wisdom in every season.

By your strength and for your glory, dear God, I want to learn how to work diligently. I commit to forming and keeping healthy habits. I will not wait until times are tough to turn to you. I need you every day regardless of how the day is going.

Wandering

When you forsake the ways of wisdom,
you will wander into the realm of dark spirits.
PROVERBS 21:16 TPT

Walking away from God doesn't happen overnight. Little by little, standards bend, morals loosen, and eyes wander. Our hearts follow our eyes, and our feet turn. Suddenly, we look up and realize we are lost. We didn't *fall from grace* with one big swan dive; we took our eyes off the Lord and took small steps in the wrong direction.

Daily decisions matter. Walking in wisdom means taking intentional, accountable steps and not being led astray by whims and impulses. It may be time to focus on our convictions, community, daily devotionals, and our time spent in prayer. Are we heading in the right direction, or are we slowly stepping off course?

Lord, with you is fullness of life. Keep me close to you, dear Lord, and when I start to stray, open my eyes and understanding to align with your steps once more.

Pursuit of Righteousness

Whoever pursues righteousness and kindness
will find life, righteousness, and honor.
PROVERBS 21:21 ESV

Why waste our lives pursuing what doesn't last? The pursuit of self-gratification is an empty, pointless quest. When we chase after temporal things, the satisfaction is fleeting and the mark always moving. This world and its wonders are passing away, but God's kingdom will reign forever. Therefore, let's be devoted to pursuing what will last. We can commit ourselves to righteous living and to being kind. Isn't that more important than getting ahead or being admired?

If our admiration is truly for the Lord, then we won't be so insistent on making sure our names are known. Our actions and attention will be fixed on what is truly important and lasting. Let's abandon the rat-race way of living that leads to burnout and disappointment. Accolades fade quickly, but the favor of God lasts forever. Fame and wealth are fleeting, but the kingdom of Christ endures.

Heavenly Father, your Word explains that if I pursue righteousness and kindness, I will find what I am looking for. I will find life, honor, and most importantly you. It is my prayer and pursuit every day to find you.

City of the Mighty

One who is wise can go up against the city of the mighty
and pull down the stronghold in which they trust.
PROVERBS 21:22 NIV

A city is organized and implemented through policies and
politics. Wherever there are people, there is a need for structure.
These structures are held in place through agreements, force, or
a combination of the two. Cities also need protection; in biblical
times, cities often used thick walls to fortify their security. These
strongholds could be overcome but not easily.

Wisdom is more powerful than policies or politics. The opinion of
the masses can be swayed, but God's wisdom stands true forever.
Individual hearts come to know God's wisdom through fellowship
with Christ and learning from his Word. Policies and politics, both
good and dangerous, will come and go; the kingdom of God has
perfect policies and politics because they have been implemented by
the Almighty God. We can breathe in relief and lean fully on him.

*Lord, show me wisdom in the policies and politics around me. Help
me know you better so I have the gift of discernment. Help me follow
the governments of my land because authority is put in place by you
for your purposes.*

Tame Your Tongue

One who guards his mouth and his tongue,
Guards his soul from troubles.
PROVERBS 21:23 NASB

Careless words are like fire: they can spread fast and quickly become uncontrollable. Once a word has left your lips, you no longer control it; it has been set free. Think about what words you want running free in the world because they may come back to haunt you if you.

The Bible warns us about the power of the tongue in James 3:5-6, "See how great a forest is set aflame by such a small fire! And the tongue is a fire." Like fire, our words can offer others warmth, light, and encouragement, or they may cause great harm and destruction. Choose wisely because you can't reclaim a word once it has been spoken. Remember, though, God's redemptive love covers a multitude of sins. If you find yourself in regret and needing to pick up the pieces after speaking careless or hurtful words, humble yourself in love. You save yourself trouble by learning to tame your tongue, and a humble heart knows when to admit when it has messed up.

Your Spirit, dear Lord, offers wisdom and discretion. Teach me to listen and think before I speak. Make me aware of my words and considerate of others.

Remain Open

People who act with stubborn pride
are called "proud," "bragger," and "mocker."
PROVERBS 21:24 NCV

When we elevate our own preferences and opinions above others, we wade into the dangerous territory of pride. Pride digs its heels in to protect its own perceptions instead of making room to learn and grow from others. Wisdom is found in remaining open to learning and admitting when we are wrong so we can turn from our ways and embrace a better one.

Pride is not a sign of strength; it is actually a sign of foolish delusion. None of us is perfect. Pride protects our egos, while humility allows us to grow in character. Stubbornness is not a sign of wisdom. Unwillingness to entertain a different opinion keeps us stuck in the limitations of our knowledge. There is so much room to grow outside of our own experience! Let's follow Christ on his path of grace and mercy, where weakness is welcome. In fact, that is where our strength is found.

Jesus, help me to reject stubbornness and pride. I humble my heart before you today. Holy Spirit, teach me and guide me in the ways of Christ.

Lord's Victory

The horse is made ready for the day of battle,
but victory rests with the LORD.
PROVERBS 21:31 NIV

There are many ways we can cultivate our closeness with the Lord. We can read, pray, and be diligent in turning to the Lord. We can volunteer and work for the kingdom, and that is all good. We can donate and fundraise to promote the Lord's purposes. We can cultivate the fruit of the Spirit in our hearts and lives. We cannot, however, do what only the Lord can do. With him is the victory.

It is good to prepare ourselves and to stay ready for whatever God leads us into. Still, it is important to remember that we cannot control how or when breakthrough will come. We remain faithful to our part, and we trust God to be faithful to his greater promise. Let's leave what is God's responsibility with him and rest in his trustworthiness. He will come through! Let's keep walking in his wisdom as we wait on him.

Thank you, Lord, that victory is yours. I can prepare on my end, but the battle is won with your power, not my own. Thank you that I get to partner with your purposes in waiting and in action. I trust you!

Better than Gold

Choose a good reputation over great riches;
being held in high esteem is better than silver or gold.

PROVERBS 22:1 NLT

A good reputation is worth more than great wealth. This may not play out in the world around us, but it is true in the kingdom of God. Riches come and they go. Money can be earned and lost. But a good reputation is built over time and holds with it a weight that cannot be stolen.

A good reputation starts with strong character. It doesn't matter if we are well-known if what we are known for doesn't match the reality of our hearts and lives. A façade will fade, but those who build their lives with integrity, honesty, kindness, and peace build upon the strong foundation of God's love. False accusations will have no place to land, and the truth will stand firm. If we compromise our convictions and live double lives, however, those will be revealed in time. Let's walk in the wisdom of God's ways. There's no reason to hide when we live in the light of truth.

Lord, I know that a good reputation is built with good character. I choose to walk in the wisdom of your love, pursuing peace and acting justly, generously helping others when I can. May I reflect you in all I do.

Reward for Humility

The reward for humility and fear of the LORD
is riches and honor and life.

PROVERBS 22:4 ESV

Pride will end up costing us everything whereas humility leads
to a rich and honorable life. Surrendering our lives to the Lord and
allowing him to guide us guarantees we will know the abundance of
his life. Jesus said in Matthew 16:25, "Whoever would save his life
will lose it, but whoever loses his life for my sake will find it." If we
only live in self-protection, we will lose what we could have known.
However, if we live yielded to Christ, we will find true life in him.

The only path to life is through God, and living in awe of him
compels us to make healthy, wise decisions. We haven't yet seen the
full majesty of our God, but if we understood exactly who we serve,
we would not hesitate to follow him. He is full of laid-down love
that goes to the ends of the earth to meet us. He is also the King and
Creator of the universe whose power is unmatched. He is love and
justice, mercy, and truth. Let's remember there are consequences for
the proud and rewards for the humble.

Lord God, I choose the humble path and follow you.

Careful with Debt

The rich rules over the poor,
and the borrower is the slave of the lender.
PROVERBS 22:7 ESV

*P*aul wasted no time telling Christians what they should do about debt in Romans 13:8, "Owe no one anything, except to love each other, for the one who loves another has fulfilled the law." Our money should be secondary to loving one another. Those with money tend to hold the power, but we are not to let anything get in the way of Christ's mandate to love one another. As far as we are concerned, we should try our best to avoid debt and be gracious with those who have less than us, sharing resources freely.

Money is a powerful force and always has been, but God is more powerful. We are to submit ourselves to God and to serve him first. If we owe anyone money, it is best to deal with it sooner rather than later. We are indebted to the one to whom we owe money, and God doesn't want his people compromised in that way. Work toward resolving your debt, and trust God to help you do it.

Lord, help me to take steps toward paying my debts. Give me persistence and integrity to resolve it and to live within my means.

Portion of Peace

Drive out the mocker, and out goes strife;
Quarrels and insults are ended.

PROVERBS 22:10 NIV

We all know people who seem to breed chaos and problems wherever they go. Though we cannot isolate ourselves from troublesome people in every area of life, we can certainly decide how close we let them. Do you have a friend who makes everything about her? Does she sow trouble between you and others? Does she refuse to make space for your own struggles? Is she exhausting to be around?

Dear one, maybe it's time you put some boundaries around that friendship. Perhaps you only agree to be around her with others. Maybe you decide that you simply do not share your vulnerable self with her anymore and leave that to your trusted and trustworthy friends. Protect your peace. It's worth it.

Lead me in your way, Lord, in my friendships. I'm not looking for perfection, but I also can't be close with a person who makes me feel bad about myself when I am with her. Thank you for your wisdom, discernment, and love that leads me in putting necessary boundaries in my relationships.

Don't Crush

Do not rob the poor, because he is poor,
or crush the afflicted at the gate,
for the LORD will plead their cause
and rob of life those who rob them.

PROVERBS 22:22-23 ESV

Our Lord is Lord of the vulnerable. He does not side with powerful oppressors; he is with the underdog. He is the defender of the defenseless, those young, old, poor, and alien among us. He loves the blind, the deaf, the lame, and the mentally challenged. To make this eminently clear, God sent his one and only Son to be born in poverty. He was a baby in a poor family in an oppressed people group. Trouble lays heavily on all these people, and God invited trouble to rest on Jesus' shoulders for the ultimate plan of salvation.

1 Samuel 2:8 says, "He raises up the poor from the dust; he lifts the needy from the ash heap to make them sit with princes and inherit a seat of honor. For the pillars of the earth are the Lord's, and on them he has set the world." Things will change; oppression will not last forever. The poor are challenged now, but they will live in abundance later. Don't neglect any of these people for they hold our Lord's heart. They are his beloved.

Let me see your heart, Lord, and let me love those you love. Make me a servant to those who are beaten down, overlooked, and afflicted.

Not Like Them

Don't make friends with quick-tempered people
or spend time with those who have bad tempers.
If you do, you will be like them.
Then you will be in real danger.

PROVERBS 22:24-25 NCV

There is relief and blessing in following the wisdom of today's proverb. God is full of peace, and he wants us to be a people of his peace, controlling our words and practicing patience in the face of conflict. When God's peace reigns in our hearts, we are able to measure our words rather than being quick to anger. It is best to avoid those who use volatile speech to heighten emotions because that is not of the Lord, and it has bad repercussions on people around such behavior.

Romans 16:17-18 instructs, "Brothers and sisters, I ask you to look out for those who cause people to be against each other and who upset other people's faith. They are against the true teaching you learned, so stay away from them. Such people are not serving our Lord Christ but are only doing what pleases themselves. They use fancy talk and fine words to fool the minds of those who do not know about evil."

Speak to me, Lord, when I need to leave a situation or a relationship. Let me know if I need to be the one to step in or out to best honor you.

Prioritize Your Energy

Don't wear yourself out trying to get rich.
Be wise enough to know when to quit.
PROVERBS 23:4 NLT

If we spend our energies comparing ourselves to those who are rich, we waste so much of what we could be giving to better endeavors. Comparison is a trap when it means we are endlessly striving for something that is out of reach. How much better is it to focus on the resources and blessings we already have and cultivate them?

It is wise to surrender our selfish ambition. It is not wrong to build a better life, but to what end? And why does it need to look like a specific level of comfort or status? Let's rid ourselves of envy, focus on cultivating the values that actually matter deeply to us, and pour ourselves into our relationships, our communities, and into our fellowship with God. There is a wealth of wisdom available to you today, right where you are, so give up striving and focus on where God meets you in the reality of your present day. There is beauty to uncover right there in front of you!

Thank you, Lord, for the clarity of your wisdom. I don't want to work for things simply to appease my vanity: a bigger house, a nicer car, etc. Help me to put my energy into the present and pour into what matters most.

Your Thought Life

For as he thinks within himself, so is he.

PROVERBS 23:7 TPT

It is important to cultivate our thought life, to recognize the fruit of our mindsets and to challenge them when they don't align with God's wisdom. Not every thought is even something we believe. Some of them are reactions to our environment. Some thoughts come from something we've listened to or watched. It is wise to get curious about our thoughts without judging them. We can learn to direct the stream of our thoughts by taking them captive.

Though not every thought is born out of a belief system, many are. It's important to fill our minds and hearts with the wisdom of Christ so that we can filter our thoughts through his lens of truth and love. Let's not be lazy about our thought-lives, simply becoming products of our environment. Let's think critically, question our biases, and let love cover every motive so it moves us closer to Christ.

Lord, thank you for renewing my mind in your redemption. I yield my thoughts to you and your higher wisdom. Help me to direct my thoughts in ways that please you and reflect your values.

A Hopeful Future

There is a future,
And your hope will not be cut off.
PROVERBS 23:18 NASB

If you are exhausted or discouraged, remember the future God promised his children. Perhaps life has beaten you down, and regardless of how hard you fight, it doesn't feel like you're winning. Beloved, you have already won! Turn your eyes back to Christ and trust him with your future. Yes, we still need to be responsible and do the work that is ours to do, but we do not need to worry about the future. That is in God's hands.

Make plans and be wise, but don't lose hope. There is a big difference between diligence and desperation: one works hard but with a heart of peace and faith while the other works fearfully, having given way to hopelessness. If you don't have hope for the future, perhaps it's time to ask God for renewed vision and a reminder that he is faithful and trustworthy. The Lord always fulfills his promises.

Oh God, no matter how bad things become, there is always the promise of a great future with you. I refuse to become discouraged, I cling to your hope, and I choose to follow you. Help me to keep my eyes fixed on you.

Right Paths

Listen, my son, and be wise,
and set your heart on the right path.
PROVERBS 23:19 NIV

If we want to make right decisions that lead us down paths of righteousness, then we need to listen to the wisdom of God. It is paramount that we take Christ's words seriously. His law of love is not something that we can opt in and out of if we truly want to be wise.

As we set our hearts on the right paths, our feet will follow. We don't have to worry about tomorrow because no matter what comes, we are following the loving lead of our Savior. He never leaves or forsakes us. He is there to guide us in the light of day and in the black of night. When the fog of chaos leaves us disoriented, it is important that we trust his instructions. One foot in front of the other. Wisdom begins with listening, and it comes back to it, too. Never grow so self-assured that you forget to listen for the guidance of your good shepherd. And even when you do, you can redirect, dear one. Listen for his voice today and follow his wise advice.

Good Shepherd, thank you for your loving leadership and your trustworthy guidance. I rely on you to lead me into right decisions today.

Reason to Be Glad

Make your father and mother happy;
give your mother a reason to be glad.
PROVERBS 23:25 NCV

In this proverb, there aren't any qualifiers about whether your parents are Christians or even good people. We are told to work to make our parents happy. This doesn't mean we bend to their every whim. The preceding verse states, "when a father observes his child living in godliness, he is ecstatic with joy—nothing makes him prouder" (verse 24 TPT). When we pursue godliness, we honor our parents because we choose to live with integrity. We choose the right way rather than the easy way. This reflects well on any parent.

It is always the best choice to choose the path of wisdom and integrity. Honesty pays off, and so does hard work. When we live with kindness in our interactions and gracious generosity in our lifestyles, we bring honor to God and all who know us.

Lord, help me to be persistent in wisdom, honesty, and generosity. I want to walk in your ways and bring honor to my loved ones because of it.

Give Your Heart

My son, give me your heart,
and let your eyes observe my ways.
PROVERBS 23:26 CSB

When we give God our hearts, we commit to trusting him and following his ways above our own. We trust that he knows what is best, and we take him at his word. He is faithful to every promise. There's no need to worry about anything because God will take care of us, even when unforeseen trouble comes our way. We look to the example of Christ and model our lives after him. We learn to love his Word and look forward to spending time with him in prayer and worship.

If spending time with God feels like a chore, you may not truly understand who he is or what he's like. If God's ways seem rigid or unnecessarily restrictive, then you probably haven't yet recognized the extraordinary generosity of his love. God wants to give you more than you can imagine, and he has amazing adventures to take you on.

Almighty God, I am often prone to worry. Teach me again and again about your power and faithfulness. Open my eyes to your ways and enthrall me with the great adventure of life with you. Thank you for being patient with me.

Builders

By wisdom a house is built,
and by understanding it is established.
PROVERBS 24:3 ESV

Wise people are good builders. They consider the whole of their undertaking rather than jumping in without foresight. They consider the materials and cost of what is needed, and they bring in qualified experts to advise and work with them. Wisdom establishes something that lasts. This is true of relationships, legacies, and communities. Wisdom does not work to only benefit itself; it always works for the greater good.

Understanding and insight are not born in isolation or brought out of thin air. It is wise when we enlist knowledgeable advisors to help guide our steps. We can have our blueprints in place, but nothing is built by sheer imagination. Determination, persistence, and work will produce something that lasts. Let's remember that! Thankfully, God is there through it all, helping us with what only he can do.

Lord, help me to be a builder: of people, of truth, and of love. I want my life to reflect your wisdom. Help me to grow in your understanding.

Hopeful Wisdom

Know that wisdom is such to your soul;
if you find it, there will be a future,
and your hope will not be cut off.
PROVERBS 24:14 ESV

God has given us his Spirit to help us navigate this world. The enemy wants to cut us off from God's grace and steal away our hope and joy. He wants us to fail and fall.

That is why wisdom is so valuable; it recognizes and relies on the promises of God. It can identify and disable the traps of the enemy, and it offers focus and purpose to our lives. A wise person is filled with hope and understanding. They know the devil's threats are easily thwarted when God is on our side. Whatever else you do, first find wisdom. It is fuel to your hope and life to your soul.

Thank you, Lord, for giving me your Spirit and wisdom. By your greatness, I can succeed in every good work and escape the snares of the enemy. When my hope is firmly rooted in you, nothing can overcome it.

Get Back Up

The godly may trip seven times, but they will get up again.
But one disaster is enough to overthrow the wicked.
PROVERBS 24:16 NLT

Have you ever been struck down and struggled to get back up? Sometimes one good life-beating is all it takes to knock someone down for good, but this is not what God wants for his children. Remember, we are righteous because of him, so we rise because of him too. We cling to his hope and promises rather than our feeble strength. He is strong, and we depend on that truth even more in our weakness.

Sheer determination can only carry someone so far; eventually we are each met with terrible blows. God promises to always be with us and provide a way through. Unlike those who only rely on themselves, we will never be overcome. We may trip and fall from time to time, but we get up again because our strength comes from God. He lifts us from the ashes and heals our wounds. He is a good God.

Oh Lord, please help me get back up again today. I refuse to stay down and dwell in defeat, but I need your strength to keep going. Give me a kingdom mindset.

Compassion for Enemies

Do not rejoice when your enemy falls,
And do not let your heart be glad when he stumbles.
PROVERBS 24:17 NKJV

Jesus told his disciples in John 13:35, "By this all will know that you are My disciples, if you have love for one another." Love is our brand in a way; it is the undeniable characteristic of following Christ. We love others not because they deserve to be loved but because Christ has filled us with his love. Therefore, our love is not conditional to the recipient but to the source: God himself.

True Christians love their enemies because we realize they too are made in the image of God and deeply loved by him. We are not to gloat or rejoice when evil people are cut down. Instead, we ought to pray for their hearts to change. It can be tempting to want revenge on those who have dealt unfairly with us or celebrate when they are met with similar injustices, but God tells us revenge is only for him to enact (Deuteronomy 32:35). Wisdom keeps us true to our calling and leaves the vengeance to God.

Loving Lord, fill me with forgiveness and compassion for those who have done me wrong. In my flesh, I don't feel love and don't want to forgive, but then I remember all the undeserved love and forgiveness you have shown me. Thank you for your incredible love.

Standards of Accountability

It will go well for those who convict the guilty;
rich blessings will be showered on them.
PROVERBS 24:25 NLT

There is great relief when those who have done great harm are held accountable. There is reason to rejoice when the innocent are freed and the guilty are convicted. We receive so much mercy in Christ, but it does not mean that we escape the natural consequences of harm done to others.

We can rejoice in justice and still value the power of mercy. Both can coexist. If we want to walk in the power of God's wisdom, we cannot ignore our duty to treat others well, to love them and not harm them, and to live with honesty, consistency, and transparency. We should be people of our word and follow through with what we say we will do. Deceit, cheating, and harming others willfully is not the way of God. If nothing else, we should hold the standards of our own hearts and lives against God's ways and avoid the shortcuts of the fool who would compromise these standards for their own gain.

God, thank you for your great mercy and your heart of justice. I trust you to do what I cannot and take agency over my own life and choices. Make me more like you, Jesus!

Kiss the Lips

Whoever gives an honest answer
kisses the lips.
PROVERBS 24:26 ESV

This proverb is a figure of speech. The kiss in ancient Hebrew custom indicates affectionate friendship and sincerity. Paul repeats the proverb with his own spin by adding love when he says in Ephesians 4:15-16, "Rather, speaking the truth in love, we are to grow up in every way into him who is the head, into Christ, from whom the whole body, joined and held together by every joint with which it is equipped, when each part is working properly, makes the body grow so that it builds itself up in love."

Emulating Jesus requires this level of integrity and intimacy. We have nothing to hide and only love to show. It is possible to be honest yet lacking in love, so in a way, Paul advances the ancient proverb with more depth for believers to understand. Everything Christ did was from a heart of overwhelming love. When we love others, we can tell them the truth with kindness.

Dear Jesus, teach me more about love. Show me how I can better emulate you in my relationships. I want to be kind and loving, even when telling a hard truth.

Order of Operations

Put your outdoor work in order
and get your fields ready;
after that, build your house.

PROVERBS 24:27 NIV

When we plan our endeavors, we are able to know the order in which things need to be done. Wisdom is found in planning, and in following through with those plans. No matter our natural inclinations when it comes to planning, this is an area we can grow in. Our clarity and efforts will be more concentrated when we take the time necessary to do this.

Psalm 127:1 says, "Unless the Lord builds the house, the builders labor in vain." As believers, it is important we go to the Lord with our plans. Jesus reiterated the importance of having a plan and carefully seeing it through when he spoke to the crowd traveling with him in Luke 14:28, "Suppose one of you wants to build a tower. Won't you first sit down and estimate the cost to see if you have enough money to complete it?" Children of God, whether naturally wired for it or not, will be equipped to do the work the Lord has planned for them, and that is a comforting thought.

Teach me, God, to plan well. Help me learn the skills I will need to succeed on the path of my life.

Getting Even

Don't testify against your neighbors without cause;
don't lie about them.
And don't say, "Now I can pay them back for what they've done to me!
I'll get even with them!"
PROVERBS 24:28-29 NLT

Harboring bad feelings or holding a grudge never ends well. God does not condone this. In fact, throughout Scripture, those who love God are told to let him take care of the people who harm them. It is our job to love them. Always.

As citizens of the kingdom of God, we are to behave graciously toward everyone. God is the wisest judge and the most reliable leader. We are to trust him. Paul told the Romans, who were going through horrible persecution in Romans 12:19, "Dear friends, never take revenge. Leave that to the righteous anger of God. For the Scriptures say, 'I will take revenge; I will pay them back,' says the Lord." If they could follow this advice, we can give it a try too.

Father, I want to be generous in grace as you are. Help me to love others well and forgive those who hurt me. Help me to let go of my offenses and never look to bring someone down with a lie.

Take That Step

Professional work habits prevent poverty from becoming
your permanent business partner. And:
If you put off until tomorrow the
work you could do today, tomorrow never seems to come.
PROVERBS 24:33-34 TPT

We have all procrastinated something or other in our lives. Maybe it was a class assignment when we were in school. Perhaps it is a chore that we don't particularly enjoy. The fact is the work does not go away. It still needs to be done. When we are professional and diligent about the work that is ours to do, we avoid unnecessary stress and overwhelm.

If you have something you've been putting off, do it today. If it's too big a project to be done at once, break it down into more manageable steps, and take at least one of those steps today. You will feel better by making forward movement on it, and you will be able to focus on other things without it weighing in the back of your mind.

Lord, thank you for your grace that empowers me to do even the things I am completely overwhelmed by. Help me to make a plan and do what needs to be done. I know that is the wise way where relief and renewed vision lies.

He Has Answers

It is the glory of God to conceal a matter,
But the glory of kings is to search out a matter.
PROVERBS 25:2 NKJV

We search for God when we need answers, help, hope, reassurance, or anything lifegiving. He loves to reveal his mysteries to us, but he doesn't just throw them out there. We need to dig below the surface; God wants us to search them out. He wants to be pursued. As with anything worthwhile, the reward is worth the effort. In fact, it is more rewarding than we can imagine! Scripture says that wisdom is more costly than gold and silver, so why wouldn't we spend our time looking for it?

When we have questions, God has answers. When we feel hopeless, he gives hope. When we are confused, God gives clarity. When we feel unloved or unaccepted, he offers love and acceptance. We are his children, and he loves to give us good gifts. We will find them as we search for him.

Father God, you are the King of kings. I trust you with what I don't know because you reveal everything in its time for your glory. Teach me reliance on you above all else. Give me persistence to search for you and reveal the treasure of your wisdom as I do.

Walk with the Wise

A wise warning to someone who will listen
is as valuable as gold earrings or fine gold jewelry.
PROVERBS 25:12 NCV

Find friends who will call you out and warn you if they see you headed in a direction that could harm you. Surround yourself with people who will help you put your priorities in order and challenge you to grow in your faith. We need godly examples to point us back to Christ when we begin to wander. Accepting and offering correction can feel uncomfortable, but it can be so rewarding when it is done well. We are wise when we allow trustworthy people to speak into our lives.

We are not expected to avoid messy situations. Jesus got his hands dirty all the time and embraced the mess around him. He loved the "unlovable" and sought out sinners. He helped them turn their lives around. Let's not ignore the mess or pretend it doesn't exist. We can call it out, work through it, and rise above it together.

I love to listen to you, Lord. Teach me to listen better. Please surround me with wise friends who will encourage me to draw closer to you and prioritize my relationship with you.

December

My child,
do not forget my teaching,
but keep my commands
in mind.

PROVERBS 3:1 NCV

A Right Word

Use patience and kindness when you want to persuade leaders
and watch them change their minds right in front of you.
For your gentle wisdom will quell the strongest resistance.

PROVERBS 25:15 TPT

Repeatedly Scripture reminds us that words have power. They can bring positive, godly change if we speak wisely, with patience and kindness. Gentle wisdom is sometimes all it takes to disarm the most determined opponent. What is the point in winning an argument if nothing changes? Consider how Joseph, Esther, and Daniel approached their leaders and humbly addressed issues in Genesis 41:14-16, Esther 7:1-7, and Daniel 1:8-14. Their intentions were not to prove they were right but to change the situation.

When we are confronted with resistance, let's remember to approach the issue with patience and kindness. We can put our pride to the side and ask God to use us to bring change for his glory.

Instead of becoming discouraged when an authority makes a poor decision, help me see it as an opportunity to share your truth, dear God. Lead me in wisdom so my words and actions reflect you. I want to have a godly impact on those around me including my leaders.

Choose Generosity

If your enemy is hungry, give him bread to eat,
and if he is thirsty, give him water to drink,
for you will heap burning coals on his head,
and the LORD will reward you.
PROVERBS 25:21-22 ESV

It is easy to convince ourselves to keep our distance from those who don't like us. We cannot always avoid their company, however. When we have the opportunity to extend a kind gesture to them, we should. That is the higher way. That is the way of Christ.

When we treat others the way we hope to be treated, we reflect the light of Christ. We do what is right because it is the right thing to do. When an adversary is hungry, we can feed them. When she is thirsty, we can offer her a refreshing drink. This is the kind of graciousness that elicits strange looks from others. Why would we show kindness to someone who refuses to do the same to us? Because, simply, it is the way of Christ. It is the path of love. It is true wisdom.

Jesus, I want to love the way you love. When I see an opportunity to help someone who has made my life harder, I pray for compassion to consume me. I will choose generosity even when it feels like a sacrifice to do so.

Honey and Honors

It's not good to eat too much honey,
and it's not good to seek honors for yourself.
PROVERBS 25:27 NLT

Too much sweet food can make a person feel sick. Most of us know this on a personal level, like kids in a candy shop, we may have gone overboard and learned our lesson. Listening to someone constantly praise themselves is just as nauseating. People form their own conclusions about others, and that opinion is based on the character behind the words and not just the words. Someone who feels the need to talk about their own achievements is suspect already. Why are they insecure? What are they hiding?

We are instructed throughout Proverbs to be conscious of the words we speak. Paul was diligent about teaching humility. He was clear when he wrote to the church at Philippi in Philippians 2:3, "Don't be selfish; don't try to impress others. Be humble, thinking of others as better than yourselves." Building others up instead of elevating ourselves keeps our hearts in the right place. It is best to let others honor our efforts rather than always pointing to our achievements.

Lord, make me conscious of the best parts of people. Show me how to encourage them by highlighting those beautiful things.

Self-controlled and Protected

A man without self-control
is like a city broken into and left without walls.
PROVERBS 25:28 ESV

Is it hard to control your temper? Do people get under your skin easily? A city without strong walls can easily be broken into and overcome, but a well-built city can withstand attack. Similarly, if we have no restraint or ability to control our frustrations, we are on shaky ground. If we are prone to anger and don't have control of our emotions, we leave ourselves vulnerable to attack.

The firmer our identity in Christ, the more we follow in his footsteps. One of the fruits of the Spirit is self-control, that is, restraint. We know when to step away from a situation to cool down. We practice patience. When we do lose our cool, we come back to the person and humble ourselves to repair the situation. Self-control helps us stay rooted and gives us space to consider before reacting. It is like a wall around the vulnerable places of our heart. What wisdom there is in it!

Lord God, please help me build a wall of self-control in my life. Help me control my emotions, especially my anger. I don't want to leave myself open to attack. Thank you for your help.

Powerless to Harm

Like a fluttering sparrow or a darting swallow,
an undeserved curse does not come to rest.
PROVERBS 26:2 NIV

We don't have to worry when others wrongly curse us. If the accusation is baseless, it will have no place to land. It might flutter over you like a bird, but it will not have a landing place in your life. Though we may have to wait for the truth to be revealed, it will be. God is defender of the innocent. Let's wait on him and trust him to reveal the truth.

Beloved, we can also be assured that those who conceal the harm they do will also be found out. It may take longer than we like, but it will not go undetected forever. Let's be quick to stand on the side of the vulnerable and the oppressed, especially when the light of truth exposes dark deeds. Though an undeserved curse will not come to rest on the innocent, truth always comes to light.

Father, thank you for being so trustworthy and true. You see what others miss. I trust you with my reputation and with revealing the truth. Help me abide in you as I wait.

Focus on Today

Do not boast about tomorrow,
for you do not know what a day may bring.
PROVERBS 27:1 ESV

*N*o matter how well we plan for the future, the fact remains: we do not know what a day may bring. We don't know the challenges or the joys that will meet us. Sure, there are things we can anticipate, but there is so much we simply do not know and cannot control. It is foolish to brag about tomorrow when it remains a mystery in many ways.

It is wise to remain flexible and open in our expectations, trusting God with what we cannot anticipate. His grace meets us in every moment. Instead of getting overly caught up in the promise or the dread of tomorrow, we can rest in the peace promised today. When we slow down and put our attention on the present, we can cultivate gratitude and peace in the here and now.

God, thank you for the power of your presence that meets me every moment of every day. I turn my attention to you, and I loosen the grasp of my expectations and trust you with what I cannot know. Thank you for your present love, peace, and joy.

Busy Praising God

Let another man praise you, and not your own mouth;
A stranger, and not your own lips.
PROVERBS 27:2 NKJV

God doesn't ask us to deny the power of his work in our lives. There is a time to celebrate our achievements, and that is right and good. This verse is a good reminder to keep for those of us prone to talking ourselves up. This isn't the same as being proud of an accomplishment. This is more like trying to convince others of our goodness.

When others sing our praises, it holds more weight. We should not be so consumed by our image that it is all we are concerned with. That is a shallow life that will leave us unsatisfied in nearly every way. We should do the character-building work of loving God, loving others, and putting our hands to the work that is ours to do. All else will flow from that. As 1 Peter 5:6-7 encourages, "Therefore humble yourselves under the mighty hand of God, that He may exalt you in due time, casting all your care upon Him, for He cares for you."

God, I choose to focus on you first and foremost. I don't want to be so concerned with my own image that it costs me what truly matters. I give you all my cares.

Jealousy

Wrath is fierce and anger is a flood,
But who can stand before jealousy?
PROVERBS 27:4 NASB

Jealousy is a fire that consumes. It can lead people to act in extreme ways. At its most extreme, it can lead to criminal and cruel behavior: from controlling manipulation, stalking, and even to taking someone's life.

Wisdom teaches that we should stay away from envy and jealousy. It might not lead to us committing a crime, but it also won't lead to anything good. Our hearts, when consumed with jealousy, cannot be filled with love, joy, peace, patience, kindness, goodness, faithfulness, gentleness, and self-control. When we focus on the fruit of the Spirit, however, envy loses its spark. What are you filled with today?

Oh Lord, thank you for your love that covers everything. I want to be filled with the goodness of your Spirit. When I feel jealousy's spark in my heart, douse it with the living waters of your wise presence.

Greater Good

Better is open rebuke
than hidden love.
Wounds from a friend can be trusted,
but an enemy multiplies kisses.
PROVERBS 27:5-6 NIV

A real friend will offer a rebuke instead of lip-service. A good friend cares more about being honest and helpful than being liked. Flattery feels good, but it accomplishes nothing. Honest and constructive criticism can help us mature and learn, especially when given lovingly and carefully. God is a true friend who doesn't hide his love. He openly gives his correction because he cares about our growth.

If we want to be more like God, we ought to consider what kind of friend we are. Do we only say nice things and avoid uncomfortable conversations? Or are we ready and willing to challenge our loved ones to confront harmful attitudes and behaviors? We all need true friends like this. Let's be loving and honest so our friends know we are trustworthy and reliable.

Lord, in your love, you correct me and set me straight. Though it stings for a moment, I know it is for my good and it produces greater good in me. Help me be an honest and true friend to others.

Helpful Advice

*Perfume and incense bring joy to the heart,
and the pleasantness of a friend
springs from their heartfelt advice.*
PROVERBS 27:9 NIV

Some people are simply pleasant to be around. When you're with them, you feel peaceful and loved. Their words matter to you because they matter to you. Their opinion carries weight because you know the heart behind the perspective. True friendship is sweet, pleasant, and fills our hearts with joy. When a beloved friend offers advice, we are more apt to listen because of the relationship we share.

God's ways are harder to follow if we don't have a loving relationship with him. When we know him, love him, and recognize how much he loves us, his commandments are easier to adhere to. We know it comes from a heart of love. The same is true for parents, teachers, employers, and friends. Direction is easier to follow, and we are more apt to take advice, when we know the person truly cares about us. Relationships matter.

Lord, thank you for pleasant and mature friends who love me and look out for me. Thank you for the gift of wisdom that is revealed through relationship.

Prudence

The wise see danger ahead and avoid it,
but fools keep going and get into trouble.
PROVERBS 27:12 NCV

It requires more than worldly cunning and street smarts to predict danger and avoid it. Only God knows the future and can lead us safely through this word's plethora of potholes. It may sound simple to stay vigilant, but it's difficult because of the onslaught of information and messaging thrown our direction every single day.

We need to tune out the noise, stop hastily rushing to judgment, slow our pace, and spend time with God. Only by focusing on him can we refocus our lives, gain perspective, and realize which way we ought to walk. God offers us practical wisdom for everyday scenarios as we take the time to patiently listen, read the Scriptures, pray, seek wise counsel, and practice prudence.

Father God, I don't want to jump on bandwagons because of the hype around them. Help me to be prudent, wise, and discerning. I know wisdom does not rush to conclusions, so help me to slow down and follow you.

Relationships Take Work

As iron sharpens iron,
so a friend sharpens a friend.
PROVERBS 27:17 NLT

Spending time with others of the same mind and spirit can help us mature our faith and walk in truth. This doesn't mean we agree on everything, but we do share the value of growing stronger in faith, wisdom, and pursuing peace. It takes work and dedication to sharpen iron, and it takes work and dedication to be a friend. Casual friends or acquaintances can't nonchalantly address our issues or polish out our flaws. To build a relationship where there's enough mutual trust and spiritual camaraderie to work through problems together requires a foundation of love and connection.

The Lord made us to live in community, have the support and accountability of friends and family, and walk through life with others. We are not supposed to hide away in comfortable isolation. God's intention is for us to embrace community, relationships, and all the human variables which accompany being vulnerable with others. As we do, our edges will smooth out as our lives rub against each other.

Lord, I am so thankful for wise ones who challenge and sharpen me in word and deed. Thank you for putting people in my life who speak truth and encouragement to me and who live by example.

Strength in Integrity

Better is a poor man who walks in his integrity
than a rich man who is crooked in his ways.
PROVERBS 28:6 NKJV

The power of integrity cannot be overstated. When we live honestly, not changing our story from person to person, we have nothing to hide. There is no reason to fear when we live openheartedly before the Lord and before others. With wisdom as our guide, we follow through on our word, we are careful to what we agree to, and we are trustworthy. Integrity is a shield for all who follow it. There is no hiddenness or shame to cover.

Integrity is not perfection. It is the ability to admit when we are wrong and seek to repair relationships that we have injured with our words. We do our best until we know better, and then we do better. God is at the center of all of this. His love compels us in our own compassion. We trust God because his ways are higher than ours, and his wisdom stands the test of time. It is always best to follow the path of truth rather than one riddled with lies and compromise.

Oh God, thank you for the confidence that comes with living according to your wisdom. Help me to be full of honest integrity and reliability.

Confessions

Whoever conceals his transgressions will not prosper,
but he who confesses and forsakes them will obtain mercy.
PROVERBS 28:13 ESV

When we do wrong, it either eats away at our hearts until we find forgiveness, or we grow calloused. Unresolved sin weighs us down so it's hard to move forward or focus on anything else. It may wake us up at night, distract us during the day, and add an unnecessary load to our shoulders. Concealing sin is not worth it! The initial conversations and admissions are difficult, but they are crucial to healing, freedom, and moving forward. We can't control how others will respond to our confession, but we know God will grant us mercy and strength to overcome sin and walk in freedom from it.

God doesn't want us to wait until we've gotten everything figured out before we come to him. He wants us to come to him for help as soon as we realize we need it. He has the strength we lack, the forgiveness we need, and the love we desperately yearn for.

Oh God, you offer freedom and forgiveness when I bring my burdens to you and hand them over. Sin is heavy, and I need your help to be free from it. I confess everything to you today and ask for your help to walk in the liberty of your love.

Blameless in Christ

The one whose walk is blameless is kept safe,
but the one whose ways are perverse will fall into the pit.
PROVERBS 28:18 NIV

When we live in the light of God's wisdom, following his ways instead of the ways of this world, we walk in the peace of God's protection. Even when life's storms come, we don't need to fear. Even if we lose greatly in this life, we cannot lose our tested character. We cannot lose God's love. We cannot lose his grace.

Walking blameless is the only way to avoid all snares and pitfalls, but everyone messes up from time to time. When that happens, correct your course, and follow the loving voice of our Lord. He is always nearby and ready to help the repentant. We don't walk blameless because we are perfect; we walk blameless because we walk with God who has taken away our sins and helps us every step of the way.

Thank you, God, for leading me on your straight and narrow path. Please take my hand and keep me from going the wrong way. Save me from snares and pick me up when I fall. I want to always walk with you.

Bringing Calm to Chaos

Fools give full vent to their rage,
but the wise bring calm in the end.
PROVERBS 29:11 NIV

Jesus faced confrontation often, yet his response was always calm, controlled, and truthful. He did not back down from the truth he knew and stood for, but he also acted in love, even when he was angry. He was always right and always justified, but he never used justification as an excuse to create chaos or react with rage. Jesus calmed storms; he didn't create them.

As his followers, we can also bring peace and calm. Being peaceful and controlled does not mean we allow sin to go unchecked or we don't become upset in the face of injustice. What it means is our approach is wise, compassionate, and measured. We think about what to say instead of immediately lashing out. Real change can happen when we submit to God rather than our feelings and act in wisdom instead of anger.

God, teach me how to live like you in the face of confrontation and injustice. Help me control my anger and be a voice of peace in a world of chaos.

Discipline Brings Delight

Discipline your child,
and it will bring you peace of mind
and give you delight.
PROVERBS 29:17 CSB

When we think of parenting, rest is not what comes to mind. Being a parent means losing a lot of sleep. Yet in the long run, when children have matured and grown well, they bring delight, and even rest, to their parents.

When God invited us into his family, he knew the baggage we were bringing with us. He has never been surprised by our selfish tendencies. He did not require us to have it all figured out before we approached him; he fathers us tenderly, meeting us where we are. Like a good father, he lovingly corrects us, redirects our hearts, and leads us. Although our disobedience causes him sadness, he never gives up. He truly delights in us. The more we mature with the help of his Spirit and by his grace, the more we prove that godly discipline produces rest and delight.

I want to delight your heart, Father God. I want to embrace your correction because I know it's done in love. Sometimes that's hard, so remind me how important and worthwhile it is. I love you.

Divine Guidance

When people do not accept divine guidance, they run wild.
But whoever obeys the law is joyful.
PROVERBS 29:18 NLT

The essence of running wild is to roam without direction or purpose. Many of us have a wild season in our lives, and most of us who have grown past that season recognize it as one of endless searching and painful consequences. We were looking for something—whether a peaceful place to land or a way to like ourselves more—so we lived with frenetic energy. We were running, many times away from something, and in some cases, ourselves.

Joy is the opposite of that lifestyle. The Word brings joy. We calm our spirits by reading the Word and knowing the laws of God. By following God's path to righteous living and seeking and knowing his presence, we find ourselves less frenzied, less wild, and more loving. We find real peace and experience deep joy. This work of the Holy Spirit within us is both shocking and wonderful. Divine guidance is a gift that brings delight and satisfaction.

Be my everything, Father. Be my purpose and my peace. Be my focus and my calm. I praise you forever.

A Humble Spirit

Pride will ruin people,
but those who are humble will be honored.
PROVERBS 29:23 NCV

There is a reason the Bible repeatedly reminds us to serve others, consider others, put others first, and so on. When we are too self-focused, we are consumed with our own needs rather than taking notice of the needs of others. Love is a force that moves us outside of our own limited perspectives. Compassion is a hallmark of humbleness. Pride separates us from others, while humility makes connections with others.

True honor is reserved for those who aren't looking for it. Jesus was direct when he explained in Matthew 16:25, "Those who want to save their lives will give up true life, and those who give up their lives for me will have true life." God's opinion of us is the most important. When we follow his wisdom, we honor him. Looking for accolades ourselves is a wasted effort, for it will not satisfy in the end, even if we find them. Let's humble ourselves before the Lord today, for he is the best example of humble leadership and honorable character.

Lord, I praise your name! Thank you for your love, forgiveness, blessings, and continued grace. Please help me embrace humility so I can continue to grow closer to you and bring honor to your name.

Fear of the Lord

Fear and intimidation is a trap that holds you back.
But when you place your confidence in the LORD,
you will be seated in the high place.
PROVERBS 29:25 TPT

A free person can live unconcerned about the approval of others. They aren't consumed with worry about other opinions. Instead, they are confident in what God says about them, and that is where their identity is. Fear does not hold them back because they walk in the freedom of Christ. They are not intimidated by anyone or anything because they know the truth in Philippians 2:13, "God will continually revitalize you, implanting within you the passion to do what pleases him."

There is nothing we need to be afraid of or intimidated by when our confidence is in the Lord. God works on our behalf, so what could foil our plans? God loves and defends us, so who could knock us down? We choose to honor God above man's ways because we understand God holds all the cards. Don't be fooled by someone who talks big but doesn't have a hand to play.

You hold my heart, allegiance, and reverent honor. Lord, you are my confidence. Help me to not be intimidated by those who oppose you.

Promise Keeper

Every word of God proves true:
he is a shield to those who take refuge in him.
PROVERBS 30:5 ESV

The promises of God are "yes and amen." Second Corinthians 1:20 reminds us of this. Simply put, God's promises never fail. Even the ones that are in process will faithfully come to pass. God is loyal to his word, and he is unchanging in his nature. He is not like the waves of opinion that change with a shift of the wind.

God is a shelter to those who take refuge in him. Whether or not we believe his Word will not affect its outcome. He is faithful regardless. However, the confidence of our own hearts can change based on our faith. Let's ask God to remind us of his faithfulness throughout the generations, to bring to mind the power of his fulfilled promises in our own walks with him, and to increase our trust as we take in the glory of his goodness.

Lord, thank you for your beautiful and unchanging character. I want to stand in the confidence of your Word; open my eyes to the truth of your loyal love once again as I look to you. Thank you for keeping your promises!

Mystery of Love

> There are three things that amaze me
> no, four things that I don't understand:
> how an eagle glides through the sky,
> how a snake slithers on a rock,
> how a ship navigates the ocean,
> how a man loves a woman.
> PROVERBS 30:18-19 NLT

God has created many marvelous wonders in which we get to participate. Step into nature, and you will be reminded of how creative and intricate God's design is. He fashioned every detail in this world for us to live in and enjoy. Also consider the people God has put in your life. Relationships are a gift from God. He gave us loving relationships like the love shared between spouses, children to parents, siblings, and friends.

Love is remarkable and unexplainable; it is in many ways a mystery. Even more mysteriously, all the love in the world we feel for one another is simply a reflection of the love God feels for us. We are mirrors capturing the image of real love. It's truly astonishing.

Lord, you have created great and marvelous things that I can't fathom. The way love works is incredible and yet full of mystery. I am in awe of your majestic power and filled with gratitude for your love.

Full of Confidence

There are three things that walk with
stately stride no, four that strut about:
the lion, king of animals, who won't turn aside for anything,
the strutting rooster, the male goat, a king as he leads his army.

PROVERBS 30:29-31 NLT

In ancient times, a king was expected to be as brave as any soldier in his army. He needed to be an example to everyone who served him. He needed to be a leader of leaders. Today's verse illustrates four things that have majesty. The writer of Proverbs 30 was a man named Agur, and he used the three-four structure in many places throughout this chapter (read verses 15-16, 18-19, 21-22). Three examples were animals: the lion, the rooster, and the male goat. The fourth was a king.

Animals come by their stateliness naturally. They are born with it. The king, on the other hand, chooses his nature and demeanor, and these animals are an example for him. The lion backs down for nothing; the rooster presents a strong presence; the male goat is stately and ready to fight any who oppose him. When we choose how to present ourselves, we should consider our position as daughters of God and seek the Word for whatever God has to say about it.

Lord, make me aware of my position in life. Open my eyes to how I can grow in confidence in your love and walk with the surety of my identity as your daughter.

Cover Your Mouth

If you have been foolish, exalting yourself
or if you have been devising evil,
put your hand on your mouth.

PROVERBS 30:32 ESV

It's better to physically restrain ourselves than to speak foolish words that will bring damage to others and ourselves. It's better to remove ourselves from a situation before we compromise our values than create the need to go back later with an apology. It's better to take time with God and in the Word than to walk about aimlessly.

There is wisdom in waiting, in being discerning about where we give our time and energy, and in choosing what we agree to. God asks you to pause. Think about what you are about to say. Consider the consequences of your words and don't put yourself in a position where you must backpedal and make up for the damage. Consider what it means to be a child of the living God and let whatever comes out of your mouth reflect the power of God's love and redemption. His wisdom is always the best way.

Lord, teach me to control my words and only say things that edify others and bring joy to your heart. Even if I have to put a hand over my mouth today, help me to practice restraint.

Motherly Wisdom

The sayings of King Lemuel contain this message,
which his mother taught him.

PROVERBS 31:1 NLT

Throughout Scripture, it is easy to find the sayings of men. This may make us wonder at the power of our influence as women. However, wisdom does not discriminate. It is not a gendered thing at all. Wisdom is found in the halls of learning and also the humble homes of the poor. Your voice matters. Whether or not you are a mother, as a woman, you have great influence over those in your circle.

Don't overlook the power of your words, the strength of your influence, or the weight of your intent. If you are a mom, you know how much it can limit your time to pursue other things, especially when your kids are young. However, there is great purpose in loving and taking care of your family. Mary's greatest honor was to be the mother of the Messiah. Don't overlook the worth and power of your role to nurture those in your care. It is greater than you know!

Loving Lord, thank you for the gift of being a woman. With or without children, it is a privilege to walk in wisdom and use my voice for your glory.

Speak for the Defenseless

"Speak up for those who cannot speak for themselves;
defend the rights of all those who have nothing."
PROVERBS 31:8 NCV

There are plenty of people around us who do not have the ability or stance in society to speak up for themselves. We don't have to go far to find them. There are children, people with disabilities and chronic health issues, and aging populations all around us. As God's children, we should not hesitate to defend the rights of others. It is a privilege to stand up with and for the vulnerable in our society.

Be glad when your eyes are opened to ways you can partner with God in your community. Count it an honor when you are given an opportunity to speak up for others. We needn't drown out the voices of the oppressed with our own. We should stand with them and partner with them. Remember, the powerful don't need our backing; it is those who have nothing that need our support!

Keep me on my toes, Father, so I may serve you in defending the defenseless. Give me wisdom and discernment to know when to let others speak and when I should raise my own voice.

Things that Matter

Who can find a virtuous wife?
For her worth is far above rubies.
PROVERBS 31:10 NKJV

In a world that lives by the clock, chasing the dollar, let's be people who value virtue above our bank accounts. Let's prefer morals over money, character over convenience, and righteousness over rubies. A virtuous person brings blessings to their family, value to their workplace, and honor to God.

Why are we consumed with worldly riches that will not last? We can instead refine the hidden places in our hearts, which will have an eternal impact on our lives, and on those we are closest to. As Christians, it's time we got our priorities straight and focused our time and energy on things that matter. What do you look for in a spouse? What do you hope for in your children? What sort of employee do you want working for you? What kind of person do you want to be?

Above all else, God, I want to be like you. I will put my time and efforts into things that matter.

Enriching Life

Her husband can trust her,
and she will greatly enrich his life.
She brings him good, not harm,
all the days of her life.
PROVERBS 31:11-12 NLT

As Christians, we are all members of God's family. We work together within the body of Christ. Therefore, we should never try to tear each other down or harm another believer in any way. Doing so brings harm to all of us and cripples the body of believers. Instead, let's learn how to support each other, make amends, be a blessing, find a way to overcome differences, work together, humble ourselves, act in love, and enrich the lives of others.

We are called to be good, trustworthy, helpful people. Our mission ought to be love. Instead of fighting for ourselves, remember it's God who fights for us, and let's fight for each other. Even the most difficult Christian is a brother or a sister, so consider it a God-given challenge to learn how to break through and bring life instead of strife to that person.

Heavenly Father, please use me to enrich the lives of others. I want to be a bearer of blessings and not a burden to my brothers and sisters. I want to do good and not bring harm.

Strength and Honor

Strength and honor are her clothing;
She shall rejoice in time to come.
PROVERBS 31:25 NKJV

Tough times are telling. Anyone can look put together and strong when they are undisturbed. Pull the rug out from under someone, and you can see who they truly are. How do you react when your world gets turned upside down? Who do you run to when you're given bad news? What are your first assumptions when disappointment smacks you in the face?

Life happens to all of us, but it won't be the undoing of a righteous person because they are clothed with God's strength and honor. God is the giver of good gifts. He takes our mourning and turns it into dancing. This doesn't happen overnight. It is a process, but we trust the one who leads us through the dark night toward the dawn of a new day. Perseverance is a trait of those who trust in the Lord. Even when they are caught in a cloud of confusion, they trust that clarity will come from the wisdom of God. Stay close to your good Father. He will not let you down!

Powerful Lord, clothe me with your strength and honor. In you, I am unshakable. In you, I will always find reason to rejoice.

Wisdom and Kindness

Her teachings are filled with wisdom and kindness
as loving instruction pours from her lips.
PROVERBS 31:26 TPT

There are defining moments in life, but it is important to remember those moments didn't make us. The groundwork had been laid and the decisions already made leading up to that point. We act on what we've already built.

When we speak, what comes out of our mouths? Is it bitterness, complaint, and self-promotion? Or is it wisdom, kindness, and love? Does what we say have a negative or a positive impact on others? Are we working to bring glory to ourselves or to God? Our words reflect our hearts, and there will be moments when our hearts are exposed by what we say. Let's lay a godly framework right now and create habits of good decisions. When tough moments arise, our reactions will be wise and kind.

I am led by your Spirit, oh Lord Almighty. You guide me and teach me. When I listen to you, my words are filled with wisdom and kindness that only comes from knowing you and spending time with you. I press in to know you more today!

Live Before the Lord

Charm is deceitful and beauty is passing,
But a woman who fears the LORD, she shall be praised.
PROVERBS 31:30 NKJV

Our priorities matter. What we give our time and attention to affects the satisfaction of our hearts and the well-being of our relationships. There is nothing wrong with wanting to look nice. This isn't something to abandon. However, youthful charm and beauty are fleeting. We cannot turn back the hands of time. It will show on our faces and in our bodies. This is not something to despise!

The most important thing about us is our character. How are we known to treat people? Do we speak with kindness and sincerity? Are we wise with our pursuits? Are people better for knowing us? We will never be perfect, but that's truly not the point. Think of those you love the most. What do you expect from them? Is it perfection, or is it commitment, love, and grace? Worship the Lord and follow his wisdom, and as you grow, the beauty of your heart will not fade.

God, don't let me forget what is important and lasting. Thank you for the godly examples you have put in my life and recorded in your Scriptures. Help me to focus on the things that truly matter. I love you!